exploring

DIGITAL WORKFLOW

Penny Ann Dolin

THOMSON

DELMAR LEARNING

Australia Canada Mexico Singapore Spain United Kingdom United States

Exploring Digital Workflow
Penny Ann Dolin

Vice President, Technology and Trades SBU:
Dave Garza

Marketing Coordinator:
Mark Pierro

Art/Design Coordinator:
Nicole Stagg

Editorial Director:
Sandy Clark

Production Director:
Mary Ellen Black

Editorial Assistant:
Niamh Matthews

Senior Acquisitions Editor:
James Gish

Senior Production Manager:
Larry Main

Cover Design:
Steven Brower

Project Manager:
Jaimie Weiss

Senior Production Editor:
Thomas Stover

Cover Image:
Chris Navetta

Channel Manager:
William Lawrensen

Technology Project Manager:
Linda Verde

Cover Production:
David Arsenault

Library of Congress Cataloging-in-Publication Data

Dolin, Penny Ann.
 Exploring digital workflow / Penny Ann Dolin.
 p. cm.
 Includes index.
 ISBN 1-4018-9654-5
 1. Web site development.
 2. Digital media. 3. Electronic publishing. 4. Databases.
 5. Workflow. 6. Interactive multimedia. I. Title.
 TK5105.888.D65 2006
 2005023233

NOTICE TO THE READER

This book is dedicated to my wonderfully supportive family: my husband Ron, our daughter Sage Ann, and our above-average dog Blue, who all weathered my long hours at the computer with patience and understanding.

table of contents

Preface **VII**

1: Content Is King **2**

What Is Content? 4
What Is Digital Data? 4
What Is Digital Workflow? 6
Where's My Stuff? Digital Asset Management 11
 Managing Your Assets 12
 Organizing Your Stuff 14
The Nuts and Bolts 15
 The Speed of Your Computer 15
 The Memory in Your Computer 16
 Storing Your Stuff 17
 Platforms 17
 Servers and Networks 18
 Networking Standards, Topology, and Bandwidth 20
Summary 21
In Review 22

2: Digital Content for Print & Web **24**

The Vocabulary of Print 26
 Samples, Dots, Spots, Pixels, and Lines 26
 SPI 26
 PPI 27
 DPI/LPI 28
 So, Why Does This Matter? 30
 PostScript 31
 So, Why Does This Matter? 34
 Color 35
 Profiles 36
 So, Why Does This Matter? 37
Getting It Out of the Computer 38
 Preflight 38
 What Preflight Prevents 39
 Getting Organized 40
 Packaging It All Up 41
 Submitting Your Files 43

Publishing to the Web 43
 To Code or Not to Code 44
 Exporting Your Print Job to the Web 46
 Keeping It All Straight 47
Summary 48
In Review 50
Exercises 50

3: PDF: Print to Rich Media 52

The Birth of PDF 54
So, What Exactly Is a PDF? 54
 Advantages of PDF 56
The X in PDF/X 58
 Preparing Your PDF/X File 59
 Fonts, Again 61
Rich Media PDF 63
 A Rich Media Magazine 67
Summary 70
In Review 71
Exercises 71

4: XML, Metadata, & More 74

XML 76
 XML Conversion 77
Metadata 82
 More Than the Web 84
 Metadata Palette 86
 Metadata at the System Level 90
XMP 91
Summary 94
In Review 95
Exercises 95

5: Automation and Scripting 98

Automating Content Creation 100
 JDF 100
 Application-Based Automation 101
AppleScript 105
 How It Works 106
 Scripting Resources 110
 Other Scripting Possibilities 111
Versioning 111

TABLE OF CONTENTS

Summary 118
In Review 120
Exercises 120

6: Project Management: Mapping and Tracking 122

What Is Project Management? 124
 Logistics 125
 Mapping 126
 Software for Flowcharts 128
 Scheduling and Estimating 129
 Gantt Chart 130
 Tickler Files 131
Managing a Project 132
Care and Feeding of Your Client 137
Summary 140
In Review 141
Exercises 141

7: Making It All Work 142

Content Creators 144
 Brian Drake 144
 Shannon Ecke 147
 Kathleen Evanoff 149
Those That Hire 152
 Morgan and Company 152
 PrimeView LLC 154
 Moses Anshell 156
Those That Get The Files 158
 Frontend Graphics 158
 LAgraphico 159
Summary 161
In Conclusion 161
Night of the Living Page 161

Appendix 168

Appendix A–Aquent's Approach to Skill Assessments 168
Appendix B–Graphics Communications Industry Glossary 172

Index 196

preface

INTENDED AUDIENCE

In a world gone digital, it is important that those with creativity not get sidelined due to any lack of technical expertise. The goal of this book is not to make computer gurus and programmers out of all graphic designers, but to help them understand the tools and concepts needed to make a living as a content creator today. If you can't get your work out of the computer, you can't get work!

This book is intended for two- and four-year college graphic design programs. In addition, this book can be extremely useful to designers starting out in their career or even established talents who don't feel they are using the most efficient digital workflow. Today, how you work is as important as what you create. The luxury of endless creative gestation is not always available to a working designer. Whatever tools help speed up the less than creative parts of the job will make your entire workflow more productive, and more profitable.

WHAT THIS BOOK IS NOT

This is not a book about design or how to create content. I make the assumption that you are already on your way to content creating. I leave topics such as designing an elegant page, or using typography, or readability and usefulness of a Web site to the many excellent books already out there. This book is about managing your content and working smarter. This is the book content creators need to fit into the production workflow with less aggravation and frustration. I have seen students design magnificent Web sites and printed pieces, but the sites do not work with their backend applications and the print job has choked the RIP (Raster Image Processor). In particular, I have seen different designers take far longer than necessary to create a document or Web site and in the process lose track of billable hours, expenses, due dates, and job parameters. This book is meant to be bridge between content creators and technical production. I couldn't find any book addressing this chasm, and so was born *Exploring Digital Workflow* for those who produce content.

BACKGROUND OF THIS TEXT

I spent the beginning of my career as a creative—a commercial photographer in the Northeast. I learned early on that as good a photographer as I may have thought I was (or aspired to be), I needed to master the technical requirements of producing good photographs by understanding my equipment, working smarter, and managing the requirements of multiple clients. It was quickly evident that talent was only the initial ingredient necessary for success as a working creative. Creativity was needed upon demand—I couldn't say I just didn't feel like shooting on a particular day. I couldn't say that I didn't want to be bothered with managing the studio, because if I didn't, there would not be a studio.

Traditionally, content creators (the "talent"), did their work in their chosen medium and handed it off to production. As I began working in the prepress industry and became more and more interested in the concept of digital workflow, it became obvious that the dividing lines between the content creators and production were blurring and becoming tangled. I often heard disparaging comments about the incoming files and complaints about the designers—didn't they know how to make a good file? It wasn't that the work did not look great, but there were often problems getting it out of the computer and onto film, or plate, or direct to press. Then came the Internet and a different set of parameters had to be met to make it all work. A Web site that only runs well on the Web designer's computer is of little use. The bold goal of this book is not only to help designers work smarter and produce work that can be output to a variety of destinations, but to also close some of the chasm that seems to have opened up between those who create and those who produce the work. The more that those who create content understand the workings of digital workflow and how to manage it all, the better the files/sites that will be created and the smaller the chasm will be between the two sides. And, that will make for a happier and more productive digital workflow for all involved from creation to output.

This book was compiled from a variety of sources including personal experience, trade publications, noted texts, numerous interviews, whitepapers, and industry reports. In addition, industry experts were invited to participate, and their contributions make up the numerous Expert Corners and articles seen throughout the book. My extreme gratitude goes to those profiled in Chapter 7 who agreed with me that young designers need to hear true stories "from the trenches."

SOME ASSUMPTIONS

It is assumed that the reader of this book is not a complete beginner in the sense that they have had some exposure to imaging, illustration, page layout software, and Web site design. It also assumes a certain familiarity with computers, in particular Mac OS X. Most of us have heard of Moore's law, which observed that an exponential growth in the number of transistors per integrated circuit would result in a doubling in the number of transistors every 18 months or so. Well, there must be a law about software somewhere because no sooner do we settle in with a new software release than the next revision is out.

With that in mind, the goal of *Exploring Digital Workflow* was not to make you expert in a specific version of a specific software, but to make you familiar enough with the concepts so you could apply them as needed and as the software changes. As this book goes to bed, the new version of Adobe Creative Suite 2 has recently been released. That does not change the basics discussed here—they can be applied to any current version of software mentioned in the book. The same can be said for Apple OS X with its new release. Any creative working today has to be able to adjust to the technical advances of the tools they use as it's never going to slow down. However, many of the basics will remain the same. This book is intended to provide you enough useful tools to make your digital workflow work regardless of the version of software release. In addition to adjusting to a never-ending parade of new software releases, things get even more confusing as one company buys another. As this book goes to press, Adobe has bought Macromedia. What will happen to Adobe GoLive and Macromedia Dreamweaver is certainly up in the air. Stay tuned. Links are provided to the sites of most software mentioned in the book and the reader is encouraged to check out the links regularly to see what is "new and improved!" Graphics never stands still!

TEXTBOOK ORGANIZATION

This book is structured to provide the most accessible path to the information covered in each chapter. From Learning Objectives to Sidebars and Expert Corners, the goal is to provide the reader with facts, examples, and useful content on the topics covered. Each chapter has corresponding material on the Companion DVD, review questions, and exercises where applicable.

Chapter 1: Content Is King

This chapter seeks to put the idea of content into proper perspective and introduces the term content creator (CC). It also explores Digital Asset Management and begins a discussion of metadata. In addition, a review of computers, servers, and topology is included because it is important to understand the technical environment within which you work. All content creators today by necessity must be part creative and part technologist. Understanding the digital world is imperative to success.

Chapter 2: Digital Content for Print and Web

An understanding of the basics of workflow in both a print and a Web environment are necessary for getting the job to "work." It is also important for those who only think of the Web as their medium to understand the challenges of print. And those who work on page design have to incorporate an understanding of what is takes to put their work online. No designer or content creator today can exist in isolation and only think of one possible output destination for their work.

Chapter 3: PDF: Print to Rich Media

PDF, the most ubiquitous file format of our time, has become much more than just a document format for print. From PDF/X to Rich Media PDF, it is the defacto standard for document distribution. It is also evolving into an interactive document format that has endless possibilities, from both a design and a marketing perspective. Understanding its uses and benefits is essential for anyone creating and wanting to deliver content today.

Chapter 4: XML, Metadata, and More

XML is one of the most important languages for creating and managing dynamic Web sites. But understanding how you go from a printed page to the corresponding Web site through the use of XML tags and CCS (Cascading Style Sheets) is critical to someone wanting to grasp today's print-to-Web workflow. Metadata is so much more than just keywords that get your Web site "spidered" properly. It is becoming a requirement for files as the metadata fields are being used for databases and cataloging purposes. To facilitate that, standards have to be established and utilized. This chapter introduces the content creator to some of those standards that are being supported, which involve metadata, XMP, and XML.

Chapter 5: Automation and Scripting

Those in production, both in the print and Web world, have long understood the value of automating their workflow to achieve greater efficiencies in output. The same lesson should be learned by those who create the content, no matter the final destination. Automating on an application level through software-specific actions, or managing your computer system through a scripting approach, help reduce tedious tasks and allows for more time for true creativity. This chapter serves as an introduction to ways to work smarter and faster no matter what media you're headed for.

Chapter 6: Project Management: Mapping and Tracking

No matter how creative you are, if you can't manage your projects, keep track of what needs to be done when, and what charges are billable, you are pursuing a hobby, not a career. The skills required to manage job parameters can seem very left brain to a naturally right-brained creative person, but the two must work together. This chapter covers the basics of mapping and tracking workflow. It pulls it all together with a project taken from start to finish using the tools discussed.

Chapter 7: Making It All Work

Making a living as a creative is where the dilettantes get separated from the professionals. This chapter introduces those who create content for a living, those who hire the creatives, and those involved in the

production of their content for output. Understanding the different approaches to managing a creative workflow and gaining an understanding of the tools and resources used, can help one prepare for a career in graphic content creation. Beyond words of wisdom, this chapter includes an article from one of the top people in our industry, Gene Gable, former president of Seybold Seminars and Publications. He envisions a future for designers that may or may not be imminent, but really needs to be thought about. The way you work now may be quite different in the future.

FEATURES

- provides the information and resources needed for results-oriented content creators to begin streamlining their workflow processes

- written with an eye to helping users manage and deliver their content with greater speed and fewer resources

- hands-on exercises and opportunities for practical application encourage readers to learn by doing

- interesting, attention-grabbing features—including revealing interviews with industry professionals— offer a wealth of helpful advice for getting organized, managing assets, prioritizing tasks, and much more

- an accompanying DVD features video clips, demo software, valuable Web links, and sample files that enrich the book's content

SPECIAL FEATURES

▶ **Chapter Objectives**

Learning Objectives start off each chapter. They describe the competencies readers should achieve upon understanding the chapter material.

▶ **Fast Facts**

Fast Facts are interspersed throughout the book to provide tidbits of relevant information regarding what is being discussed on a given page.

▶ **Sidebars**

Sidebars appear throughout the text, offering additional valuable information on specific topics.

▶ Expert Corner

These profiles feature successful content creators, industry consultants, and production supervisors in the field and offer valuable advice to those new to the industry.

▶ Review Questions and Exercises

Review Questions and Exercises located at the end of each chapter allow readers to assess their understanding of the chapter. Exercises are intended to reinforce chapter material through practical application.

DVD CONTENT

You will find useful links and files for each chapter of this book on the Companion DVD. Among these resources are demo versions of software, video interviews with top industry people, sample files, and tutorials. In addition, there are relevant Internet links for each chapter.

TEACHERS GUIDE (E-RESOURCE)

This guide on CD was developed to assist instructors in planning and implementing their instructional programs. It includes suggested syllabi, PowerPoint lectures, review questions and answers, and illustrations from the book.

In addition, please check out the book's Web site at www.exploringdigitalworkflow.com. Content will be added on an ongoing basis, and will include featured artists, exercises, and important links.

ISBN: 1-4018-9657-8

about the author

▶ Penny Ann Dolin

Penny Ann Dolin has been involved in the graphic communications field for more than 25 years. She developed her passion for photography while earning her bachelor's degree at Bard College, New York. As founder and operator of Silver Sight Studio, a successful commercial photography studio based in Stamford, Connecticut, she photographed for Fortune 500 companies and traveled extensively for many years.

After receiving her Masters of Technology from Arizona State University (Phi Kappa Phi), she joined American Color Premedia, the third largest prepress company in the United States at the time, as a member of the Corporate Research and Development team.

Prior to joining the faculty at Arizona State University in 1998, she held the position of Western Region Technical Manager for American Color Premedia, with responsibilities for four facilities. She maintains her ties with industry through consulting and professional organizations. Her previous book is *Printing Technology, 5th edition*.

At ASU, her areas of specialization are digital workflow, digital photography, digital publishing, and the business of the graphics industry. She thoroughly enjoys teaching and supports the students by advising the Graphic Information Technology Club and encouraging them to participate in industry activities.

ACKNOWLEDGEMENTS

A book like this could never have happened without invaluable input from industry associates and faculty from ASU and elsewhere, including the many trade organizations that are so important and supportive of our industry. Thanks to those who put up with my questions at various trade conferences and business meetings as I sought to find out what the technical side of the graphics industry felt could be improved upon by the content creators. And, thanks to all those designers—Web, print, and multimedia—who shared with me their thoughts on what makes a content creator a more valuable working artist. It is with humility that I have tried to serve as a "bridge" to get both sides to understand each other better.

My extreme gratitude to the students who assisted with the process from art work to research. Magdalena Soto and Divya Marwaha were wonderful contributors to the process of writing this book and, judging from my experience with them, I am most assured that they will be wildly successful in whatever graphic career path they choose. And many thanks to Dan Sturm for his assistance in producing and editing the footage for the industry interviews on the DVD.

I am in debt to the many designers and companies that supplied artwork without asking for recompense, knowing that I was on an "educational" budget. I also want to thank my fellow faculty members and my chair, Dr. Thomas Schildgen, for putting up with my working frenzy as I proceeded to work non-stop on the book and carry a full teaching load.

And, as always, the wonderful editorial team at Thomson Delmar Learning has been there every step of the way. In particular, James Gish, Senior Acquisitions Editor, who made this book possible, and Jaimie Weiss, my Development Editor who kept me on course and on schedule. Her calm and upbeat demeanor has been invaluable in defusing and solving any roadblocks encountered along the way.

In particular, I want to thank my wonderfully bright and loving daughter, Sage Ann, who understood that Mommy had to finish this project and made me promise "a lot of quality time" once this book was published. And I thank my husband, Ron, who allowed me the freedom to work, understood my goal, and supported this project from beginning to end.

Thomson Delmar Learning and the author would also like to thank the following reviewers for their valuable suggestions and expertise:

Carla Diana
Interactive Design Department
Savannah College of Art & Design
Savannah, Georgia

Raymond Fontaine
Chair, Graphic Arts Technology Program
Springfield Technical Community College
Springfield, Massachusetts

Michael LaMark
Graphic Design Department
Art Institute of Pittsburgh
Pittsburgh, Pennsylvania

Frank Romano
School of Print Media
Rochester Institute of Technology
Rochester, New York

David Pipp
Graphics Department
Waukesha County Technical College
Pewaukee, Wisconsin

QUESTIONS AND FEEDBACK

Thomson Delmar Learning and the author welcome your questions and feedback. If you have suggestions that you think others would benefit from, please let us know and we will try to include them in the next edition.

To send us your questions and/or feedback, you can contact the publisher at:

Thomson Delmar Learning

Executive Woods

5 Maxwell Drive

Clifton Park, NY 12065

Attn: Graphic Communications Team

800-998-7498

Or contact the author at:

info@exploringdigitalworkflow.com

http://www.exploringdigitalworkflow.com

CHAPTER

Chapter Objectives

- Gain an understanding of what digital data is

- Explore managing digital assets

- Define digital workflow

- Understand the hardware and software concerns of a content creator

- Understand network basics and transmission issues

Introduction

In this chapter, we will explore the basic material that makes up our graphic world—content. We will examine what it is and why it is so important for the content creator to understand it, as well as what digital workflow is and how we can manage it without becoming overwhelmed.

CONTENT IS KING

WHAT IS CONTENT?

Content is the "stuff" that is created and then output in a variety of ways. It is the product and the most important part of the chain in graphic information technology. Content can be destined for the Internet, PDAs, phones, TVs, digital billboards and so on. In fact, there are ultimate destinations for graphic content that we don't even know about yet. Perhaps some day ubiquitous computing will be a reality.

Ubiquitous Computing—What Is it?

Ubiquitous computing refers to anytime, anywhere computing. The definition of ubiquitous is "existing or being everywhere at the same time: constantly encountered." Many consider it to be the third phase of computing, which we are about to enter. The first phase was the mainframe, followed by the PC era. According to Mark Weiser and John Seely Brown, writing from the storied technology campus Xerox PARC, "The 'UC' era will have lots of computers sharing each of us. Some of these computers will be the hundreds we may access in the course of a few minutes of Internet browsing. Others will be imbedded in walls, chairs, clothing, light switches, cars— in everything. UC is fundamentally characterized by the connection of things in the world with computation. This will take place at many scales, including the microscopic."

In terms of content creation, this means that the possibilities for future graphical user interfaces (GUIs) are endless. The ultimate destination for your content may be your watch, the wall of a building, or even someone's T-shirt!

Underpinning all of this is the original material—the content. Content, in digital form, is the product of the content creator (CC), much like an original sketch is the product of an artist. In production facilities, increasingly digital content has become the asset that is controlled—not film and rarely comps. And now that content is digital, it can all be reduced to the same basic material—digital data.

WHAT IS DIGITAL DATA?

Much of our world today comes down to bits and bytes, 0s and 1s. Analog processes are metamorphosing into digital technologies. Broadband access, digital cable TV, digital cell phones, and even refrigerators that are Internet ready are becoming part of our everyday experiences.

In line with this, graphic information production is leaving the realm of analog processes and entering the digital arena. Almost all graphic content printed today is digitized at some point. Very few printers are stripping film or shooting with a process camera. The Internet is now a required communication channel. To understand how this has changed the concept of workflow in the graphics industry, it is necessary to understand what is meant by *digital*.

The Internet Toaster

In 1989 John Romkey, a Silicon Valley technologist (at that time with Epilogue Technologies) was challenged by a colleague to connect a toaster to the Internet. By doing so, Romkey would receive top billing at Interop, an Internet networking trade show. The toaster was connected via TCP/IP and had one basic control—turning the power on or off. The "toastiness" of the toast was determined by the length of time it was on. It was a great hit at the show, but as great as the technology feat was at the time, the question remains: If you pop your toast remotely, how do you eat it?

The Internet toaster.

Digital data is created by on/off switches. Under the hood of your computer are millions of tiny switches that ultimately create the visual represented on your computer display. To a computer, data is composed of numbers based on the binary system—functions in base2. Because a switch is either on or off, only two states exist—hence all computer data is binary in nature.

No matter how complex your ultimate graphic piece is, it all boils down to either an on or off binary digit (bit). In the analog world, many different materials, such as film, paint, charcoal, and ink, can be used to create specific graphical content. But when you boil it all down to the same basic material—bits—you suddenly have a common denominator linking all graphic content. You then open the door to many different destinations for the original digital content; print is no longer the only output. Once the common language is developed, there is no end to potential destinations. But each destination will have unique concerns or specific parameters to be satisfied, such as size of

figure |1-1|

Our computing world is binary in nature.

image/display, colors supported, client side languages and more. This is why understanding the specific digital workflow that content may encounter is so important to making it all work. And it is also why both the CC and the production person need to understand digital workflow in a cross-media world.

WHAT IS DIGITAL WORKFLOW?

Workflow applies to a myriad of fields and industries, but we will be addressing digital workflow as it applies to graphic information technology.

Workflow in a graphics context refers to the specific steps taken to produce a communication piece from content creation to output. In a digital world, it is almost impossible to separate the CC from the production process, so

Michael Vanderbyl

Michael Vanderbyl has been a designer in San Francisco for more than 30 years. Vanderbyl Design is internationally known as a multidisciplinary studio with expertise in graphics, packaging, signage, interiors, showrooms, textiles, and fashion apparel. Beginning his career as a graphic designer in 1973, Vanderbyl evolved as he saw that he could meet more and more of his clients' needs through the concepts of good design and that the medium itself was not the determining factor. He believes that soon, graphic designers, or CCs, will be considered communication specialists and "will have to understand the importance of communicating an idea, regardless of the vehicle." He

feels that having learned graphic design is an advantage because a "graphic designer is uniquely equipped to understand the language of visual communication. To truly succeed, a good designer in the future will have to be 2-D, 3-D, 4-D."

Although Vanderbyl admits that while some designers will remain focused on just one type of design delivery—such as print, web, or multimedia, they will be relegated to niche markets as opposed to tapping into the broader market needs. Today's designers need to assume that their content, or creations, will be destined for a variety of places. Vanderbyl is very involved in the education of the next generation of designers and serves as the Dean of Design at the California College of the Arts. In his opinion, a good design program is one that "incorporates design and technology. But don't get hung up too much on specifically what today's technologies are. They will change. A good design program will teach a broader approach to design in general. One needs to avoid the vocational approach— you need the technology, but you need to also be

both areas need to understand what it takes to develop an efficient and therefore profitable workflow. Workflow is something that can be mapped out as a graphical representation of the flow of work within a process, including related subprocesses, activities, and interdependent decisions. (We will explore ways to do this in Chapter 6.) In the old analog world of graphic production, processes could be more isolated and each individual department was responsible for a specific "piece of the pie" without too much interdependency. Granted, if a mechanical wasn't done well or film was underexposed, the following step

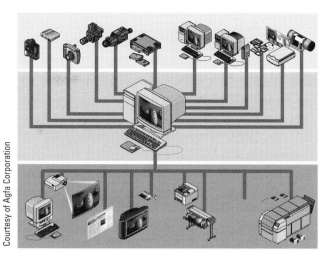

Courtesy of Agfa Corporation

figure | 1-2 |

Digital Workflow: Various forms of input and output utilized in a digital workflow.

able to analyze and talk about your work and understand the message trying to be conveyed."

Workflow is important and as many final destinations as possible need to be considered when doing the initial creative part of a job. Vanderbyl recalls a project where the original digital photography shoot (which the client insisted on) did not create a large enough file for an eventual large format output. Later, the client wanted printed output that was not possible from the

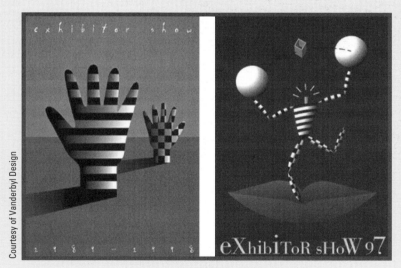

Courtesy of Vanderbyl Design

Exhibitor Show posters sponsored by *Exhibitor Magazine*, created by Michael Vanderbyl.

original raw file. "Sometimes film can still beat digital if you don't know in advance the eventual size the piece may need to be. Workflow always depends on the job. Always plan for the worst case scenario—it can happen. Be prepared for numerous eventualities and never assume the outcome."

Vanderbyl cautions his design students not to focus too narrowly on a particular form of design expression—"if I had to do the same thing every day I wouldn't be utilizing my creative abilities. Being challenged keeps creativity alive." (See the Color Inserts for more work by Michael Vanderbyl.) ■

would be impacted somewhat; but in general, it was a handoff, more like a relay race. With the process now digital, the boundaries between different parts of production are blurred. For example, before the advent of computers, a photographer would take a photograph and hand the transparency to the client (advertising agency, design firm or newspaper) and then be out of the loop. A designer would do the same—produce a good mechanical and hand it off to be shot for film prior to plates. The process of image conversion was done by production, not the

DIGITAL WORKFLOW MEETS THE CONTENT CREATOR

David Zwang

David Zwang.

David Zwang is the principal consultant of Zwang & Co, a global firm specializing in strategic development and process analysis in the fields of electronic publishing, design, prepress, and printing. He sits on many international standards bodies, has developed many industry training courses, and has written countless articles for trade publications.

The need for digital content—and its increased repurposing—has caused many content creators to shift from an analog-to-digital workflow to an all-digital one. This affects art creation, image capture, and text generation, as well as the management of all these digital assets. The software that supports this is even being introduced into the core operating systems of computers such as Mac OS X and Windows XP. This body of digital content will undoubtedly find its way into your production process at some point, if it hasn't already. Printers' and customers' processes are increasingly intertwined—what one does affects the other.

Creating and Recognizing Content

CCs and their printers need to be able to identify all of this content so that it can be easily found and used with more automated processes. Many data- and content-management systems offer ways to identify the metadata as well as attach them to the content. Users can search either manually or through automated systems by any of the attributes

CC. Today the CC can make numerous decisions that will affect the content before sending it on to the next step. This can be good or bad depending on the knowledge and skill level of the CC and can enhance and aid the overall workflow or impede it and slow the process down. Digital technology has allowed many actions to be impacted much further upstream and has forced CCs to understand more about the actual production associated with the final output of their work. In turn, production needs to be more preemptive in how they deal with CCs

assigned to the content assets. In most cases, the applications can directly communicate with these content-management systems.

While tagging content with the appropriate metadata after the fact is possible, it makes more sense to do some of this at the time of creation. Most applications provide support for adding metadata to the content. This capability is included in most digital cameras, the Adobe Creative Suite, applications from Macromedia, and even Microsoft Office.

Layout Tools

Once content is created, it must be put into a layout or form. Vendors of image- and text-layout software have enhanced many of the tools to handle multiple output needs. Layout tools from Quark and Adobe all support XML metadata, which enables them to handle cross-media projects as well as some level of automation. Many other applications are available for large-scale publishing needs. Those working with standards like XML also have the option of building their own data-driven publishing system.

Process Support

Any production process requires various levels of support to pull individual software tools and file formats together. At the core is a data-management solution, which more recently has evolved into a content-management system, for text and images. Increasingly, developers have added other process-management tools into these systems to address some of the problems that arise when operating in an all-digital workflow. Many of the systems facilitate image conversion to ensure that the image meets the requirements appropriate for its final destination. These requirements fall into a number of categories, primarily dealing with color and content structure. The conversions can affect resolution, color space, and even layer choices, if available, within the content.

Collabration

Creating and assembling content is becoming a collaborative process among printers and clients. In a collaborative workflow, each task must be checked to ensure its compliance with the process as a whole. This preflight process can be the same as the manual one you would perform in your own production process, automated, or even built into the workflow itself.

Other requirements for process collaboration include project tracking, scheduling, inter-partner communication, and proofing. These and other process-support options will become increasingly available and necessary as part of the creative and production process. ■

and must assist in content being produced properly so problems are not created within their workflow.

Workflow also refers to a plan of action for getting something accomplished. This makes it not only a technical concern but also a focus of management. Knowing ahead of time the logical priority of tasks and the most efficient way to accomplish them allows work to be profitable. The old adage is that the fastest way to give yourself a raise is do a given amount of work in half the time it normally takes. So, the challenge then is to understand the technology involved in

PEOPLE MAGAZINE

Michael Brandson

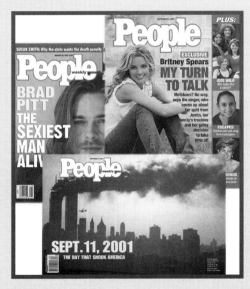

People magazine.

Michael Brandson knows about managing files. As Electronic Operations Manager for Photo at *People* magazine, he is awash in 60,000 images a week (at times as many as 117,000 images!). Not only does his department handle images for the United States edition of *People* magazine, but also for *Who Weekly* (an Australian edition), *People en Espanol, Teen People,* and a myriad of special editions that are published throughout the year. "My job is to manage the transmission of incoming images into the various systems we have and disseminate the images where they need to go," states Brandson. "From those 50,000 to 60,000 images that come in weekly, perhaps 1000 are selected. From that selection we edit it down to approximately 300 different images for publication." Keeping all that data organized is quite a challenge. Digital images come in via FTP sites, WAM!NET, e-mail, discs, and Web browsers; from large agencies such as Corbis or Getty; from small agencies, independent paparazzi, wire services,

and stock agencies; non-professional, everyday people submitting their personal pictures. Ideally, metadata, which indicates fields such as byline, caption, creation datetime, category, and object name, has already been applied to the images. The metadata specification commonly in use in newspaper and magazine publishing is International Press Telecommunications Council (IPTC). It is supported by numerous applications, including Photoshop. (See Chapter 4 for more on IPTC.) Photographers are encouraged to learn how to properly apply the metadata, but not all contributors use metadata yet. Those contributors are instructed

the creation and production of a given piece *and* the most logical and efficient way for it to happen within the context of the particular business model.

WHERE'S MY STUFF? DIGITAL ASSET MANAGEMENT

Content is king and therefore needs to be treated with the utmost respect. Content is your product and it needs to be easily accessed and able to be repurposed when required. Repurposing is

to title the images based on job numbers. The database system at *People* then matches the images internally with the correct story to automate basic metadata entry. An individual then inputs specific caption info. The DAM software that *People* relies on is MediaServer from Software Construction Company (SCC). This system, which includes the proprietary clients MediaGrid and MediaFactory, allows client-servers access to graphics, text, image objects, and PDFs. It can also integrate with standard Web browsers and Microsoft Word. Managing all these images would not be possible without a sophisticated enterprise-level database management system. More than four million images are currently on file and up to one terabyte of data can flow in per month through WAM!NET, a digital content management and distribution service. DVD jukeboxes and immense RAID (Redundant Array of Inexpensive Disks) hard drives store the images for use as needed.

Brandson has been with *People* magazine for more than ten years and has seen the change from analog to digital firsthand. No longer are several people needed to return original images to photographers and agencies. Now those same people are helping manage the

Michael Brandson, Electronic Operations Manager for Photo.

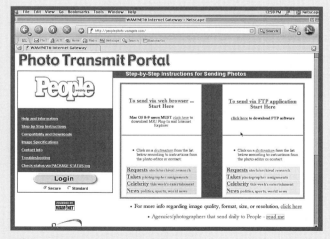

People magazine Photo Transmit Portal.

burgeoning archives. Brandson and his staff have truly become digital asset managers! ■

made easy when information is digital; data can be reformatted to suit different output outcomes. But because it is digital, it has to be managed and organized or it can easily be lost. If you can't get your hands on your data, it's gone. And if you can't get your hands on it in a timely fashion, it's unprofitable. How many times have you had to look for a file—and the latest and correct version of that file and found yourself lost within your hard drive or frantically searching through stacks of removable media? Digital Asset Management (DAM) has to do with managing your true asset, digital data, in such a way that it is organized, logically structured, expandable, and efficient.

DAM, sometimes referred to as Digital Media Asset Management (DMAM), has several levels of application. We are going to look at DAM from the standpoint of an individual designer or work team. But it should be noted that the challenge of managing digital assets is faced by many businesses, including the largest corporations in America. Coca Cola, according to CIO Magazine, has more than a million items in its archives beginning with the first newspaper ad that ran in 1886. They are not only concerned with the asset management issue, but also with the massive task of digitizing decades of analog material. Companies that produce a tremendous amount of collateral both in-house and with outside agencies have to find a way to catalog and access digital media to prevent costly duplication of effort and missed deadlines.

Managing Your Assets

A digital asset is anything in digital form that has value and needs to be tracked, managed, and utilized: photographs, text, illustrations, music, video, animation. It is also referred to as rich media, as differentiated from document management. But how do you handle cataloging, in an intelligent way, all your digital assets?

You can't just create endless folders in your hard drive and hope to have an effective workflow. In addition, DAM is not just about naming and storing your data, but also about tagging your

Issues to Consider When Managing Your Digital Assets

- Naming Convention: Will a master format be set up for naming content or will the DAM software assign a numerical designation?
- Acquisition of Content: Will content be placed manually into the DAM software or automated? (i.e. a watched folder that will "ingest" the content at specified intervals?)
- Formatting: Will all content remain RGB or will print content be converted to CMYK before cataloging? In what format will video be—raw? QuickTime?
- Tracking Usage and Versioning: How will you track usage, movement, and any changes made to content once it is entered into the catalog (e.g., a designer modifying a particular file)?
- Security: Will images in the catalog be watermarked or coded in some way to allow for review, but not for use unless authorized? Will access to the catalog itself be restricted? Who will be allowed to add and delete images?

content with additional information that may be needed. This information can range from technical data, like resolution, color space, and file format, to variables such as location for digital photography, copyright, use restrictions, history of use, and versioning.

To properly apply this kind of information to an asset, metadata is used. Metadata is basically data about data. It refers to a structured set of elements that describe an information resource (your data) in a way that is easily accessible. It defines your data. We will explore metadata further in Chapter 4.

So, you have thousands of images, illustrations, video clips, and sound files. How will you not only organize them, but be able to search intelligently to find your assets swiftly? The good news is that you do not have to build your own system from the ground up. Several companies have developed products that can help the individual user or design team catalog and retrieve their digital content easily. Extensis, Cumulus, and Filemaker Pro are representative of intelligent DAM systems for the smaller enterprise. To further understand how these systems work, we will look a little more closely at Portfolio by Extensis. The goal of this software is to manage and catalog for easy retrieval your digital assets on either platform—Mac or PC. Portfolio's features, listed here, address many of the issues handled by single user or work group DAM solutions:

- Find digital photos and other files anywhere on your system by typing only a word or phrase.
- Copy and rename images taken with your digital camera.
- Preview an entire CD of stock photography without inserting the CD.
- Create a slideshow of your favorite images.
- Quickly and easily build a Web site containing a collection of images.
- Print contact sheets of images.
- Collect a set of files and burn them directly to a CD or DVD.
- Burn discs that contain screen-size preview images.
- Access your files with a simple double-click without burrowing through multiple folders to find them.
- Extract and embed important EXIF, XMP, and TIFF metadata.
- Automate cataloging images with saved cataloging options and FolderSync.

A DAM solution should handle image conversion such as JPEG to TIFF, be able to handle metadata, and provide its own workflow automation. This automation might be in the form of a watched folder that automatically performs specific functions on an image file placed within it, including cataloging it within your DAM software. Many DAM products offer direct-to-Web publishing. What they really all do is save time (which is money!) by simplifying and automating a process that would be time intensive if done manually.

figure |1-3|

Extensis Portfolio 7 browser window.

Organizing Your Stuff

What is at the core of these systems? A database. A database is an organized and computerized collection of information. It allows data to be searched and organized, and without them DAM would not be possible. All DAM solutions are built on databases, some more robust than others.

These databases allow you to catalog your content. It is up to you to decide what keywords to attach to the content for easy access. Deciding keywords and the metadata to be attached to the files is very important. If you have thousands of stored files identified solely by a number (e.g., 101.jpg, 102.tif), it would be hard to do a selective search. Keywords help you sort, arrange, and categorize your content efficiently.

What Is a Database?

It is essentially a collection of related facts that allow for comparison and access. At its most basic, it is a compilation of data that remain independent of each other, is tabular in format, and creates a table consisting of rows and columns. It is comprised of fields that indicate the kind of data contained within it (i.e., numerical, textual, date, or currency format). A relational database is one in which groupings of data are related to each other in such a way that a change made in one field is linked to and affects the outcome of another field. Retrieving information from a database is referred to as a query. The query sets the parameters for your search. The more refined your query is, the more precise the returned results. A database is at the heart of any DAM software or system.

Remember, if you can't find your content when you need it—consider it lost. Programs such as Portfolio by Extensis allow easy cataloging and searching. (See Chapter 4.) They also facilitate distribution options, including sending content over the Internet or burning a CD.

Most DAM solutions allow for the creation of Web pages directly from the cataloged pages. This is useful for showing your work to prospective clients and for collaborative efforts where members of the team need an easy way to view and use assets.

THE NUTS AND BOLTS

We are bombarded by ads for new technology. In truth, many people don't utilize the full capability of their digital equipment and prefer to operate in auto mode. However, CCs today must have a working knowledge of their equipment's capabilities. A CC who doesn't work with computers today is most likely unemployed. We will now explore the most important concepts that need to be understood to have an effective workflow.

figure |1-4|

Keywords are very "key" to finding assets!

The Speed of Your Computer

No matter what platform you choose, the basics of computing remain the same. A computer is an electronic device that processes data and is controlled by programmed instructions. What has been changing most rapidly is the speed at which the data can be processed.

The processor of a computer is what carries out the software instructions, both at the operating system level and the application level. The speed of the processor determines the speed of execution of the in-

figure |1-5|

Database programs typically allow CD burning with preview choices.

structions. The operating speed of a computer is connected to the speed of its system clock, which is driven by a quartz crystal. The speed of vibration possible within this crystal (created by electrical stimulation) determines the megahertz (MHz), or millions of cycles per second, of the computer. A 700 MHz computer crystal can vibrate 700 million times per second. In 1981, the IBM-PC was introduced with a 4.77 MHz Intel processor. Three years later, speed had only increased to 6 MHz. At the time of this writing, computer processors can be faster than 2 GHz, or the equivalent of 2,000 million vibrations a second. This is great news for graphics, as

figure |1-6|

Extensis Portfolio has numerous Web templates for publishing.

figure |1-7|

Silicon wafers used in chip production.

much of what is done is incredibly processor intense and much more demanding than basic document management. An efficient workflow needs fast computers.

The Memory in Your Computer

Though your processor determines the speed at which instructions can be processed, the amount of data that can be processed has more to do with the memory residing in your computer. When you launch an application, the Random Access Memory (RAM) of your computer holds the program and data while they are being used. The more RAM you have installed, the more programs that can be accessed at one time and the faster overall your computer can operate. In graphics, if the choice is between a slight increase in MHz or a large increase in RAM, choose RAM.

RAM Slots

A common error when buying a computer is to choose the amount of RAM without researching the memory slots available on your computer. For example, a computer might only have two slots for RAM installation. If you wanted 500 MB of memory, you could choose your memory in a two DIMM (Dual Inline Memory Modules) configuration or as one DIMM and leave a slot for later expansion. If you fill both slots and want more RAM in the future, you will need to discard one DIMM.

Storing Your Stuff

There was a time in the 1980s when an external 20 MB hard drive was as large as a lunchbox and considerably more expensive. Now, storage options range from a USB plug-in to a small, portable Firewire drive capable of 300 GB of storage. What is critical to an efficient and smart workflow is to plan for storage that can be easily expanded and for some form of portable storage that is compatible with clients and trade alike. Issues such as what media to use for file transport or whether to use a network solution are decided by what is most prevalent and supported. The nightmare of the early prepress work was the proliferation of different cartridges, disks, and drives, which created connectivity confusion. One issue of job deliverability will be looked at more closely in Chapter Two.

Storage

Storage is either magnetic or optical. Magnetic storage involves affecting the magnetic properties, or polarity, of the surface of the media. When the polarity is set, it is considered a write operation. When the polarity is detected, it is considered a read operation. Polarity can be changed again and again, making this type of media rewritable.

Optical storage involves a low-powered laser to create a pattern of microscopic indents called pits. The remaining flat areas are called lands. These pits reflect the laser light, and the pattern of pits creates changes in the intensity of reflectance. These changes are interpreted as ones and zeroes, which is what it all boils down to. Rewritable optical media (CD-RW or DVD-RW) have a different surface for the laser to write on than regular CDs (CD-R or DVD-R) and is referred to as Phase Change Recording.

Platforms

Though a small player in the overall PC market, Apple computer has true dominance in the graphics industry as a client machine. With the development of PostScript by Adobe in the mid-1980s and the Graphical User Interface (GUI), Apple's preeminence was assured. Approximately two years ago Apple computer took a big leap forward with a new Operating System based on a Unix kernel that has proved extremely reliable and stable. The OS X GUI is elegant and, well, cool. Microsoft has converged its original Windows 98 and NT lines to create Windows XP. Though Apple computer has developed a strong server technology with its new operating system, Microsoft has come to dominate the server side in the graphics industry. It has many advanced network services and strong administrative support.

In our new cross-media world, the lines between the PC and the Mac have become less distinct. Even though Apple still dominates when it comes to design, a good designer will need some familiarity on both platforms. In particular, when designing for the Internet, both systems are needed for testing.

Servers and Networks

Servers and networks are critical components of today's infrastructure in a cross-media environment. The speed at which files can travel between processes within a given facility, between geographical locations, and between client and CC directly affects the speed of a given workflow and the profitability of an endeavor. Servers are repositories for common files that absorb some of the processing and storage requirements of a workstation in a preprint environment, and manage your Web presence in the most advantageous way. In its simplest sense, a server is a dedicated workstation that connects other computers over a network. The software and operating system determines what type of server it will be. There are four basic types of servers to be concerned with in the graphics industry: file servers, print servers, workflow servers, and Web servers.

- File Servers: This type of server is concerned primarily with file storage concentrated in a central location. CCs do not have to store all graphical images on their computer, but can download them as needed. It allows for concurrent work on a job by more than one person, with care taken to properly check in and check out files to prevent redundancy or overwrites. One of the primary considerations of a file server is making a fast machine with a fast network, connecting it to all clients.

- Print Server: The job of a print server is to relieve workstations from having to print directly to output devices. This greatly enhances the efficiency of any workflow. By collecting jobs in the server, it can then handle the processing and raster image processing (RIPing) while the workstation is free to do other work. This is especially critical in a workgroup environment. What makes a print server so useful is its ability to set up print queues. Jobs can be re-ordered based on priority, and different queues can be customized for different output devices. Customizing a queue can involve selecting color profiles, resolution, and unique screen values. The print server is typically a PC with a large storage drive that runs no other software.

- Workflow Server: This type of server is important in a commercial printing environment. At its most robust, it can handle trapping, RIPing, and color management, and can automate many repetitive functions. It is usually a very powerful machine in everything from fast processing speed to large amounts of RAM. For a smaller design environment, a workflow server would be utilized to house job management and job tracking software. It is often referred to

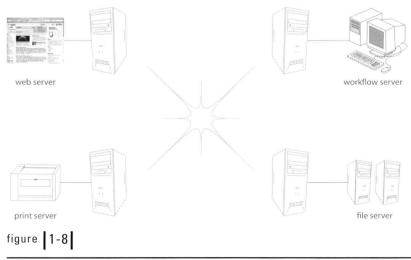

web server

workflow server

print server

file server

figure |1-8|

Different types of servers.

Metcalfe's Original Ethernet Diagram

Ethernet was originally conceived by Bob Metcalfe at Xerox PARC in Palo Alto in the mid-1970s. He saw the need for an inexpensive way to network computers, printers, and shared disks. With his colleague David Boggs, he set about to develop a protocol that would allow information to be networked efficiently. It originally was capable of running at speeds of 2.94 megabits per second (Mbps) and now can be utilized as Gigabit Ethernet, which allows for a raw data rate of 1,000 Mbps. Bob Metcalfe is the founder of 3Com, a very successful company that develops commercial networking technology.

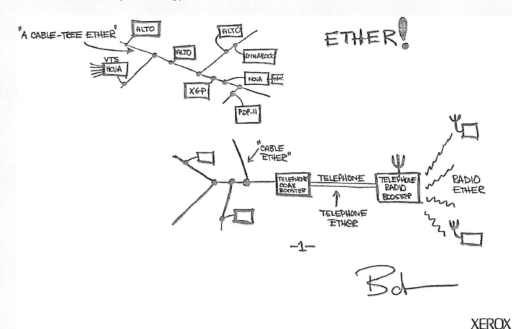

The word *ether* originally referred to a heavenly substance said to have been the origin of both energy and matter on the plane of the physical, a mystical element tapped by sorcerers and wizards. It was all-encompassing and invisible. The original diagram drawn by Metcalfe moved the word into our modern technological lexicon.

as a data server when it is used more for administrative functions than for production workflows.

- Web Server: This server is designed to house numerous Web sites and provide a variety of support applications, including cgi/asp scripting, tracking services, commerce capabilities, and e-mail. For large companies, several servers might handle the different support functions. It's important to know that the hosting company is accessible; provides 24/7 support and redundancy (power back-up) and has the ability to smoothly handle large data exchanges for multimedia downloads, streaming video, and so forth.

Networks can make or break your workflow approach. If a network is so slow that work is halted while waiting for transfers, downloads, and uploads, you have lost time and money. The network is what connects your workstations and your servers.

Networking Standards, Topology, and Bandwidth

The most prevalent networking standard in the graphic arts industry is Ethernet. It was developed in the mid-1970s and has maintained its dominance in Local Area Networks (LANs) to this day.

It is the most common method of transmitting data from your computer to the next computer, to the server, and to the printer. Apple computers come Ethernet ready, and a network card can be installed on a PC. Ethernet usually is transmitted over unshielded twisted pair (UTP) media, or it can be broadcast from a wireless hub.

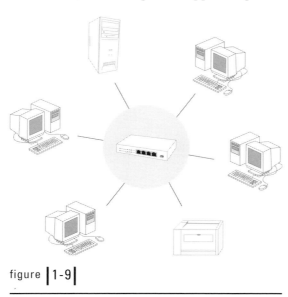

Networks are described by their topology; and the one used most often in the graphics industry (and for Ethernet networks) is the star topology. A topology refers to the physical layout of the network and how it all connects. The star topology has a hub, which is a hardware device that connects all the computers on a network with the server, at its center. Like spokes on a wheel, it radiates connections out to various devices. You can lose a node (a device on the network) without bringing the network down, but you can't lose the hub.

figure |1-9|

Star topology.

Carrier Technology	Rate	Description
OC-1	51.8 Mbps	Optical Fiber carrier
T-3	44.7 Mbps	Twisted pair copper wire- Typically used to connect an ISP or large companies to the Internet
CABLE	512 Kbps to 52 Mbps	Coaxial Cable for downstream transfers with phone lines for upstream data transfers
T-1	1.54 Mbps	Twisted pair copper wire- Typically used to connect an ISP or large companies to the Internet backbone.
DSL	512 Kbps to 8 Mbps	Digital Subscriber Line (digital twisted pair)
SATELLITE	400 Kbps	Radio frequency in space (wireless)
ISDN	64 Kbps to 128 Kbps	BRI (twisted pair for home and small business use) PRI (T-1 line for medium to large companies)

figure |1-10|

Digital bandwidth comparison.

Bandwidth refers to the capacity of the media carrying your data. Think of it in terms of pipe width; the difference between a dial-up modem today at 56 Kbps and a broadband connection of more than 1.5 Mbps would be the equivalent of a straw compared to a drainage pipe. A 10 Mb transfer might take up to 28 minutes via an analog dial-up modem, but only 1 minute via a cable connection. It's best to get the fastest bandwidth you can afford. CCs can create extremely large files due to the color and resolution levels required. In addition, digital video can be a true bandwidth "hog."

SUMMARY

As is obvious from this chapter, content creation today in the graphics industry has to do with digital data: how you manage and organize it, where you put it, how you connect to it, and how you transmit it. This data is your original, and it can be repurposed into parts and pieces of other newly created "originals." Be aware when creating content for a client what rights are being sold, such as usage and transferability.

Digital Rights Management (DRM) and copyright issues, though beyond the scope of this book, are critical and should be examined by today's CC. Your intellectual property is no longer on canvas, sketch pads, or film, and there is no longer any generational loss between the original and a copy. Learn how to properly create, manage, and protect your content!

in review

1. Explain the connection between content and digital data.

2. What is the basic material of digital data?

3. Discuss what the meaning of workflow refers to in a graphical context.

4. What is DAM and why is it so important?

5. Name at least four different features that a DAM solution should have.

6. What is metadata?

7. What is a database?

8. How is the speed of your computer determined?

9. Why is being cross-platform important?

10. What are the four basic types of servers in the graphics industry?

11. What is the most popular networking standard and the most prevalent network topology?

notes

CHAPTER

II

Chapter Objectives

- Understand the differences between DDPI, PPI, and LPI
- Understand PostScript and its relationship to printing
- Understand the importance of color management and profiles
- Appreciate the complexities of getting information out of your computer correctly
- Review standards and guidelines
- Understand the importance of preflight and file submission
- Explore code, HTML editors, and packaging for the Web
- Explore strategies for document management
- Understand ways to control versioning

Introduction

The importance of how you build your file cannot be overstated. Great design work that cannot be printed or published to the Web is of no use. No matter how talented you are, if the job won't print, the images won't load, or the animation won't play, you will not be a successful CC. We will review some print and Web basics along with document management with the goal of getting your content out of the computer and on to its final output!

THE VOCABULARY OF PRINT

Many CCs encounter difficulties getting their work to display properly by not knowing the parameters of its final destination. Creating content for print involves knowing the terminology, or vocabulary, of print. Often content is created for brochures, posters, newsletters, etc., and unwanted font substitution occurs. Text then flows incorrectly, image resolution is wrong, and colors are way off their mark. Understanding what happens to your file in the print process is key to having it come out correctly.

Samples, Dots, Spots, Pixels, and Lines

There are three basic stages your work goes through—input, assembly, and output. In each stage, your digital data is referred to in different ways. When analog work is scanned or a photo is taken with a digital camera, you are dealing with samples per inch (SPI). When working on your display, you are in pixels per inch (PPI). When outputting to print, you enter the realm of lines per inch (LPI) and dots per inch (DPI). It is necessary to understand the relationship among these three stages to create work that will print properly. In this section, we will look at issues relating to raster graphics.

SPI

When you scan an image or shoot an image, you make a decision regarding how large your scan or capture will be. The correct term for this is samples per inch (SPI). SPI refers to the amount of information a scanner or camera can read. The more SPI, the more information per inch, the higher the image resolution, and the closer to the original image it will be. But be aware that scanner manufacturers more often than not refer to dots per inch (DPI) when referring to a scanner's capability. DPI is also commonly used by designers and printers when speaking of scanning. DPI is actually the amount of dots of colorant, or laser spots, that can be produced by a given output device. Due to the commonplace usage, we will also refer to SPI as DPI from this point on—but be sure you understand what is really being referred to. In addition, you

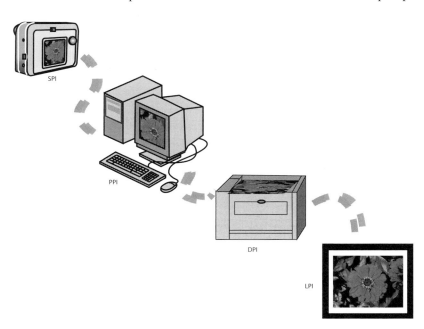

figure |2-1|

Output from SPI to LPI.

will see two numbers on a scanner that refer to possible DPI (think SPI!) settings. It is important to be aware that only one number is the actual indicator of the sampling ability of the scanner. A scanner may purport to scan at 600 × 1200 DPI, but only the first number actually represents the optical scanning ability of the device. The 600 means that it takes samples that are spaced 1/600 inch apart horizontally, so it offers 600 DPI optical resolution. The second number is a software interpolated number. Interpolate means to calculate or estimate intermediate values occurring between two known values. This number is reached through software, not by hardware. Always pay attention to the first number in determining the quality of your scanner.

In many ways, a digital camera is a vertical scanner. It, too, samples information via either its Charged Coupled Device (CCD) or Complimentary Metal Oxide Semiconductor (CMOS) chip. A CCD is a silicon chip that is covered with small electrodes called photosites. Each photosite represents one pixel, and the number of photosites (or pixels) is what determines the resolution of the CCD along with other factors. (See Sidebar.) Light striking the photosites causes electrons to cluster—the more light, the more electrons. The voltage is then measured at the site and converted into a number via an analog-to-digital converter. A CMOS works in a similar fashion, differing at the point where the analog (light) charge is converted to a digital value.

PPI

Once you have brought your work into the computer, you are in the realm of pixels per inch (PPI). This is due to the fact that your monitor, or display, uses a fixed grid of pixels to display information. These pixels have to

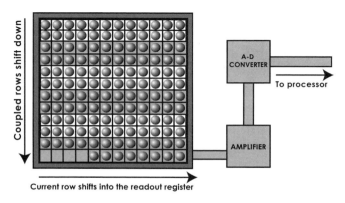

figure |2-2|

How a CCD chip works.

Not All CCDs Are Created Equal

You are probably wondering why a $500 digital camera and a $3,000 digital camera can both claim to have 4 or 6 megapixels and yet capture different size files and have such a discrepancy in price. The main difference is the physical size of the CCD. If both CCDs have the same amount of photosites, but the actual CCD chip on the more expensive camera is twice the physical size of the less expensive camera chip, obviously the photosites on the larger CCD are themselves larger and can collect more light (more data). The other challenge presented by a smaller CCD squeezing in as many photosites as it can is an occurrence called blooming. This is when light actually spills over from one photosite to another when too much light hits it. This can create smeared colors or flared highlights.

Courtesy of Kodak

Chips come in different sizes.

| FAST FACT |

The word pixel is a new word (or neologism) made up from the combination of picture and element. It is the term used to describe the most basic unit of composition of an image on a TV or computer display.

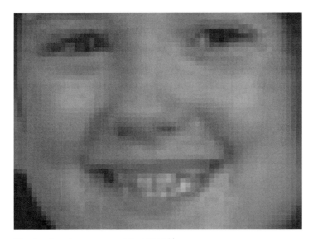

Pixels of an image magnified 1600%.

do with the actual electron guns within your CRT screen that stimulate the phosphors to display a specific color. A liquid crystal display (LCD) turns its pixels on and off through an electrical charge sent to tiny switching transistors and capacitors. Either way, pixels make up what you see on the display. A display is usually 72 PPI, and therefore the reason why Web content is designed with that resolution.

DPI/LPI

Now we come to the acronym that relates directly to output devices—dots per inch (DPI). This refers to the ability of the output device to create a specific amount of reproducible dots in an inch.

This device could be an imagesetter, platesetter, laser printer, or digital press. The capability of the imaging head could be as coarse as 300 DPI or as fine as 2400 DPI with dots measured in microns.

A little printing theory is in order. A printing press cannot produce a continuous tone image. It can only lay down one color at a time, so an optical illusion is needed to create the appearance of continuous tone. It is called a halftone. When you send a file to be printed, it is broken down into its separate color components, or process separations. Each color is represented by its own halftone. The colors in the print world are cyan, magenta, yellow, and black (CMYK). The CMY part has to do with subtractive colors, and the K (black) is added to create richer shadow depth. And, of course, there are printing presses with more than ten printing units so many more colors could be laid down on a single job.

figure |2-3|

The Heidelberg Speed Master 74 can have up to 10 printing units.

Each halftone, also referred to as a halftone screen, is responsible for the reproduction of one color. A halftone is made up of a grid of cells; in traditional screening the dot sizes vary within the cells, but the center of the dots are always equidistant. This is referred to as amplitude modulated (AM) screening. There is always one dot per cell. In frequency modulated (FM) screening, the dot size does not change, but the frequency does. This type of screening was made possible with the advent of computers and is often used in high-quality printing.

So, dots per inch has to do with the ability of the output device to create a specific number of dots on a substrate (film, plate, paper). But a term uniquely related to printing has remained with us from the early days of printing— the concept of a line screen. In fact, the grid of halftone cells now

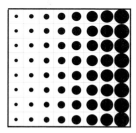

In traditional halftone screening dots are of variable size with fixed spacing

figure |2-4|

AM and FM screening.

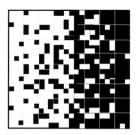

Stochastic screening varies the frequency spacing of the dot while keeping the size of the dots constant

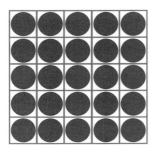

LPI of 133

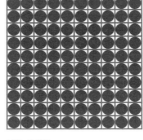

LPI of 300

figure |2-5|

If you were to take a section out of two different printed pieces, a piece printed at an LPI of 133 would have less densely packed dots than one printed at 300 LPI.

produced digitally is still referred to as a line screen, and printing resolution is referred to as lines per inch (LPI). This is actually a linear measurement and indicates how many cells can be placed side by side in one inch. A printed piece with an LPI of 133 would have fewer cells placed side by side in the space of one inch than would a piece with an LPI of 300. As a lower line screen has larger cells (and fewer cells) in one linear inch, we would say that 133 LPI is coarser screening than 300 LPI.

So, Why Does This Matter?

When you are designing for a printed piece, you have to be aware of the correlation between the resolution of your graphics and the line screen that will be used for printing. For example, let's say you had raster graphics that were scanned in at 600 DPI (remember SPI!) and saved at 600 PPI. But if your final piece was going to be output at only 100 LPI, you have worked at high resolution for no reason and the extra digital data can't be used. Conversely, and more importantly, if you work with raster graphics that have a very low resolution, say 72 DPI, and your final printed piece will be at a frequency of 300 LPI, your graphics will look quite poor. You will not have enough digital cells per inch to create the illusion of a correctly printed graphic. This is in fact a very common file error and can cause preflight headaches. (See preflighting in this chapter.)

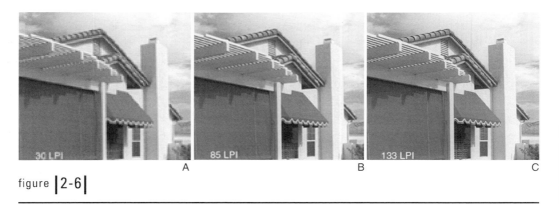

A B C

figure |2-6|

These three pictures show the effect of different screening on an image. A. 30 LPI, B. 85 LPI, C. 133 LPI.

So, to prevent incorrect outcomes when printing, always ask what line screen will be used and at what resolution the printer requires raster graphics to be submitted. A rule of thumb is that the image resolution should be at least one and a half to two times as much as the LPI. In other words—if your final output will be at 133 LPI, your image resolution should be at around 300 PPI.

PostScript

In 1985, a momentous event occurred for the printing industry. Adobe Corporation, founded by John Warnock and Charles Geschke, introduced PostScript, an interpreter-based programming language whose purpose was to describe the correct appearance of a page and send it to an output system.

PostScript, and the advent of the Apple Computer graphical user interface (GUI), made the publishing revolution of the late 1980s and early 1990s possible. Because it is designed to accurately convey a faithful rendition of any printed page, it is the foundation for producing any printed piece today.

PostScript is composed of a large selection of graphic operators that allow the correct reproduction of a printed piece. Fortunately, there is no need to master writing PostScript as it is generated by the computer.

For PostScript to function properly, two things are needed: a PostScript driver and a raster image processor (RIP). The page layout programs used for print documents today send the documents to specific output devices by utilizing drivers, which are installed at the system level of your computer. The PostScript driver's function is to convert the document information that is received into PostScript code and then download it and send it through the network to a specific output device. Drivers are specific to the device being used and are provided by the output device manufacturer.

The destination device will determine the type of RIP your document will encounter. The RIP is generally a software application running on a print server. It takes the arriving code and converts it to raster data that the device can output.

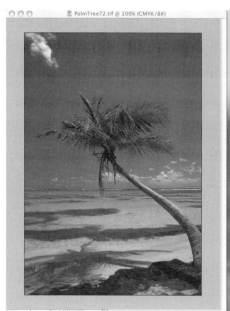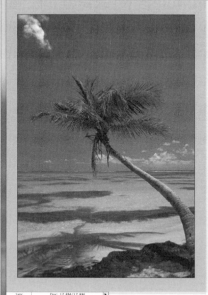

Courtesy of Apple Computer

figure | 2-7 |

As you can see, the Palm tree on the left is 72 DPI and is at 100%. The palm tree on the right appears the same size on the display (72 PPI), but is at 300 DPI being viewed at 24%. Obviously, these would print quite differently.

| FAST FACT |

Warnock and Geschke both worked at Xerox Parc in Palo Alto, California, prior to founding Adobe. There they developed the forerunner of PostScript, a language called Interpress. But Xerox didn't think it had much of a future and was not enthusiastic about promoting it outside of Xerox. Had Warnock and Geschke not broken away to form their own company to promote PostScript, the publishing industry might have a very different look today.

What follows is the code to say - Hello, world!

```
%!
% Sample of printing text

/Times-Roman findfont   % Get the basic font
20 scalefont            % Scale the font to 20 points
setfont                 % Make it the current font

newpath                 % Start a new path
72 72 moveto            % Lower left corner of text at (72, 72)
(Hello, world!) show    % Typeset "Hello, world!"

showpage
```

figure |2-8|

Sample PostScript code.

Remember that all a printing device can do is either create a spot of colorant or not; a laser-driven output device can either burn a spot or not. Therefore, the RIP translates the PostScript code into a series of on/off commands that allow the device's marking engine to print the file. In essence, the RIP 1) interprets the PostScript code, 2) rasterizes it for output, and 3) applies the proper screen (takes the pixel data and conforms it to the output device's marking engine capabilities).

In addition to a driver and a RIP, to properly print your job, PostScript fonts are needed. A font is the term used once computers arrived for what was previously called typeset text and is the sum of all characters and symbols represented by a specific typeface. For example, all the upper- and lowercase letters of the alphabet, numbers, punctuation, and special marks of the Adobe Garamond typeface would be referred to as the Adobe Garamond Font.

| FAST FACT |

For a device to properly output PostScript, it must be PostScript compatible. Although all professional level devices are PostScript compatible, be aware that not all consumer level printers are, as there are licensing fees associated with its use. If you are serious about design, you will need a printer that recognizes PostScript.

A PostScript font consists of two parts—the display font and the printer font. These files reside in the computer's system. On the Mac in OS X, 10.3 a new feature called Font Book handles font management. Previously, active management of fonts was the purview of third party applications, but as commonly happens, good ideas often get incorporated into operating systems. This system utility allows you to install, preview, search, activate, and deactivate fonts from one window.

The display font is actually a vector-described outline of the font and is used solely for display purposes. Technically speaking, it is a contour graphic, which is a modified form of a vector graphic that allows for both curved and straight lines. The display font is scalable and looks crisp and clean on the display. On the other hand, the printer font is not scalable as it is a bitmap, or raster, file. Its function is to specifically

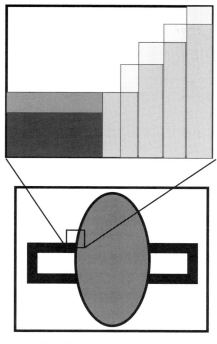

figure |2-9|

A RIP converts graphic information to bitmaps that an output device can understand.

figure |2-10|

Fonts can easily, and legally, be bought online.

Fonts Are Not Free!!!

Contrary to what some may think, PostScript fonts are not free and do not come installed on your computer. The fonts in your current computer system are almost invariably TrueType fonts. This font format, developed by Microsoft, contains printer and display data in one file and does not take into account professional print output. It has been standard on Windows systems and is now in use on Apple OSX machines. But, as well as they might perform on your home inkjet or your office printer, they are not designed for high-end RIPs. PostScript fonts are designed for printing and are the only fonts that should be used for publication. Do not copy them from another system because they are subject to the licensing terms under which they are purchased. It is illegal to use fonts that you do not own the license for. A sample license option from Fonts.com reads as follows:

"A Standard User License is issued with individual font purchases. It licenses a font for use on up to 5 CPUs and one(1) printer within an organization. The Standard User License is best suited for individuals and small organizations or in instances when only a limited number of individuals will need access to a desired typeface."

The good news is that one does not need to start with a font library costing thousands of dollars. There are starter packs and ten-font packs that can cost less than $100 and can be downloaded from numerous Web sites or ordered on CD.

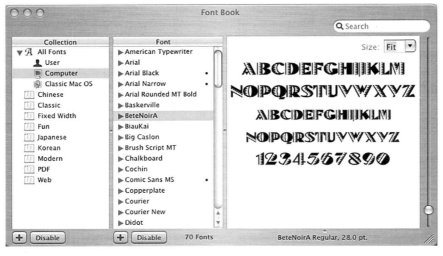

figure |2-11|

Font Book, a feature of OSX.

describe the character and is made of pixel data that is firmly defined. You cannot arbitrarily enlarge a font in your document and have it print properly unless you have the corresponding size printer font available.

So, Why Does This Matter?

One of the biggest problems in a print production workflow is corrupt or incorrect font usage. Not only does the designer need to use the correct PostScript font, but the printer also needs to be licensed for that same font in their in-house library. If the designer uses a TrueType font, or only has the display and not the printer part of a PostScript font, all sorts of problems can arise. The most likely error will be a font substitution, which is done by default in the page layout program being used for output. It is almost always a basic font such as Courier

Fonts in OS X—Where Are They?

In OS 9, fonts would typically reside in the system font folder or be managed by a third party application. Depending on compatibility between the Mac OS and the software, this could be a good thing or a bad thing. The new approach in OS X appears to provide more stability, but also many more possible locations than the earlier OS. Fonts can now reside in one of the following places:

1. Your User Fonts folder (available only to the logged in user)

2. The Local Fonts folder for the startup disk. The fonts are accessible to all users, but only the holder of the admin account can modify the contents of this folder.

3. Network fonts which are installed in the Fonts folder for the network. It is usually located on the networked file server rather than on an individual's computer and only a network admin can modify the folder.

4. System fonts folder containing the fonts that are installed by the Mac OS X installer. These are used by the system and should be left alone. Do not remove!

5. Classic fonts which are installed in the Mac OS 9.X folder, if Classic is installed on the computer. These are the only fonts OS 9 can access, but they can be accessed from within OS X.

This font becomes – This font

figure |2-12|

The dreaded font substitution.

or Helvetica. And, depending on the font size and attributes of the other text, very strange spacing and tracking can result. Often letters run together and become illegible. Text can reflow in undesirable ways and, in extreme situations, a corrupt font can prevent a document from being printed.

Color

Any workflow process that has numerous variables and an open loop production cycle, can be extremely difficult to manage.

One of the most challenging areas to get "right," is color. In the old analog days, designers did not have the ability to affect final color like they do today. Production decisions are moving upstream and designers now need to be aware of production issues that were not their concern in the past. Ultimately, it is not the graphic designer, or CC, who is responsible for final color. However, the more a file is slowed down due to incorrect color choices, the more difficult it is for your client, and it could even cost you as file prep time is charged.

As a CC, you are not expected to set up an entire color management system that will perfectly mesh with every press your work gets sent to. But the final color proofs submitted to your clients have to be attainable and reproducible within the particular workflow that will be used.

Let's look at two facets of color management a CC needs to be aware of. The first is color fidelity within your own workflow. In other words, what you see on your monitor should correlate to the output from your proofer that you will show to your client. The second consideration is creating a piece that is, in fact, reproducible by the print process that will be used. To understand both of these concerns, a basic grasp of color management is needed.

Each device in your workflow, from scanners and cameras to displays and printers, has a different color gamut. According to the GATF Encyclopedia of Graphic Communications, color gamut, as pertains to printing, is

| FAST FACT |

Never use the formatting commands found in your software to enlarge a font or to give it specific attributes such as bold, italic, or underline. Without the corresponding bitmap file matched in size and attribute, the RIP most likely will not reproduce the font properly in your document. And then you will have the dreaded font substitution occur, which is the bane of all prepress operators!

| FAST FACT |

When everything connected with the manufacturing of a product is controlled under one roof, it can be referred to as a closed loop workflow. For example, if a graphics company has in-house designers and its own prepress department, printing facilities, and binderies, it can be described as a closed system where controlling production variables is simplified. On the other hand, although consolidation is constantly occurring, most designers do not print their jobs for their clients, nor do most printers produce their own artwork and content, yet. Therefore, in an open-loop workflow, parts of the production process are done within different systems, and files that were created elsewhere are submitted to one facility.

defined as "the total range of colors that can be reproduced with a given set of inks (or other colorants), on a given color stock, and on a given printing press configuration." But the gamut or range of colors achievable by other devices varies.

The total gamut of your display is far greater than what can be printed, and this must be taken into account when developing your content. For example, if you are creating a brochure that will be output on a conventional four-color press, you need to design with colors that are reproducible on

figure |2-13|

Different devices can see/produce different gamuts.

that press. If not, what gets printed certainly will not match what you saw on your display, or your proofing device. And, do not forget that you will also be transitioning from an RGB color space to a CMYK space. This alone will cause a reduction in the range of tones that can be created and will cause certain colors to darken and flatten perceptibly. To create an effective color workflow, three steps need to be taken. The first is that you must *calibrate* your display. This means bringing it to the original manufacturer's settings, which provides a fixed and repeatable state for the device. The second step is to characterize the intended output device through what is called a color profile. The third step is what will be done via software when using the profile, which is to convert the color from one color space and its gamut to another color space. Let's first take a look at creating the correct profile for your proofing device, which is what will create the proofs that the client will sign off on.

Profiles

When creating a device profile, you are creating a file that characterizes a specific device's capability. It is device specific and takes into account a given operating condition. For example, the same output device might have several profiles if the paper, ink, or toner changes. Whether you have an inkjet proofer to produce proofs for your client or send your files to an advertising firm or design firm to create the final proofs, you need to know how the colors you create on your computer will look on that output device. Typically a print test target is used, such as an IT8.7-4 (Color Insert 4), which is a software file, usually a TIFF, consisting of known RGB/CMYK values that you print on your output device. The resulting output is then read

with a measuring instrument such as a densitometer or a spectrophotometer. The readings taken, which are specific to your output device in a given circumstance, are then used to create your device profile. The good news is that as a CC you don't have to rush out and invest in numerous measurement instruments. You can develop your own color profile in two ways: 1) off the shelf software, or 2) a profiling service.

Color profiling software typically will provide you with the ability to create ICC color profiles for all your devices (scanner/camera, display, printer) and will supply a test target to scan. For example, Monaco EZColor 2 provides a scanner target and a printer target along with its software. The stated goal of the software is to make the prints match what is seen on the display, as closely as possible; remember, we are dealing with two different gamuts! Different profiles would be made to correspond with different paper and ink sets.

Another approach would be to create a profile on your printer and send it to a company that will read your output and create an ICC profile for you. There are several companies doing this, but we will look at the process used by Chromix. The following is the overview of their procedure, which will help you understand how easy it can be to create a color profile:

- Download their profile kit from their Web site.

- Determine if your printer expects RGB or CMYK data (most home printers convert whatever you send to RGB data. Most RIPs in a printing system expect CMYK data). They provide a file that allows you to know which color space your printer actually works in.

- Open the correct profile target for your situation. In Photoshop, select "don't color manage" at the prompt.

- Print it using "Non Color-Managed Settings."

- Inspect to make sure that all patches have printed properly.

- Send target output into Chromix with completed Custom Profile Order Form.

- The target is measured, and the profile is built and sent back via Web site or by e-mail.

So, Why Does This Matter?

How often have you liked what you saw on your display and then was dismayed at what came out of your printer? A display is never WYSIWYG (what you see is what you get) unless it is properly calibrated and characterized. And if you are dismayed, imagine your client's reaction. If you present a proof along with your work that is a correct rendition of the color you expect,

| FAST FACT |

The International Color Consortium (ICC) was formed by a group of vendors to address the need for a system level approach to color management. The goal was to devise a way to achieve consistent color output, independent of the output device or application being used. The ICC color management solution involves three main components: profiles, a Color Management Module (CMM), and a Color Management System (CMS). The profile describes specific characteristics of a particular device. A CMM, which can be in an application, such as Photoshop, performs the conversion based on the profile. The CMS is the operating system level software that facilitates the whole color management process, such as Apple ColorSync. See http://www.color.org.

it makes for a much more harmonious relationship with whomever is going to be printing your final piece. It is also important to understand the color capability of your final destination press. Let's say that you have all your systems calibrated and characterized. It would also be helpful to have some understanding of the print process that will be used. A toner-based press will present your work differently than a four-color analog ink-based press or an eight-color press capable of far more than CMYK. You may not always have access to this information, but when you do it can help you design a piece that can take advantage of the printing process that will be used.

GETTING IT OUT OF THE COMPUTER

So, you've created this great document. Now you have to get it out of the computer. Not as easy as it sounds. Incorrectly made files are one of the biggest bottlenecks in the industry. Just because it outputs on your home or small office inkjet does not mean that it will print properly. This is the point where an efficient digital workflow can come to a grinding halt.

Preflight

The term *preflight* is meant to remind us of the importance of this task. You would not want to take off in an improperly preflighted plane. In turn, an improperly preflighted file can create monstrous headaches and problems for the prepress facility or printer who is getting your file ready for output. It can end up causing you to receive additional billing for handling your file or possibly miss a tight deadline. Preflight is the critical inspection that is required on every print job prior to running the press. It is the process of making sure all required components are with the job and that all parameters have been met properly.

In the analog days of prepress, the CC's task was mainly to design the piece and leave production issues to the prepress facility, or service bureaus as they were traditionally called. Now, in a fully digital workflow, where what you submit is what is intended for output, the impact a CC has on the production is far more significant.

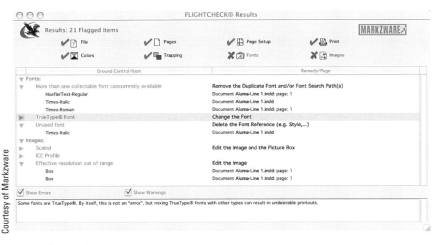

Courtesy of Markzware

figure |2-14|

FlightCheck by Markzware can catch numerous preflight errors before going to press.

What Preflight Prevents

It helps to understand some of the most common problems encountered in preflight. The more you understand about what causes the problems, the better equipped you are to prevent them in the future. It can also potentially save you from shouldering the costs of excessive alterations and adjustments to your files. Remember, prepress departments are not nonprofit! They will charge you or send your work back if there are too many problems with your files.

SWOP, GRACoL, SNAP

No, it's not a new breakfast cereal. These acronyms represent specifications and guidelines to provide uniformity and reliability within a specific printing process. They are very important and CCs who design for print need to be aware of them. They provide great guidelines to help you create jobs that will print. Standardization prevents chaos!

SWOP: Specifications for Web Offset Publications—This standard covers the creation and production of advertising materials for the Web offset publications market. Web refers to web-fed presses using giant rolls of paper rather than sheet-fed presses that use single sheets.

SNAP: Specifications for Non-Heatset Advertising Printing—This set of guidelines covers printing on newsprint using a non-heatset process. Printing on a newspaper press results in different printing characteristics than a web offset press running commercial publications. Inks are different and so is the substrate.

GRACoL—General Requirements for Applications in Commercial Offset Lithography: This represents a set of guidelines for lithography processes not covered by SWOP or SNAP. This set of guidelines refers extensively to prepress issues, design, and other attributes more commonly associated with what has been referred to in the past as desktop publishing.

If you looked for and fixed all the pitfalls mentioned on the GRAcol list on your final job submission, you would be a CC who knows how to get the job out of the computer!

According to the latest version of General Requirements for Applications in Commercial Offset Lithography (GRACol 6.0), the top eleven problems with digital files are:

- Wrong or missing fonts
- Banding
- Incomplete or corrupt files
- Excessive sizing/rotating of EPS or TIFF files in the page layout program
- Spot color not converted to process colors or vice versa
- TIFF files not converted from RGB to four-color CMYK mode
- Wrong page size
- Low-resolution images
- Inadequate bleeds

- Improper trapping or no trapping
- Improperly reformatted files

Building a file properly takes some attention. As mentioned earlier in the chapter, you need to use the correct fonts and ensure they are with your job when submitted. If the text you are using is more of a design element (i.e., a headline or slogan) rather than pages of body text, you do have an alternative if you do not have a PostScript font. Your option is to create outlines. What that does is take your font and convert it from a bitmap-driven description to vector-defined information. It recreates the font as a series of paths. This allows you to do two things: 1) print without the actual PostScript font, and 2) do numerous creative actions now that you have converted text into a series of paths.

Color becomes a preflight issue when it is not done correctly. Never forget that RGB is for the Web and CMYK is for print. Even though some prepress facilities are now maintaining RGB files further into the process and changing to CMYK only at the very end, unless your prepress facility or printer tells you to submit RGB files, assume CMYK. If you have a job that is a thirty-two-page brochure with twenty-five images, you can be sure converting all those images from RGB to CMYK will not be a freebie if it has to be done by the production house. And, if the resolution of the images you submit are way too low to print properly (i.e., 72 DPI) you will be contacted and asked to supply high-res versions. This will slow down production and quite possibly cause a missed deadline.

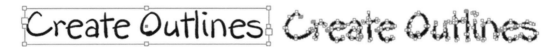

figure |2-15|

Creating outlines makes your font into to a series of paths.

Getting Organized

It is essential to become organized when working on a design project. There is no place for the proverbial messy office syndrome where you say, "but I know where it is even if it looks out of control." You need to develop a system that you follow when working on a project to maintain control and keep track of all the elements involved with the project. A prepress facility typically has a Work In Progress (WIP) folder for all current jobs. Within that folder are the specific job folders. Each job folder may be called by the customer number, the job number, or any other

identifier that is relevant and works. Within that job folder are the document itself, all related images, fonts, and text, and any other elements that will be used. In addition, there is a read me or report with any special instructions and designer/customer contact information.

You need to create this folder at the beginning of your project. From this point on all work is saved to this folder. All graphics created or supplied are placed within an images subfolder **before** you bring them into the document. This ensures that the linking is correct. Another very important preflight issue to control is color space. Make it a habit to only save final CMYK images and not to include work-in-progress images. The possibility of linking an unconverted image is far greater if it is floating in your folder.

Packaging It All Up

When you have completed your job and think you are ready to deliver it, there are

figure | 2-16 |

A WIP folder—keeping organized is important for efficient workflow.

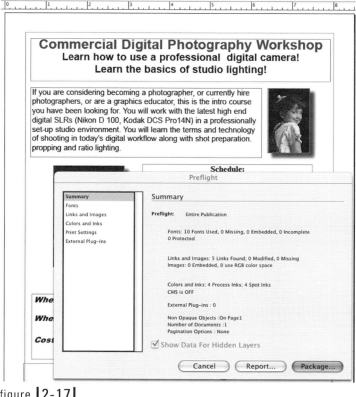

figure | 2-17 |

InDesign can preflight your document before sending it to the printer.

still two more steps to do. The first is to package or collect for output using the page layout application command, and the second is to print out laser proofs to be sure your job is separating and printing properly.

Let's examine the Preflight and Package plug-in in Adobe InDesign CS. InDesign's preflight plug-in is a good tool for analyzing your job and spotting errors inconsistent with printing. It is not as robust as third-party preflighting systems such as Markzware FlightCheck, but it can help you substantially in cleaning up your file.

The next step is to package your job. In QuarkXpress this is referred to a Collect for Output. InDesign has a plug-in feature called Package that is accessed from the File menu. This assembles all the files needed for publication. In addition, it creates a report containing detailed information about your document.

figure |2-18|

If you have a problem with your file, the report will also note it.

This is critical! Though you may have everything assembled in a WIP folder, this is your insurance that in fact everything you need is together and accompanied by a detailed report. Two things to take note of are: 1) be sure to have Update Graphic Links in Package checked so that the non-embedded images are linked to the correct document, and 2) check Use Document Hyphenation Exceptions Only to prevent the possibility of text reflowing. At some point, sooner rather than later, an update to your layout program will occur and commands may not be in the same place, so always check your documentation to be clear about where the Package function is and how it is currently operating.

A final step that will help you spot any last minute problems is to output your separations on a PostScript-capable laser printer. When you print your job out as a composite proof, it may look all right but mask certain production problems. By outputting separations you are able to view each plate. This assures you that in fact your file can output properly on a PostScript-enabled device. It also confirms that all graphics and fonts are printing properly.

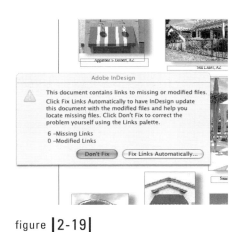

figure |2-19|

It's important to know if all image links are correct before sending a job out.

Some prepress facilities will specifically request this type of output so they can ascertain ahead of time if

there will be production snafus. It doesn't guarantee a perfect file, but the odds are very good that it will print properly.

Submitting Your Files

Once you have packaged everything properly, you have to deliver the job. In the past ten years, different transportable storage media have come and gone. (Does anyone remember SyQuest?) It appears that USB magnetic storage such as ZIPs and optical discs like CDs and DVDs are the current favorites. Always ask the facility or agency that you are submitting your work to what they can accept. A faster way to send your files is by using File Transfer Protocol (FTP). FTP is an application protocol similar to Hypertext Transfer Protocol (http) or Simple Mail Transfer Protocol (SMTP). It is a way to exchange files over the Internet and is the protocol of choice for sending graphic files, which can be quite large. (Please, do not send your jobs as e-mail attachments!) If you are going to manage this process yourself, you need two things: an FTP client and a receiver who has an FTP server set up. The best known of all clients has been Fetch, which originated at Dartmouth in the late 1980s and is designed for the Mac platform, but it is compatible with FTP servers on a variety of platforms. It is a simple interface that allows you to "put" and "get" files, folders, and directories. You can synchronize a folder on your Mac with a directory on your server, with one command, transferring only the files that have changed. It used to be free, but now carries a nominal charge (see Companion DVD).

If you are not interested in running the client, or your customer or facility does not have an FTP server set-up, another solution is to use a file transfer service. You upload your files through your browser to their site, where they are stored for a period of time—perhaps seven days. The receiving party is notified that they are there, and they download the files through their Web browser. There is usually a flat fee per transfer. And remember, FTP is not just for sending print jobs. Web files can be transferred and published also. Regardless of how you approach it, you will find FTP sending and transferring of files extremely valuable.

figure |2-20|

Fetch software, originated at Dartmouth, is designed for the Mac.

PUBLISHING TO THE WEB

As we have seen, print has some pretty specific constraints and procedures to follow to get accurate output of your design work. The Internet, on the other hand, is not quite as controllable. In particular, so much depends on the viewer as to how your site will be seen. Let's take a look

| FAST FACT |

According to Internet World Stats, as of December 2004, more than 812 million people worldwide are regularly surfing the Web. Nielson/Net Ratings has reported a 25% increase in online shopping sales from 2003 to 2004—translating into $23.2 billion worth of sales. And that's just in the United States!

at a hypothetical magazine that is published to print and on the Web. Once printed properly, the viewer can choose the lighting by which to view the publication. Some eyes have better color judgment than others, but the actual piece of paper itself is not adjustable by the viewer. In contrast, when you publish the same magazine to the Web as an HTML or XML page, you don't know if your viewer has 8 MB or 80 MB of video RAM; has thousands or millions of colors selected; has chosen an odd character to substitute for the fonts you have chosen; and whether they are viewing full screen on a 17" display or a 14" portable. And you can almost be assured that the average home viewer has not calibrated and characterized their display. The World Wide Web is perhaps one of the most challenging media for a designer because the viewer can affect it so much.

So, what is the best answer as to how do you produce your work for the Web? At this time, the best solution to maintain the integrity of your original print design is by using Flash or PDF. We look at PDF technology extensively in the next chapter, but we can look at some of the workflow challenges one has to deal with when publishing to the Web.

figure |2-21|

HTML code.

To Code or Not to Code

When discussing code and the Web, the most ubiquitous form is Hypertext Markup language (HTML). It is a markup language that tells your browser how to display your HTML-tagged content. It was created by Tim Berners-Lee and Robert Calillau at a physics research firm in 1989. At the time, there was no easy way to exchange documents between researchers over their network. HTML, along with http (Hypertext Transfer Protocol) allowed for the birth of the graphical Web, which had been basically command line text until then. According to Berners-Lee, for the Internet to really work "the computers, networks, operating systems, and commands have to become invisible, and leave us with an intuitive interface as directly as possible to the information." (See http://www.w3.org)

HTML is built on the concept of tags that are responsible for defining the structure of the Web page. They define such things as headers, tables, images, and the body of the document. Its ability to hyperlink, or connect other documents into one 2-D space is at its core its best benefit. Its inherent weakness is its simplicity. It is not very robust when it comes to formatting and style options.

The best HTML is less complex, so it is accessible by the widest audience. Extensible Markup Language (XML) was developed to further the scope of control over Web publishing. It is extensible, meaning customizable, and can also be read by various computer programs and systems. Think of XML as a way to define the usage of a given set of tags—a way to implement a markup language. In fact, XML work is often ultimately translated into HTML for display in the browser. It is considered a metalanguage and provides the syntax for creating a particular markup scheme. XML itself does not define the style of the document, but specific style sheets can be applied and the appropriate final result attained.

The very broadness and customizability of XML is what makes it so powerful. It has certainly become one of the most powerful languages as relates to print and Web publishing. For example, one style sheet could determine the formatting for a print publication and another style sheet could determine the Web appearance, but both style sheets are applied to the same data. From the perspective of an efficient workflow, this allows for streamlining of production and eliminates the need to duplicate information. If you are serious about designing for the Web, some knowledge of XML is crucial. On the other hand, if coding bores you to tears, you are in luck. Over the past few years the sophistication and user friendliness of WYSIWYG editors has improved substantially. As an analogy, envision the connection between a standard stick shift car and an automatic transmission. In the first, you control when to shift based on RPM and the feel and sound of the engine. In an automatic transmission, the same events occur with the car shifting from one gear to another based on speed and load effort, but it is transparent to you as the driver. Nothing different is happening except that now it is "behind the scenes." Essentially a WYSIWYG editor takes the coding "behind the scenes" and allows you to work more intuitively.

For many CCs this is an easier path and allows for stylistic choices based on a representation of what the code will produce. You can work with a graphical user interface rather than text and let the software effect the HTML translation. The down side is that by allowing the conversion to happen under the hood, so to speak, you may pay a price with code that is not as clean or as elegantly written as if you had made all the decisions yourself. Pages may take a little longer to load and the editor may not always allow for the latest revs or updates to browsers and helper applications. And off-the-shelf editors are not free as they are more than just a

| FAST FACT |

Extensible Stylesheet Language (XSL) is a companion standard developed as an advanced technology for defining style sheets for XML documents. There are two parts to XSL: XSL Transformation, which is used for transforming one XML document into another XML document; and XSL-FO, which provides a language for specifying presentation. (Excerpted from The Columbia Guide to Digital Publishing. This is a reference book worth checking out.)

simple text program. One approach preferred by designers is to work with an HTML editor for the basic shell or repetitive elements, but use their knowledge of code to tweak and refine the page. The good news is that editors have continued to be refined by various vendors including Macromedia and Adobe.

Exporting Your Print Job to the Web

Adobe has very astutely capitalized on the interconnectedness of content creation and delivery today. From print to the Web, they are attempting to make cross-media publishing as effortless as possible. In Chapter 4 we will look specifically at the ways XML conversion has been incorporated into their suite of products, but now we will examine packaging a print project to go directly to Adobe GoLive CS, an HTML editor.

You can approach repurposing a print project several ways. You can build a companion Web site from scratch, you can write the project to rich PDF to be downloaded and viewed locally, or you can export to an HTML editor. It is important to note that the most time-consuming method is to totally build the site, but it will be crafted properly for the Web. The next choice, using a PDF file, will maintain the visual integrity of the project and can add rich media sources such as animation, video, and audio to your project. But it does need to be downloaded and the user would need to have the most current Acrobat reader installed to read it. The final way is a relatively quick solution that may take some code tweaking and adjustment, but it can be a great way to produce cross-media work quickly. It involves a feature called Package for GoLive that is accessed via the file menu in Adobe InDesign.

After you have created your InDesign page or project, you choose Package for Adobe GoLive.

This begins a process of taking your data and recreating it as a set of selectable assets. The result is a "smart" PDF that contains links to all the elements of the page and allows you to drag and drop the elements onto your GoLive page. This is not a regular PDF that can be opened from within Adobe Acrobat, but is unique to this process.

All the text is converted to XML and, depending on the options you select, all images added to the page can be optimized at the moment they are added to the page

figure |2-22|

Adobe GoLive application.

rather than having to work separately within Photoshop (it has the same Save for Web feature that Photoshop and Illustrator use). It does not convert everything 100% for Web page usage, but it is a great way to move major elements quickly. The downside is that it does not effortlessly recreate your document exactly as it is visually represented on your InDesign page. You do need to move things around, resize and possibly adjust color selections for nonimage items. What is powerful from a cross-media standpoint is that text in the PDF file is actually a component now and is linked to the original file. If a change is made on the original, it will update the HTML page automatically.

Keeping it all Straight

One of the difficulties in managing workflow is keeping track of versions and what was done when. Strategies for management

figure |2-23|

Packaging your page for GoLive.

figure |2-24|

Asset window in GoLive.

figure |2-25|

The asset window in PDF form.

of documents is certainly critical in a networked environment with multiple users, but it is also extremely important for the solo CC. In a networked environment with collaboration, it is necessary to track whether the copy in the document is complete, whether any changes to graphics have been made, and which version is the final and complete one. Files shared on a central server are especially vulnerable. There is nothing more unproductive (and unprofitable) than going to press with the wrong version of the job or uploading a Web site with dated information because the most recent files were not used.

Two approaches to maintain chronological control are to use versioning or a check-in/checkout approach. In versioning, the simple use of a suffix can indicate whether the version is the most recent one or not. A suffix can also indicate who worked on the file last. In addition, folders labeled initial draft, in progress, final, and so forth can be used. But as you might guess, once you move beyond two people working on a job, this sort of approach can prove unwieldy. There are also stand-alone products to assist in managing this process, but you have to ensure compatibility with your graphic software and that it is open and usable by everyone on the team. As a result of the tight integration between all the Adobe Creative Suite products, Adobe has created a feature that allows one or more CCs to work on the same project and easily keep track of all changes and revisions regardless of which CS application they are in. This feature is called Version Cue and is an asset management system. (Remember DAM? If not, refer back to Chapter 1.)

Version Cue itself is not an application but an interface that is accessible through your system and other CS applications. It creates a common workspace that allows for a team of CCs to work on the same file without losing continuity and without inadvertently deleting or editing out something that should remain.

figure |2-26|

Version Cue control window.

By allowing comments to travel with each version and maintaining all versions in a common workspace, anyone on the team can review the history of a document and clearly see what is still needed for completion. It is a powerful tool for ensuring that your workflow is correct and the final job signed off on **is** the final job.

SUMMARY

In this chapter we have explored the numerous challenges in producing content for print and the Internet. Please be aware that this chapter was

not meant to be exhaustive and by intent has not tried to include all possible workflow approaches or issues. The main goal was to make you aware of production areas where you as the CC can help ensure efficiency of workflow and make sure that the correct output occurs whether you go to print or Web. Knowing the limitations of your processes helps you produce your document properly, as does knowing the final end result. Workflow becomes **so** important when your original content may end up being repurposed for a variety of outputs.

in review

1. Discuss the differences among SPI, PPI, DPI, and LPI

2. What is the difference between optical and interpolated resolution?

3. Describe the correlation between your image resolution, DPI, and your output, LPI.

4. What is PostScript?

5. What are the three things a RIP does?

6. What is the difference between a display font and a printer font?

7. Contrast an open loop with a closed loop workflow.

8. What are the three steps needed to have an effective color workflow?

9. What does a color profile do?

10. What does preflight try to prevent?

11. What does a typical WIP folder contain?

12. Why should you output separations for your proof instead of just a composite?

13. Why is XML such an important language?

14. What is the difference between a WYSIWYG editor and HTML coding?

15. What are some strategies for document management?

exercises

1. Create a document in InDesign. Place at least four images and five text boxes within the page. Preflight it and note if you have any problems. Then package the file using the Package option in InDesign and see how your report matches up with your final preflight assessment.

2. Create a custom color profile for your OS X Mac. In your preferences panel, select Displays and then choose calibrate. You will be taken through the steps by the Display Calibrator Assistant. See how different your profile is from the default setting of the display.

3. Take the page you created for Exercise 1 and package it for Adobe GoLive. Create your page using the PDF assets and then open the resulting Web page in your browser. How close does it come to looking like your print document? Print out both the document from Exercise 1 and the screen shot from Exercise 3. How similar do they look?

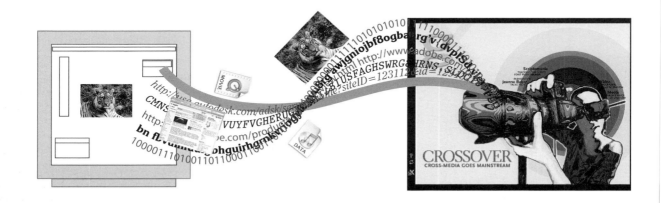

CHAPTER

III

Chapter Objectives

- Examine the development of the PDF file format from inception to the present
- Explain what a PDF is
- Understand the advantages of PDF
- Understand the PDF/X standard
- Define the basics of good preflight preparation
- Reveal the proper way to make a PDF/X-1a file
- Explore the possibilities of Rich Media PDF

Introduction

It was inevitable that out of the chaos of different file formats and applications and operating systems, a file format would come along that would be accessible by all. Thanks to an early development at Xerox Parc in Palo Alto, California, PostScript and all things PDF have become a guaranteed part of our publishing world.

THE BIRTH OF PDF

Back in the dark ages of print—the late 1980s and early 1990s—there were far more heterogeneous environments with operating systems and networks that couldn't communicate with each other. Semi-chaos was reigning and getting your files to appear on someone else's computer who didn't have the same software and platform was pretty much impossible. If you had QuarkXPress and someone else had Aldus PageMaker and someone else was in Word, well—fogedaboudit! Image files formatted on the Windows platform wouldn't open on the Apple platform and vice versa. And without the same exact fonts as the sender had, even if everything else was equal, you'd be battling font substitution and text reflow. In 1993, Adobe tried to address this problem with its first release of Acrobat 1.0. It created a file called a PDF, which stands for Portable Document Format. Its original intention was to allow people to view files on their computers without having the native application loaded. In addition, you didn't need compatible hardware or need to own specific fonts. For the print industry, it looked like a way to do initial nonbinding proofs primarily for content.

Around 1994, the Internet began to be more commercial, and more and more people were beginning to "surf." The possibilities of this new graphical interface really began to take off. Adobe began to incorporate features that were useful for Web display and Acrobat 2 came out just a year later. Now PDFs are everywhere—from the average consumers desktop to high-end printing to rich media files distributed via the Web. So, exactly what is this wonderful and ubiquitous thing called a PDF?

SO, WHAT EXACTLY IS A PDF?

As we discussed in Chapter 2, PostScript is not a particularly user-friendly programming language, and there is no standard way to view a PostScript file on a computer. A PDF is a PostScript file that is interpreted (distilled) and becomes data that is represented as an object list when displayed.

The types of objects it defines are numbers, arrays, and names. The actual page description is built from these objects and is what you see. Although a PostScript file and a PDF share the same under-the-hood imaging model, they are put together quite differently. A PostScript file needs to be interpreted as a whole file, but a PDF file is page independent. Each individual page can be interpreted separately without having to reference other parts of the file.

If you have the Adobe Acrobat Reader, you can read any PDF sent to you, provided you have kept up with the latest version of the Reader.

A PDF file embeds images, fonts, and any other data needed to make up the file so you don't need any of the originating native applications.

This feature was what really caught the attention of prepress facilities in the 1990s. One of the main challenges production has had in receiving CC files has been trying to keep up with the latest version of software being submitted. But it wasn't until 1996 with the release of Adobe Acrobat 3.0, that high end print options were introduced, making it possible to envision for the first time a truly universal document format for print.

PostScript

```
%!PS-Adobe-3.1
%%Title:
6month05.indd
%%Creator: Adobe
InDesign CS (3.0.1)
%%For: Penny
%%CreationDate: 1/
15/05, 10:52:48 AM
%%BoundingBox:
```

Distiller

figure |3-2|

Adobe Acrobat Reader.

At the same time, third-party developers began making plug-ins that made the format even more viable in a print production environment. But what was still missing until 1999 was some sort of standardization to ensure that a PDF was correctly made. Up until then it was a bit of a free-for-all as far as the quality of submitted PDFs. Missing fonts and incorrect resolution images were common and PDFs were often considered a problem upon receipt. Prepress facilities and printers were understandably wary of PDF files. Then, in 1999, two things happened that allowed the full possibilities of PDF as a file for print production to come to fruition. The first was the development of a standard for the exchange of digital data introduced by the Committee for Graphic Arts Technologies Standards (CGATS), a consortium of members of printing and publishing companies dedicated to developing national standards.

figure |3-1|

PostScript being distilled into a PDF.

The standards released by CGATS became known as PDF/X-1, a restricted subset of PDF 1.2. A restricted subset indicates that the file has imposed certain limitations on what can and cannot be included if it is to be considered in compliance with the subset. There will be more on PDF/X later in the chapter.

The second event in 1999 that helped establish the importance of PDF to production was the introduction of Acrobat 4.0, along with the PDF 1.3 specification. This release contained the remaining options that would be required for high-end print production workflows. ICC-based color, trapping information, bleed/trim/art box, and the means to define metadata were some of the important new features. In 2001, Acrobat 5 was released with the PDF 1.4 specification, which included better color management options, conversion options (PDF to HTML), transparency and more. As of this writing, we are at PDF 1.5 specification, with the release of Acrobat 6, which now includes preflight and previewing tools along with the ability to create separations.

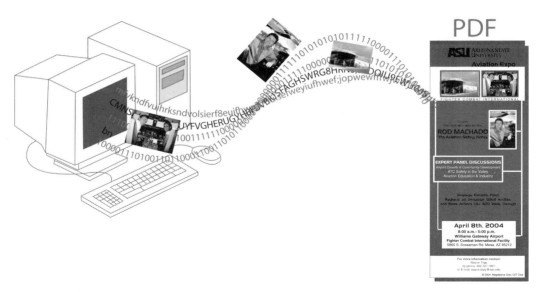

figure |3-3|

Text and graphic images combine to make a PDF for print.

Print Issues Covered in Acrobat 3.0 (PDF Version 1.2)

- CMYK Color Space
- Spot Color Support
- PostScript Level 2 Patterns
- OPI 1.3 Support
- Device Independent Parameters
- Halftone Information
- Transfer Function
- Black Generation
- UCR
- Overprint
- Stroke Adjustment

Advantages of PDF

PDF is one of the most common file formats used to exchange data whether in the office, on the Web, or via e-mail. As of 2004, more than half a billion copies of the free Acrobat Reader had been downloaded from Adobe's Web site. There are numerous reasons why PDF has become a defacto standard for document exchange. It is platform-dependent and thereby avoids

any PC/Apple/Linux issues. It lets users view information without the originating application. This is vastly less expensive in a company environment; everyone doesn't have to own QuarkXPress or Adobe InDesign or Microsoft Office. In particular, it facilitates exchange of information between a CC and a client because the client doesn't have to have graphic software to view the proof.

It is also a very portable document, compressible and compact. This has made it the format of choice on the Internet for information that needs to be distributed and still maintain a faithful rendition of its original layout. It is also self-contained and able to have embedded data. This alone can remedy the missing font issue that plagues print production. Files created through Adobe Distiller, part of a full version of Adobe Acrobat, are actually being interpreted through a PostScript Level 3 interpreter, and that is a good indicator of the printability of the file. The predictability of a PDF file, that is to say that what you see on the screen almost always is what you get when you print, brings our industry as close as we've ever been to a WYSIWYG world (what you see is what you get).

The beauty of PDF for print is that the file contains PostScript data that has already had the first stage of the RIP process completed. (Refer to RIP in Chapter 2.) The PostScript has been interpreted, and the resultant PDF is actually a compressed and interpreted Post-Script file. This means that there are no native application products linked to it; all the objects, are now embedded. The original elements have all been converted to vector objects, raster objects, and text objects. In addition to these original page elements, the PDF is also, in effect, a container for other elements not tied to PostScript—elements such as interactive hyperlinks, movies, and sound.

| FAST FACT |

CGATS was formed in 1987 following a year-long assessment of the need for an umbrella standards committee by the Image Technology Standards Board (ITSB) of the American National Standards Institute (ANSI), and received ANSI accreditation in 1989. The goal of CGATS is to have the entire scope of printing, publishing, and converting technologies represented in one national standardization and coordination effort, while respecting the established activities of existing accredited standards committees and industry standards developers.

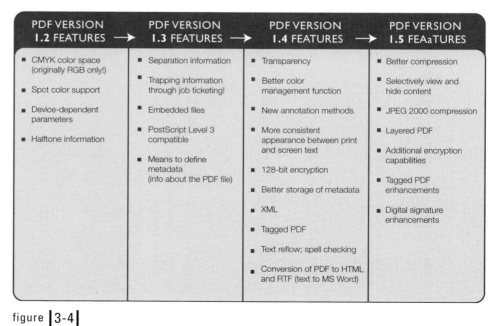

PDF VERSION 1.2 FEATURES	PDF VERSION 1.3 FEATURES	PDF VERSION 1.4 FEATURES	PDF VERSION 1.5 FEAaTURES
• CMYK color space (originally RGB only!)	• Separation information	• Transparency	• Better compression
• Spot color support	• Trapping information through job ticketing!	• Better color management function	• Selectively view and hide content
• Device-dependent parameters	• Embedded files	• New annotation methods	• JPEG 2000 compression
• Halftone information	• PostScript Level 3 compatible	• More consistent appearance between print and screen text	• Layered PDF
	• Means to define metadata (info about the PDF file)	• 128-bit encryption	• Additional encryption capabilities
		• Better storage of metadata	• Tagged PDF enhancements
		• XML	• Digital signature enhancements
		• Tagged PDF	
		• Text reflow; spell checking	
		• Conversion of PDF to HTML and RTF (text to MS Word)	

figure |3-4|

The evolving PDF specifications.

THE X IN PDF/X

The original intent of the PDF/X specification was to create a complete data exchange that would be correct without any additional technical involvement. In other words, it would be designed correctly for a publication's advertising workflow. It would indicate a subset of the PDF file that adheres to all the print production parameters required for an accurate print workflow. The X is what determines what can be included and what can't. It indicates how the file will be rendered to ensure correct output. For example, it would only allow CMYK images, not RGB.

Content in a PDF/X File Is Limited According to Four Conditions

- Content that is required: a conforming PDF/X file must contain this key or object.

- Content that is prohibited: a conforming PDF/X file cannot contain this key or object.

- Content that is restricted: where and how certain keys or objects are used is limited by preestablished rules.

- Content that is recommended: it is suggested that the conforming PDF/X file contain this key or object, but it does not have to.

(From The PDF Print Production Guide, 2nd Edition [Marin and Shaffer], GATF Press)

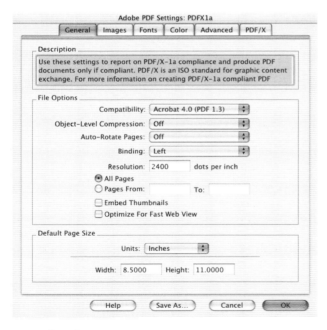

figure |3-5|

Some of the settings in Adobe Acrobat Distiller required for PDF/X-1a compliance.

PDF/X itself is not a file format, but a completely nonproprietary accredited standard for the exchange of digital data. As with all technology, it is an evolving specification, with the suffix after the PDF/X determining what particular subset it is. For print production purposes the most important one is the PDF/X-1a:2003 specification.

This specification makes sure that the file meets certain criteria, such as no RGB or Lab color, trim or art box cannot exceed the media box array, and all fonts must be embedded and legal. In addition, it prevents certain options such as partial transparency, JB1G2 compression, and encryption. PDF/X-3:2003 allows the use of device-independent color spaces such as Lab and ICC profiles, as well as CMYK. It is more appropriate for a color-managed workflow and is most often the standard format of choice in Europe. Now, do you need to know all the settings all the time as a CC? The good news is that the Digital Distribution of Advertising for Publications (DDAP) organization, who was responsible for promoting the development

of a PDF/X standard by CGATS, has provided tools and clear directions on their site at PDF-X.com.

In addition, other companies such as Time Inc., who have a very critical interest in the production of PDF/X files when it comes to ad submission, have created sites solely to help their clients prepare their files properly. (See Companion DVD.)

figure |3-6|

The PDF-X Web site supported by Digital Distribution for Advertising Publications (DDAP).

Preparing Your PDF/X File

What does it mean to prepare a file properly? The recommended process is to save the file as a PostScript file, and then distill it to a PDF file using the recommended DDAP settings and procedures.

On the Windows or Apple platform, the first step in proper PDF/X creation is setting up your Adobe PDF printer. In Windows this also means setting up the Adobe PostScript (Adobe PS) printer driver. On the Apple platform in OS X, this is no longer necessary. When Adobe Acrobat 6 is installed, the Adobe PDF printer will also automatically install. This printer is actually a "virtual" printer, meaning that it creates a digital file on

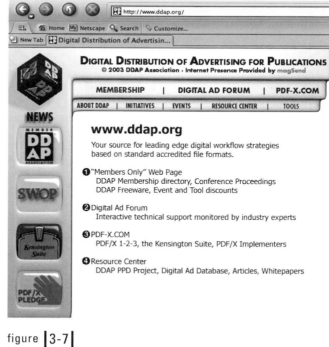

figure |3-7|

The Web home of the DDAP.

your desktop rather than printing to a device. But it still creates a PPD—a printer description file—that is placed in the appropriate library folder on OS X.

PDF/X

Linda Manes Goodwin

Linda Manes Goodwin.

Linda Manes Goodwin is a consultant to the graphic arts industry, specializing in digital print production. She has had an extensive and accomplished career, currently serving as the vice president of the DDAP Association in addition to being an evangelist and educator for the design and implementation of digital workflows.

Although it is possible to make a very good, print-ready PDF file that does not conform to the PDF/X Standard, it is also possible to make a very bad one. For this reason, many publishers and printers insist on files being submitted in the PDF/X-1a format. Says Keith Hammerbeck, Director of Manufacturing Services at Advanstar Communications, "78%, or 1,326 of the PDF ads we receive each month, are problematic. Fonts are missing, overprint is handled incorrectly and images are low

The next step is to thoroughly preflight your document in its original application (QuarkXPress or InDesign) for certain correct settings so your ultimate PDF/X formatting starts out as clean as possible. Although InDesign has an excellent preflighting application built in and extensions exist for QuarkXPress, it is recommended that any CC get very familiar with the basics of good preflight for print.

Once you have properly preflighted your document, it is time to create a PostScript file. The best way to do this is to submit the file to a PostScript interpreter. In Adobe InDesign or QuarkXPress, the way to a PostScript file is to print to "PostScript file" and choose the correct PPD, which would be Acrobat PDF.

Ensure you have the page set properly for bleed and printer's marks. Also check that scaling is at 100% and composite CMYK is selected. Then select save.

Now it's time to launch Adobe Acrobat Distiller. There are six possible ways to create your PDF file, depending on the ultimate end destination. There is Smallest File Size, Standard, High

resolution or RGB." Dave Tompkins, Director of Pre-flight Operations for Science Magazine, had a similar experience. "50% of the PDF ads we receive do not pass preflight. Of those, 30% are successfully repaired automatically, 17% percent cannot be fixed by the system but are corrected offline by internal prepress operators, and the remaining 3% contain errors that can only be fixed by the advertiser." Such inefficiency leads to a loss of productivity, which results in additional costs and loss of precious time. Scott Borhauer, Central Premedia Manager at Brown Printing offers the perspective of the printer. "40% of the PDFs we receive from customers fail. As an industry, we must demand PDF/X-1a. When you leave the "X" world, it is ugly: missed press dates, cycles messed up because of a bad file exchange. If they had only taken the time to learn X-1a, the errors could be eliminated."

The use of PDF/X-1a eliminates the most common file errors, such as RGB color, missing fonts, and incorrect overprint settings. It does not, however, prevent the presence of low res images or spot colors. To eliminate 99.9% of all file errors, PDF/X in conjunction with a market specific, or even publication specific, preflight parameter should be used. This is referred to as PDF/X Plus.

According to Brad Stauffer, Senior VP of Operations at 101 Communications, "By converting all our magazine to PDF/X-1a, the internal production cycle was reduced by three to four days, with a similar reduction in cycle time at the printer, and ad close dates were made later." In addition the PDF/X-1a workflow resulted in a less than .001% file error rate over three years. Brown Printing reports a similar error rate. Say Borhauer, "During a new trial period, PDF/X-1a files were not only impositioned and RIPed, but run on press. The success rate was 100%."

But even beyond the benefit of reliable files is the easy conversion to other media, such as E-publications, which offers prepress providers and printers additional revenue streams. ∎

Quality, Press Quality, PDF/X-1a and PDF/X-3. Remember, unless requested by your prepress facility or printer, you want to choose PDF/X-1a for as close to a "blind exchange" as possible for print production. This means that the color space is CMYK and/or spot colors, with no RGB or device-independent (color managed) data. You can edit your settings and save them if requested, but when in doubt, choose PDF/X-1a. Acrobat Distiller will also produce a log file to further confirm the status of your file; that is, whether any problems were found.

Fonts, Again

The number one problem reported in file submission is missing fonts. This is still a touchy area in PDF/X-1a creation. For Acrobat Distiller to properly embed your fonts—provided they are legally licensed to be embedded—Distiller must have access to them. This can happen in one of two ways. If the virtual printer used to create your original PostScript file was set up to include them, they are there. If not, you need to indicate the font location in the system under

Basics of Good Preflight Prior to PDF/X Creation

- Do not use RGB images—set all to CMYK.

- Make sure all color choices are properly named: For example, if a color is referred to as company red, make sure it is set to a process build.

- If using spot color, make sure it is named properly and consistently throughout the document to avoid creation of unneeded extra plates.

- Make sure all elements in the document are linked.

- Make sure all fonts used are available and open for proper embedding in the PDF/X file. Ensure that your font choice can legally be embedded and is not restricted due to its license.

- Do not use menu-styled fonts; that is, attributes such as Bold chosen via the formatting bar rather than the actual font, and use only actual PostScript fonts.

- Ensure that high resolution images appropriate to printing are in the document—no 72 DPI!

- Check that media size is appropriate for the document and for any bleed and printer's marks that might be applied.

- Check for incorrect overprint choices for page elements.

figure | 3-8 |

Printing to PostScript from InDesign.

the Settings menu. If the fonts are found, Distiller will embed them. But—and this is very important—if they are not found, the dreaded font substitution will occur. Remember Courier? It is wise to set your Distiller options to cancel PDF file creation if fonts are not found so that it can be remedied.

Only Type 1 (PostScript) fonts can be fully embedded! If other font types are used, such as True-Type or Multiple Master fonts, something called subsetting will occur. When this happens, Distiller will only use the information required to draw actual specific characters in the document and will not embed the entire font set. Suffice to say that subsetting of fonts is not

desirable in files headed for high-end printing. In addition, for proper file delivery, always include your PostScript fonts in your folder because the current policy on embedding fonts, according to Adobe, is that "documents with embedded typefaces may not be edited unless those embedded typefaces are licensed to and installed on the computer doing the editing."

figure |3-9|

The log window in Distiller alerts you to any problems.

RICH MEDIA PDF

Rich media refers to the inclusion in a document or online page of everything from streaming video and audio to interactive applets and special effects. It has become more prevalent as bandwidth has increased and computers have become faster in processing their information. Typically one thinks of rich media as being delivered via a Web page. We have all seen video clips and interactive features in everything from pop-up ads to news sites. In fact, we take for granted that some sort of animation or multimedia will be part of our surfing experience. This is supported by the fact that, according to Macromedia, their flash player is one of the most widely distributed pieces of software on the Internet. But, the application that surpasses even that and is also distributed widely, is Adobe Acrobat Reader. As mentioned earlier, as of 2004 more than half a billion copies of the free Reader have been downloaded from Adobe's Web site. The ability of PDF files to contain rich media is a boon to publishers and to those who design for print who want to bring their print products to the Internet, retaining a faithful rendition of the original printed piece, but also delivering extra rich media features. PDF files are now able to embed or stream almost any multimedia content, which creates a hybrid document that seemingly melds the best of print, the Internet, and television.

For a CC, this is a whole new way to look at PDF. More than just a file delivery format or a way to preserve the look of the print document, it opens new creative ways to communicate

RICH MEDIA PDF & CONVERGENCE

Bob Connolly

Bob Connolly is a principal in BC Pictures, a new media production company creating content for TV, CD-ROM, DVD, and Internet Web sites.

Convergence. This term has often been touted by futurists as being the Holy Grail for monolithic media industries. Companies such as AOL and Time Warner merged for the sole purpose of reusing each other's resources. The goal was to put all of the various assets such as print, TV, and Internet content under one roof where content creators could mix and match and finally deliver the data in some sort of converged delivery platform.

Adobe's PDF has grown to become much more than a printer driver. It is a full-fledged multimedia operating system capable of merging several file formats into a tiny compact data file that is perfect for delivery via the Internet. Apple computer's QuickTime file format is also a full-fledged multimedia operating system capable of merging several file formats into a tiny compact data file that is also perfect for delivery via the Internet. The

Bob Connolly.

strength of PDF is its print capabilities. The strength of QuickTime lies in its interactive capabilities. But when you combine the two, you have true convergence.

When Adobe released Acrobat 6 and the free Adobe Reader 6, PDF and QuickTime became the heart and soul of a brand new media, one that could truly be described as the king of all rich media. Using PDF pages as the foundation for embedded QuickTime content, multimedia developers

information. To gain the full benefit of it, users download the file to their desktops, because a rich media PDF can be large. Let's look at some of the features that can be added.

Interactive buttons, which have long been an integral part of Web sites, function in a similar fashion in a PDF.

Courtesy of BC Pictures

An example of a rich media PDF formatted for a full display. This client also looks the same and has the domain name > .tv <. The domain name is owned by a tiny island in the South pacific called Tuvalu who controls the name through VeriSign.

employed often will allow the video to be manageable for Internet downloading. Compressed mp3 music files are fairly small and easy to download, so this is a media type that seems to be popular and growing by leaps and bounds.

Since an electronic document contains rich media such as video that cannot be printed, it is important to approach the design of the document from a TV point of view. Instead of portrait, the document needs to be designed in landscape display and the aspect ratio of the page needs to fill the screen of the computer monitor from edge to edge. The eBrochures that are produced by our company, BC Pictures, will launch full screen to simulate a TV viewing experience and the rich media content such as video and virtual reality photography will appear in or above that page when requested by the user.

People often ask me, "Why do I need an Interactive Rich Media PDF file to promote our company. I have a Web site." To them I reply, "Can you download your Web site? Can you print your entire Web site with one click? Can you e-mail your Web site?"

Then I add the convergence angle, "How about e-mailing your printed brochure, promotional video, and Internet site all at once? This is direct marketing. This is convergence!" ∎

now had an alterative delivery platform that could eventually compete with HTML Web pages, which often feature animation and video in Flash and Windows Media formats.

To take advantage of this new PDF Rich Media content delivery system, several other factors had to emerge to bring this medium to the masses. In the United States, broadband Internet connections in the home now outnumber the dial-up users. Even though PDF is well known for its ability to compress pictures and text to very small file sizes, video is still bandwidth intensive. Careful consideration for the dimensions of the video and the compression code

These buttons can play, pause, or stop a movie clip or initiate any other action you may design into the PDF. Actions or events can change based on the movement of the mouse. To add an interactive button, one simply selects it through Tools>Advanced Editing>Forms>Button Tool. Rollover functionality can be added and you can make a button from any file format that can be displayed in Acrobat, including PDF, JPEG, GIF, and other graphic formats.

figure |3-10|

Many varieties of media go into a rich media PDF.

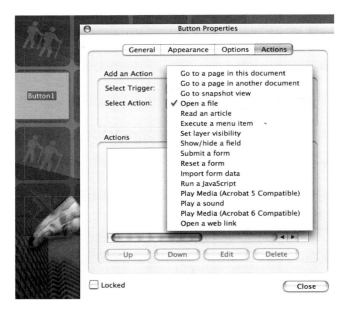

figure |3-11|

Making an interactive button in Acrobat.

figure |3-12|

The Tools menu in Acrobat.

Integrating media clips requires that the supporting software be resident on the user's computer. For example, if you embed a QuickTime movie, the computer must have the player. PDF documents can also include clips that are compatible with Macromedia Flash, Windows Built-in Player, RealOne™, and Windows Media Player. When adding a movie clip, you can choose to embed it or create a link to it. If you choose to link it, you need to include the correct path names for the link to find the media. If you embed it, it becomes part of the document and downloads with it. Once again, all you need to do is choose Tools>Advanced Editing>Movie Tool.

The play area will be the exact size of the movie frame. You can choose to have the play area invisible until the movie is started or have what is called a Poster, which would be either a frame from the movie or any other image you want to use when the movie isn't running.

Another important property that can be set for any media clip is its rendition. This refers to the size the media will play at, whether as a large file and high quality or as a small file and low quality. This is useful when trying to reach a broad audience

with varying bandwidth connections. Another powerful feature is the ability to work with JavaScript actions. JavaScript was developed by Netscape Communications to allow the creation of interactive Web pages. It is now possible to integrate JavaScript into Acrobat Forms to format, calculate, validate, and assign actions to data.

A Rich Media Magazine

Graphic Exchange Magazine, now known as gX, is published by Brill Communications out of Toronto, California. In the summer of 2004 they published both a printed version of the magazine and a complete rich media version. As attractive and well done as the printed piece is, the PDF version is full of video clips, informative links, virtual reality photography, and flash. It is stunning and beautifully displayed on a computer display in a way that could not be done if viewed directly from the Internet. There are three choices as to how to download the file, but the full version, which can weigh in at 90 MB, provides by far the most satisfying experience.

figure |3-13|

Placing a link within a PDF document with the Movie Tool.

figure |3-14|

Choosing to make a poster either from the movie or from a component from the open file.

THE NEXT STANDARD

Dan Brill

Dan Brill, the founder of Brill Communications (Canada) is also the publisher and editor-in-chief of Graphic Exchange (gX) which is published quarterly and reaches more than 40,000 qualified creative and production professionals in the United States and Canada.

Throughout the brief history of desktop technologies, the underlying story has actually been less about the technology developments themselves (astounding as they have been) than about establishing the digital standards for working with these tools. Given the torrid pace of changes in publishing and design, the standards which we have adopted over the past two decades have been, by necessity, "de facto" rather than "official." PostScript got the ball rolling; Type 1 fonts, TIFF, and EPS defined our text and images; and QuarkXPress pages became the standard for content assembly. Then along came the Internet, which added a whole new dimension to our concept of the page.

Portable Document Format has been a work-in-progress along with all of this, reconciling the incompatibilities between platforms, file formats, and applications. The printing industry has finally settled on PDF as its standard file format for computer-to-plate; now PDF is ready to also become a standard for delivering multimedia content.

The new features of PDF 1.5, which let us create what we call "rich PDF," allow us to make pages for both print and the screen. In essence, rich PDF merges three media forms—print, the Web, and video—in one format. In the course of conceptualizing a cross-media publishing model for our magazine, Graphic Exchange, I found myself being forced to think differently than before. It was no longer good enough to think simply in words and pictures; now I had to look at how each article could be presented in video as well as what interactive elements could logically be incorporated. Editorial choices and perspectives now depended on how effectively each topic or theme could be presented within this cross-media context. The decision to run a piece that did not lend itself easily to multimedia, such as a dissertation on fonts and typography, now had to be weighed against its overall value to my readership. The role and responsibilities of a cross-media publication's editor has changed and expanded—and *so must the graphic designer who bears responsibility for executing these pages.*

This kind of page creation is still in its infancy. Production and workflow issues are not unlike

Cover of the Graphic Exchange Magazine—Summer 2004.

the ones which we faced at the beginning of the desktop publishing era: the lack of tools for building CMYK/RGB pages in parallel, multiple format preflighting, and customizable job collection, not to mention integrated multi-purpose digital asset management, version tracking and updating within workgroups, and sophisticated color management for multiple color spaces. However, in a world where the lines dividing different forms of content have disappeared, and where all content can be reduced to a particular subset of digital code, designers will have to adjust their attitudes and approaches to the page. The page is now simply a container for any conceivable form of content, whether it's static type and graphics going to press, or interactive elements for a Web page, or words, images, video, animations, forms, dynamic database-driven fields, and hyperlinks embedded in PDF. The challenge will be to maintain predictable consistency and the highest graphic esthetics across all media.

Rich PDF is, to me, the most interesting new dimension in publishing. It eliminates the often appalling compromises in color and typography which designers have been forced to make with Web design, while expanding the possibilities for utilizing the power of rich media. But it retains what I still view as the most fundamental requirement for graphic communications: the ability to be printed at the highest quality resolution with no sacrifice in color integrity or typography.

What is enabling this new publishing format? The answer is at once simple and complex: the confluence (not convergence) of technologies which include personal computers with faster processors, widespread adoption of high speed Internet services that let content creators easily deliver large files, new desktop applications for the simple creation of cross-media content, and—most important of all—digital standards across all media from type to images to video and sound to the page itself.

PDF in its basic form has gained acceptance as a digital standard in government and business, print manufacturing, and general document delivery. Rich PDF will soon be recognized as another new standard, and I predict that it will be a potent one. ∎

SUMMARY

The PDF file format has come a long way from its initial debut. From being simply a tool to allow viewing of a document without the native application, it has transformed into the most ubiquitous means of sending information, both static and rich, between people at work and at home. It has also become the defacto file format for submission in high-end printing and is now poised to become the vehicle of choice for all types of media delivery, not just for viewing on your computer but anywhere. Convergence is coming, which means that you may be watching your rich media creations on your large home entertainment screen in your living room in the future! All CCs today have to be versatile enough to repurpose their work to a variety of final media and formats. PDF is one of our best tools to help facilitate that.

in review

1. What was the original purpose of Adobe Acrobat?

2. Compare a PostScript file with a PDF file. What are the major differences?

3. What were the two events that allowed the full possibilities of PDF for printing to unfold?

4. Discuss several advantages of the PDF file format.

5. What does the X in PDF/X indicate?

6. What is the most important PDF/X specification for print? Why?

7. What are some steps one should take to properly prepare a file for PDF/X creation?

8. In Adobe Acrobat Distiller, how many ways are there to create your PDF file? Which is the correct one for print?

9. What are the 3 main things to be concerned with regarding fonts and a PDF/X file?

10. What is a Rich Media PDF?

11. What can JavaScript be used for in a Rich Media PDF?

12. What kind of information could a Rich Media PDF add to the PDF version of a printed publication?

exercises

1. Take the document you created in Chapter 2 in InDesign, or create a new one, and save it to PostScript. Open the file as PostScript code (you can do that through Microsoft Word or a similar word processor). Print out the first two pages and put them aside to compare with what you are going to do next.

2. Launch Distiller and write your file as a PDF/X-1a. Save it to your desktop. Open your log report, which will be on your desktop also, to ensure that no errors occurred.

3. Open your original PostScript file in Distiller and save it to at least three other setting choices. Each time you do, your new file will replace the previous one. Before that happens, select the current file and choose Get Info (on OS X under File). Note the size difference in the files created with the different settings. Open each one and see

if there are any differences in how they look. Print at least one of them and see how the file looks next to the raw PostScript code. Aren't you glad you don't have to learn PostScript?

4. Open your PDF file and experiment with embedding different media within it. Using the advanced editing tools, add a movie, and then add sound.

notes

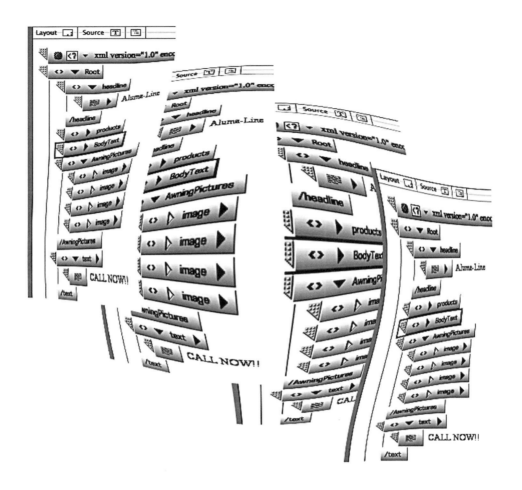

CHAPTER

IV

- Understand what XML is and is not

- Explore XML conversion approaches

- Develop an understanding of metadata and why it is so important

- Understand a standards approach to data: DISC, IPTC, and PRISM

- Explore XMP

I n t r o d u c t i o n

Content that is easily repurposed becomes more valuable than content that has to be completely reformatted for every use. Metalanguages such as XML make this repurposing much easier. Content also needs to behave in a smart fashion in today's workflow. Having destination, copyright, creator, location information, and more attached to a file allows smarter management of a digital asset. This chapter looks at the ways content can be managed, tagged, and, in effect, behave more like an asset with intelligence!

XML, METADATA, & MORE

XML

As we discussed in Chapter 2, XML is a very robust and useful mark-up language. It is a meta-language that allows reformatting of data through the use of style sheets. We will look at one of the most useful applications of XML when going from print to the Web—XML conversion. There are two ways to approach it—either through a powerful software program that will translate from one format to the other or by customizing your page layout document to map to the XML in the destination Web site. But first, we need to look a little more closely at XML.

XML does not define the document so much as it defines its structure—where information is to go and how (styles can be set for tags). To understand it more clearly, certain terms need to be clarified. A Document Type Definition (DTD) is generally used to create a set of tags that formally defines the way the content is to be handled. The best way to approach this is to set up your DTD, or schema, before actually developing the component parts of your content.

In a company where huge amounts of documents need to be translated via XML, a formal, well-thought-out schema needs to be developed. This can be quite time-consuming, but it is needed when dealing with large volumes of content, such as the publishing of a daily newspaper to the Web. It is also needed as a way to apply a particular XML schema to a set of documents that share mutual characteristics (e.g., financial documents as opposed to medical documents). For an individual content creator, setting up your DTD ahead of time can help with conversion, but it is not always required. What is needed, though, is knowing what tags you have so you can convert your data properly. To put it simply, when you convert your print document to XML, using any conversion method, the parts of the document have to know where they are going and match corresponding tags in the destination document or database.

| FAST FACT |

Schema: According to the American Heritage Dictionary, "A pattern imposed on complex reality or experience to assist in explaining it, mediate perception, or guide response."

| FAST FACT |

Before everything was digital, text for publication was "marked up" by hand to indicate formatting such as indents, new paragraphs, bold this text, italicize this text, and start new sentence here. In this way, a block of text became a properly formatted page that was printed properly and was easy to read. In the same way, in XML, the tags and codes created are what format the data to be seen properly.

Size and Style of Type

Direction		Corrected Result
lc	Lower ¢ase letter	Lower case letter
lc	Set in ⟨LOWER CASE⟩	Set in lower case
C	̲capital Letter	Capital Letter
caps	SET IN ̲capitals	SET IN CAPITALS
ital	Set in ̲italic type	Set in *italic* type
bf	Set in ̲boldface type	Set in **boldface** type
sm caps	̲Set in Small Capitals	SET IN SMALL CAPITALS

An example of how mark-up is done, the manual way.

XML is a structured language, which means that it is well-defined and predictable. It allows for groupings of related items and hierarchical relationships. To do this, it has a very specific vocabulary and method for defining its structural components. In an XML document, a tag is something that describes an element in the document. For example, if you have a headline, you would tag it in the following way:

<headline>This Is About XML<headline>

The headline itself is the element. Attributes can be applied to the data also. Attributes are additional pieces of information regarding the element, usually represented in a text string. They are considered modifiers of the element and can also contain metadata, which we will discuss later in the chapter. Attributes contain data about the element that is separate from the final visual display but critical for easy repurposing of data.

The most common way XML is used, and the most relevant to CCs, is in the creation of HTML pages for Web display. This allows the browser to understand how to graphically display the page, as strings of code are not much fun to look at. One approach uses Cascading Style Sheets (CSS), which allows a style sheet to be applied to the file that contains presentation specifications of a document. By giving a name to a specific formatting instruction, it can be applied to other documents easily.

XML Conversion

So, your eyes glaze over at the thought of learning all the structure and valid formatting rules for XML. The good news is that creating XML documents whose aim is to recreate a printed piece can be done through XML conversion tools. But, you should have a good reason for converting your document to XML. If you have repetitive data and your client has told you that the information will be repurposed to many different end uses, then XML is the best choice. You may, for example, have designed a Web site for a real-estate company that requires very few template changes, but will be updating images and information on a regular basis. It is also a good choice for driving variable data pages or printed documents. But if you have created a site with little repetitive information, or one that is fairly static and the information does *not* need to be repurposed, there may be no need to go through the time and effort of creating XML pages. It is important to note that to create a dynamic Web site you need to publish to a site that has the server technologies capable of supporting it, such as Active Server Pages (ASP), JavaServer Pages (JSP), and Hypertext Preprocessor (PHP).

| FAST FACT |

Choosing a style for your document means indicating a particular formatting option for a part, or the whole, of your document. For example, you could apply a paragraph style called Body Copy that represents text that is italicized and justified and uses the font Goudy. Once created, this style can be applied to other blocks of text easily with one click, saving time and allowing for consistency, when needed, to be applied globally to a document.

From Broadsheet to Display

Did you ever wonder how the daily editions of printed newspapers get repurposed for the Internet? There are many different methods, but they all use XML at some point.

How is *The New York Times* published on the Web? Prior to publication, articles and photographs are handled in similar ways, with different applications, before being merged in one content management system. On each side of the production process, newspaper and Web, there are currently varying degrees of automation and content, both textual and visual that can be manually pushed or pulled.

Articles are stored in an Oracle database and then edited and paginated using CCI NewsDesk. Once a page is laid out in CCI with final text and photographs, it is released and articles are spooled into an intermediate system. The article is then converted into an XML format and pushed to the Web site's database. A script looks for new files in a specified directory every minute and copies those files to an asset management system that uses a Web-based interface. The files are then parsed and formatted to Web standards by creating multimedia files for photographs and graphics, and article files for stories, as well as setting styles for attributes like headlines, bylines, and paragraphs.

Once the files are formatted, a producer adds multimedia elements like photos and slide shows and related articles and keywords for search strings, performs any additional editing or formatting, and publishes the file. This system then publishes an HTML page with the advertising, navigation, and editorial content onto the Web site.

Photographs, both staff and wire, are input by FTP or e-mail into Merlin, a digital photograph management system. In Merlin, editors are able to browse pictures by thumbnail, full image, file name, date, self-created collections, or search strings. Once pictures are selected for publication, they are downloaded to a desktop for color correction, cropping, sizing, and general production. For the Web site, once images are prepared on the desktop, they are browsed into the larger content management system. Once the photo (a multimedia asset) is added, it can be associated with an article or a section front and published to the site.

You can create static Web sites from XML in an HTML editor such as Adobe GoLive or Macromedia Dreamweaver, but it requires working with style sheets.

For CCs wanting to export data from QuarkXPress or Adobe InDesign, there are specific solutions that can handle the conversion for you. First, let's look at QuarkXPress. Many third-party developers create extensions and applications that work well with QuarkXPress. One in particular, Atomik Xport from EasyPress Technologies, allows content from a QuarkXPress document to be easily converted into XML. The software scans the document, identifies content, and tags it according to styling and labeling based on style sheets applied. The one downside to this solution may be the price. The challenge inherent in any third-party solutions is the cost encountered in addition to the cost of the page layout program. Although these solutions can be very robust and advisable for a small design firm, for the individual CC it may be out of reach.

Adobe InDesign provides a solution that is incorporated into the application itself. Once created, the document can either be brought into Adobe GoLive or utilized by any publishing system that supports XML. If the conversion is done through an HTML editor and simply published to the Web, remember it will not be considered a dynamic Web page in which the file is connected to scripting software on the server.

Before you can tag a document's content for XML, you need to have a valid set of tags. If you were working on a project with server-side developers, they would supply you with the correct tags that needed to be used so the information is converted into the proper fields in the browser. For our purposes, we will create an InDesign document, tag it, and export it to XML in order to understand the basic process.

The first step is to create your document in InDesign. To begin to tag the content for correct XML export—and for this exercise you will make up your own tags—you first need to identify the different categories of content in your document. For example, headline, body text, or images.

In our example, you are going to create the following tags: bodytext, headline, image, products, text. To access Tags, choose Window>Tags and then choose New Tag.

You will not be allowed to create tags with incorrect syntax. For example, no spaces or tabs are allowed.

figure |4-1|

InDesign page with empty Tags window open.

figure |4-2|

Naming and color coding a new tag.

figure |4-3|

You are flagged if syntax is incorrect.

figure |4-4|

The structure pane showing the hierarchy of your document.

After each tag is created, it can be linked to the corresponding data in your document. You can do this by dragging the tag to the document item. Your tagged item will be color coded; these colors can be seen by choosing View>Structure> Show Tagged Frames (Color Insert 7). Once you have all your data coded, you should open your Structure pane through View>Structure>Show Structure. What you will see is the hierarchy of your document. This is also where you can add additional information to your elements such as attributes and parent tags. Parent tags encompass others that make up a category or similar grouping. In our example, Awning Pictures is the parent tag to the four images in the document.

In the Structure pane, there is a structural element called Root. Each document can only contain one root, under which all other elements are nested. It is similar to the concept of an index page in an HTML site.

Once all the data is tagged, it is time to export it to an XML document. Choose File>Export and select XML. You can choose how you will view it, and image options.

This file will open in Adobe GoLive where the structure can seen in well-formed XML.

As indicated in the Netscape browser window, no styles are applied to this code. To see it the same as the printed page, Cascading Style Sheets (CSS) would need to be used to interpret the style properly for display.

figure |4-5|

When exporting to XML, you select image settings and where you want to view your code, such as in Adobe GoLive or Macromedia DreamWeaver.

figure |4-6|

How the XML looks in the Source Panel in GoLive.

This XML file does not appear to have any style information associated with it. The document tree is shown below.

```
- <Root>
  - <headline>
      Aluma-LineSuperior Shade Solutionswww.alumaline.com
    </headline>
  - <products>
      RetractablesAwningsRoll-CurtainsStructural Steel Designs
    </products>
  - <BodyText>
      Increasing your shade decreases your costs! Aluma-Line has delivered the highest quality shade solutions for over 25 years!Residential or commercial - there are
      hundreds of styles and colors to choose from. Or, let us do a custom design for you. Please contact us today for your free estimate.
    </BodyText>
  - <AwningPictures>
      <image Restaurant="Gilbert, AZ" href_opt="images/restaurantdw_opt.jpg"
      href="file:///Users/Penny/Desktop/Delmar%20In-Progress/Artwork/Art%204/Alumalinexml/restaurantdw.tif"/>
      <image Alumawood="" href_opt="images/Aluma-wood%20dw_opt.jpg"
      href="file:///Users/Penny/Desktop/Delmar%20In-Progress/Artwork/Art%204/Alumalinexml/Aluma-wood%20dw.tif"/>
      <image HighSchool="AZ" href_opt="images/%20HS%20dw_opt.jpg"
      href="file:///Users/Penny/Desktop/Delmar%20In-Progress/Artwork/Art%204/Alumalinexml/%20HS%20dw.tif"/>
      <image href_opt="images/clubdw_opt.jpg" href="file:///Users/Penny/Desktop/Delmar%20In-Progress/Artwork/Art%204/Alumalinexml/clubdw.tif"
      nightclub="Scottsdale"/>
    </AwningPictures>
    <text CallNow="">CALL NOW!!</text>
  </Root>
```

figure |4-7|

XML code seen in Netscape without style sheets being applied.

FASHION OR TIMELESS INVESTMENT?

Linda Burman

Linda Burman is founder and past chair of the IDE-Alliance PRISM Publishing Requirements for Industry Standard Metadata (PRISM) Working Group, co-author of Mastering XML PRO (Sybex, 1999, 2001), and the leading provider of JDF-enabled workflow demonstrations. She is currently president and CEO of L. A. Burman Associates, which provides strategic planning, marketing, project management, and technology partnerships to companies in publishing, media, and the graphic arts.

XML is "en vogue." It's been the hot label for years, in data applications and for data exchange and is finally becoming "de rigueur" for graphic arts professionals to know something about it as well. But it isn't just a "fashion" item.

XML (Extensible Markup Language) describes not only the structure of a document, but it can also describe the content. It can be used to convey meaning across dissimilar systems—as long as there is agreement on the set of tags and their meaning. As a result, XML-enabled systems can increase productivity and interoperability while enhancing the value of the content.

As graphic arts professionals, you work with text, photos, graphics, charts, maps, audio, and video assets from your clients. Your job is to combine, shred, manage, personalize, exchange, convert, post-process, and repurpose this content for multiple media such as print, the Web, mobile devices, TV, radio, e-books, and catalogs. And of course, you want to deliver it in the manner your clients expect—with high aesthetic quality and a logical context that transcends media boundaries.

XML makes the effective repurposing of that content a whole lot easier.

Why should you care about XML? In a cross-media world where the final destination of content is not always known, a coding scheme that allows for repurposing is vital. It allows for one document source that can be routed into many different designs.

METADATA

According to the World Wide Web Consortium (W3C), metadata is machine understandable information for the Web. Though by no means exclusive to the Web, we will explore it first in the manner in which many CCs were introduced to the concept. First, a review of what metadata is: It is data about data. Or more specifically, it is structured information about

By consistently applying the same meaningful set of tags to articles, books, documentation, brochures—any kind of document—you can automate the repurposing and recombining of content components for different media types and applications. Some people use the phrase "Author once; publish many" but as multiple media publishing has evolved we have learned that some intelligence has to be applied to this statement. Certain components can be created once and reused as they are. However, it would be absurd to send a whole article to a cell phone.

Encoding documents in XML provides other benefits. XML markup enables you to identify names, key phrases, and other important data elements within a document, making it easier to consistently format, search, and turn data into links.

Content can be written in XML or described in XML metadata. Using a metadata standard such as IDEAlliance PRISM (Publishing Requirements for Industry Standard Metadata), which contains tag sets that the leading magazine publishers have agreed upon provides many benefits to your project. Consider an item such as a date. Is it the date the article was written or when the magazine was published or the date on the cover and so on. The PRISM standard provides specific names for each of those different types of date so that systems can reliably determine which date is being used and act accordingly.

Or, say you are trying to develop a Web magazine but you aren't sure if your enterprise client has the appropriate rights to all of the images, and it's the weekend so you can't call anyone. If the images are all tagged with consistent rights information you can immediately locate the images that you can publish on the Web.

XML is the ubiquitous data interchange language—the lingua franca for interoperability.

There is much more to say about the value of XML but one thing should be clear. Although you may not need to work with XML directly today, learning more about it is a timeless investment. ■

information. It can describe data in easy ways such as by keywords, author, title, or type of file. In the analog world, a good metaphor for metadata would be the job jackets that used to be used to store all relevant data about a print job. When combined with tools that can search and index metadata, it is a powerful tool for organizing information. And the more complex—and huge—the Web becomes, the more necessary it is to have a way to find and organize data. As internal documents within a site that are PDFs or graphics or that reference internal databases can't be searched in a global manner, the metadata associated with the HTML pages becomes increasingly important. The most common way to associate metadata with your Web site is through metatags that are placed in the HEAD section of your pages. This provides data for the search engine robots to comb through, which, when catalogued, allows people to search for your content based on keywords.

figure **|4-8|**

If you view a Web page through Source view in your browser, you will see the metadata that has been associated with the site.

Unfortunately it's not a level playing field when it comes to search engines as a company can influence its placement in, say, Google by paying to appear under Sponsored Links. If you just want to be listed based on your metatags, a CC can submit a site to a search engine to be "crawled" or "spidered" and indexed according to the particular software and system used by a given search engine. This is where your metadata becomes quite important. You can review examples of metadata on the home page of any site by choosing to view the page as View>Pagesource.

| FAST FACT |

The Semantic Web, a concept and approach to the Web created by Tim Berners-Lee, James Hendler, and Ora Lassila, is defined as follows: The Semantic Web provides a common framework that allows data to be shared and reused across application, enterprise, and community boundaries."

More Than the Web

Moving beyond just keywords for the Web, metadata holds the promise of bringing true automation to the graphics industry. It can provide contextual information about a file that remains with the file and is editable and indexable. In fact the standards organization PRISM was formed to address establishing an XML-based metadata vocabulary to allow for interchange of data between different publishing streams.

Why would you want to have a common standard among different publishing streams? If your content was traveling from print to the Web to a PDA to a multimedia presentation, you would want to have a standardized way for important data about your content to be read and categorized. And true automation comes into play when the metadata, which is machine usable data, can be utilized by the production process itself. (We will explore this further in Chapter 5 as it relates to automation.) Software applications can be designed to read, edit, and take action based on a file's metadata.

One of the challenges to making data truly cross-media is that often metadata is embedded based on proprietary system and application needs. When it is customized that way, interoperability becomes almost impossible. It would involve different systems speaking different languages. When you want to exchange metadata about content between different systems, you

▶ PRISM: Publishing Requirements for Industry Standard Metadata

The Publishing Requirements for Industry Standard Metadata (PRISM) Specification defines an XML metadata vocabulary for syndicating, aggregating, post-processing, and multipurposing magazine, news, catalog, book, and mainstream journal content. PRISM provides a framework for the interchange and preservation of content and metadata, a collection of elements to describe that content, and a set of controlled vocabularies listing the values for those elements.

Metadata is an exceedingly broad category of information covering everything from an article's country of origin to the fonts used in its layout. The scope of the PRISM Specification was driven by the needs of publishers to receive, track, and deliver multipart content. The focus is on additional uses for the content, so metadata concerning the content's appearance is outside of PRISM's scope. The working group focused on metadata for:

- General-purpose description of resources as a whole

- Specification of a resource's relationships to other resources

- Definition of intellectual property rights and permissions

- Expressing inline metadata; that is, markup within the resource itself

need an agreed-upon approach for how that is going to be done. For the publishing industry at the production level, PRISM has been instrumental in moving the standardized approach forward.

What are some metadata fields that might be important? They could be as simple as the date of creation, name of content creator, and type of file or as complex as production instructions and digital rights management. Digital photographers are already creating metadata every time they shoot an image without even having to input any data. There is a standard file header called Exchangeable Image File (EXIF) that was developed by the Japan Electronic Industry Development Association (JEIDA) to promote interoperability between imaging devices.

Every time you take a picture, a header is automatically created that stores the factual data about the image you take and is broken down

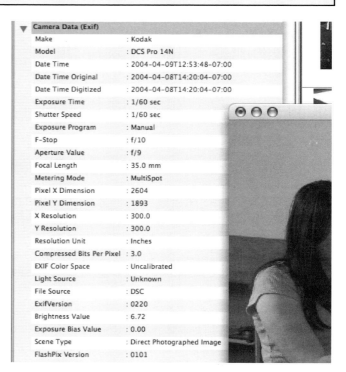

Camera Data (Exif)	
Make	: Kodak
Model	: DCS Pro 14N
Date Time	: 2004-04-09T12:53:48-07:00
Date Time Original	: 2004-04-08T14:20:04-07:00
Date Time Digitized	: 2004-04-08T14:20:04-07:00
Exposure Time	: 1/60 sec
Shutter Speed	: 1/60 sec
Exposure Program	: Manual
F-Stop	: f/10
Aperture Value	: f/9
Focal Length	: 35.0 mm
Metering Mode	: MultiSpot
Pixel X Dimension	: 2604
Pixel Y Dimension	: 1893
X Resolution	: 300.0
Y Resolution	: 300.0
Resolution Unit	: Inches
Compressed Bits Per Pixel	: 3.0
EXIF Color Space	: Uncalibrated
Light Source	: Unknown
File Source	: DSC
ExifVersion	: 0220
Brightness Value	: 6.72
Exposure Bias Value	: 0.00
Scene Type	: Direct Photographed Image
FlashPix Version	: 0101

figure |4-9|

The EXIF data is created in the camera and gives details on when and how the image was captured.

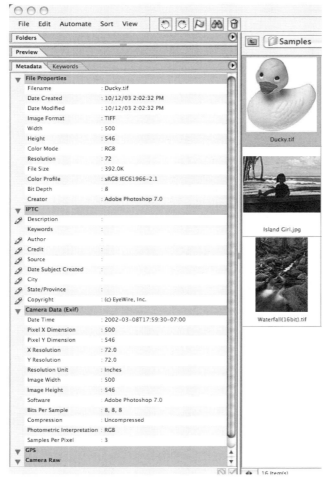

figure | 4-10 |

The metadata information as viewed in the Photoshop File Browser.

| FAST FACT |

The International Press Telecommunications Council (IPTC) was originally formed in 1965 to safeguard the telecommunications interests of the World's Press. Since the late 1970s it has focused on developing and publishing industry standards for the interchange of news data.
http://www.IPTC.org

into different categories. This data can be lost after image editing, which reaffirms the fact that the original image should always be saved in its raw state. The categories are Camera, Image, and Miscellaneous. Under Camera, data that is maintained includes the camera make and model, the date and time, and the software version being used. Under Image, information such as exposure time, F-stop, light source, focal length, and color space are saved.

When a file's metadata is accessed through an image editing program, certain fields are editable; this is where the real power of metadata can become apparent to a CC. To fully understand this, it helps to look at the metadata palette available in Photoshop.

Metadata Palette

In Photoshop CS, you can access any image's file info through the File Browser. This opens a palette that maintains metadata about the images. Several types of metadata automatically appear.

The first is File Properties. This covers characteristics of your file such as creation date, name, file type, and color space. This is not editable metadata as it is determined by the file creation. Next is an area called International Press Telecommunications Council (IPTC).

The IPTC fields are editable and allow for descriptive data, copyright info, and credit lines. The pencil icon to the left of the fields indicates that you can enter data. This same data will appear when you view a file under File> File Info under Description.

In the File Browser, you can also enter keywords of your choosing to be associated with the file.

The next area is the camera data (EXIF) discussed earlier. This is the data assigned by the camera including settings and date of image creation. There are also sections for Global Positioning System (GPS) data, camera

figure |4-11|

Information accessed through File Info in Photoshop.

raw for metadata from images in a camera raw format, and finally an edit history that keeps a log of changes to the image.

In addition, you can create metadata palette templates so certain information is always included in the palette when it is being applied to certain images.

Custom panels can also be added to display under file info. Digital Image Submission Criteria (DISC) is a national working group formed under

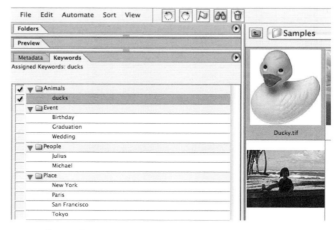

figure |4-12|

You can assign keywords in the File Browser.

IDEAlliance to "develop a set of specifications for use by Creative Professionals to include photographers and illustrators as a standard format prior to submission for publication." The specifications they are helping to develop have to do with key issues such as size, resolutions, compression, color space, and metadata. Regarding metadata, they have worked with Adobe to create a custom panel, or user interface that is accessible under the File Info window. This panel

| FAST FACT |

IDEAlliance is a nonprofit membership organization dedicated to advancing user-driven, cross-industry technology solutions for all publishing and content-driven enterprises. IDEAlliance develops standards, identifies best practices, and fosters business alliances to advance technology solutions. The membership is made up of those who create, produce, and deliver content, digital assets, and knowledge-based solutions, and the technology vendors who support and facilitate these activities.

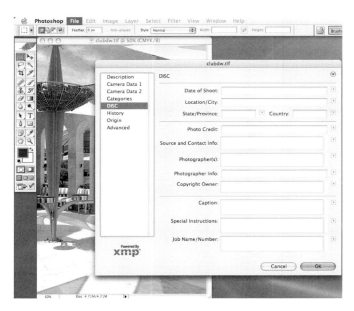

figure |4-13|

The DISC panel with editable fields.

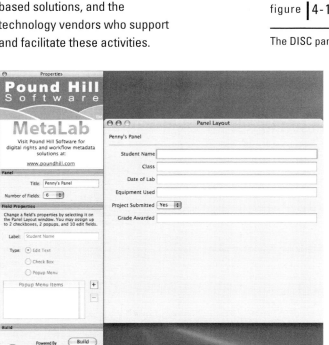

figure |4-14|

The Poundhill MetaLab XMP panel.

is downloadable at their Web site: www.idealliance.org/disc.

Why is this important? Within a few years it is expected that all image submissions to publications will be digital. There needs to be a standardized way for publications to track data about the images they have. In Chapter 1, Michael Brandson of People magazine said that more than 60,000 images can come through in a week. With correct metadata attached, such as photographer, caption info, and story title, these images could be cataloged far easier than if they all came with word files or long names.

You can even create your own custom panels if you need to. Third-party developers, such as Poundhill Software, provide software, some free of charge, to create your own custom panels that will show up in the File Info window in Adobe CS applications. It creates a basic panel that allows you to specify and implement custom metadata. You might have a unique set of details that need to accompany an image such as medical references or technical specifications.

Creating your own panel would allow for greater ease in cataloging and ultimately repurposing your image assets.

Database Applications benefit greatly from the inclusion of metadata also. When large volumes of information are databased, it is far easier to search and to create a precision sort if there are numerous bits of data associated with each file. Extensis Portfolio, which we reviewed earlier, offers a great way for a CC to catalog and review images. But the true power of organizing your data becomes apparent when you begin adding metadata to your images.

Portfolio allows two basic ways to work with metadata—extracting or embedding. You can first map existing metadata fields extracting—to—refered to as your catalog fields. That means that incoming files with metadata already embedded can have that data automatically map to Portfolio catalog fields. You can also change how the extracted metadata is mapped by changing the catalog field list in the properties dialog box.

The most common metadata fields are already listed—TIFF, IPTC, EXIF, XMP, and PixelLive—but you can edit the metadata list if you want to. You can create new metadata fields

figure |4-15|

A database in Extensis Portfolio.

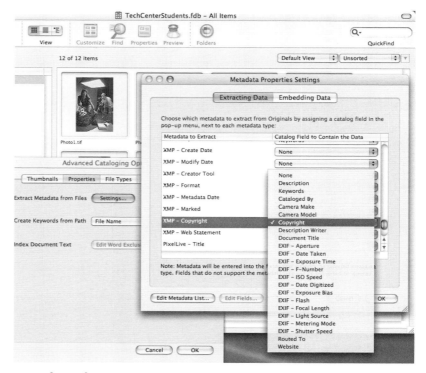

figure |4-16|

Assigning catalog fields.

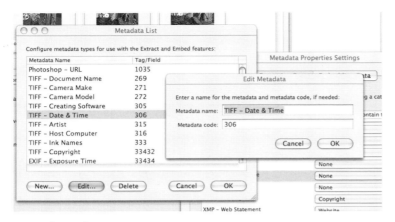

figure |4-17|

Editing the metadata list.

by selecting the Edit Metadata List button, but the metadata code must specifically match the field in the original file. This is helpful if you have images created by an imaging device that has unique and proprietary metadata code. You can create the corresponding field in Portfolio, but do not create arbitrary metadata fields in Portfolio because then logical mapping will not occur.

You can modify the existing metadata list, but be careful to not alter codes as they are set by standards committees. When your images are cataloged, the default action is to extract the existing metadata fields that your file has. If this has not been done, the metadata can be extracted through a menu choice.

In addition, you could choose to embed selected metadata information into your cataloged files. This allows you to tag a selection of files in such a way that they can easily be found through a specific sort. For example, you might want the location to be the same on twenty-five pictures taken at a concert or an event. Your camera will not enter the location information at the time of capture, but you can add that data into the file.

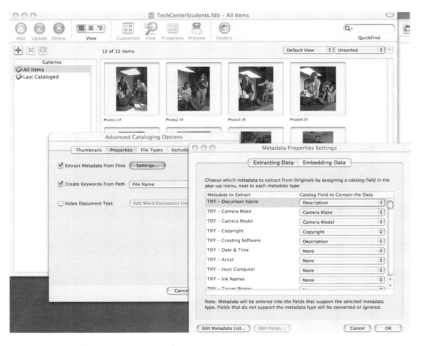

figure |4-18|

Extracting metadata.

Metadata at the System Level

The power of metadata for searching and organizing data is not only available for specific applications, it is also available at the operating system level. Apple's latest operating system

includes a core technology that involves a metadata search engine. This has the ability to provide a more global access to data with metadata already applied. It can't edit your data through the search engine, and it is not a true asset management system because there is no management capability, but it makes the data on your hard drive much easier to find. This technology is being referred to as "metadata aware." It functions by examining a file's metadata and content every time it is saved and placing that information in an indexed database. The database is then queried when a search is initiated.

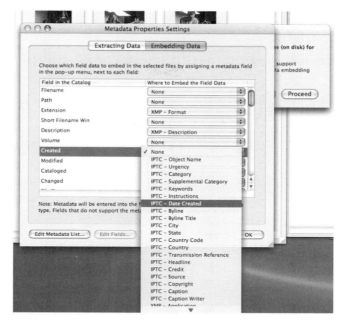

figure |4-19|

Mapping field data to embed in files.

XMP

You have probably noticed the letters XMP as you have explored the metadata panels in Adobe CS applications and Extensis Portfolio. XMP stands for eXtensible Metadata Platform, and it is considered by Adobe to add "machine-readable labels, or semantic content to application fields, databases and content repositories." In the past, much of metadata application has been tied to proprietary vendor-driven set-ups. Even if the information was readily available, the lack of a standard metadata labeling system made interoperability quite difficult, if not impossible. What XMP strives to do is to create an open framework by which any application can use the XMP approach to their metadata. This allows for wide adoption and the potential for a defacto standard, such as PostScript and PDF have evolved into.

XMP is built on two basic standards: Resource Description Framework (RDF) and XML. RDF is composed of a specific syntax and a schema that provides a formal specification on how to structure a given set of metadata. Think of it as the foundation that allows the interchange of metadata between varying systems. RDF takes the way something is described and translates it into a label. Any resource can be labeled. The label itself provides three types of information regarding the resource:

XMP

Gunar Penikis

Gunar Penikis is the product manager for the XMP data model for Adobe. What follows is an in-depth explanation of XMP, according to Adobe.

XMP provides a standard framework in which other metadata standards can be described and extended. This framework consists of three major parts: the language or syntax, the packet technology that describes how the information is stored in the file, and the specification that describes how standards are supported.

The XMP data model is based on a subset of the RDF data model, and it is described using XML.

RDF provides a very rich and flexible way to describe data; a subset set was chosen in order to provide simplicity. RDF can be described in many ways. XML was chosen because it is a standard and works with a variety of existing tools. Like RDF, XMP is extensible, meaning that anyone can create their own set of custom properties and have it be carried throughout the applications and systems that support XMP.

The packet technology provides a simple way to inject and update XMP (XML) data into a variety of file formats. Most file formats contain an area where custom data can be added. The packet is identified by a unique value and then followed by the XMP data, additional extra space, and a final marker.

The great advantage of the packet is that workflows can be built that can process metadata without needing to know how to decipher the file format. They simply scan for the unique value, process the XMP, and update in the extra space.

A subject—resource being labeled with the property

A predicate—attribute of the resource

An object—value of the attribute

Add to that XML (the label itself is expressed as a sequence of XML statements), and you have in XMP an approach that provides for integration among numerous applications and differing contexts.

XMP itself is not a solution, but a platform that provides consistent infrastructure from application to application. It not only can manage metadata at the document level, but at what is referred to as the sub-document level; for example, an article that also has a photo with credit info and a caption. With XMP, the labeling and sub-labeling can go on as deep as is necessary to have the needed metadata be part of the file.

As an infrastructure technology, XMP builds a communications foundation between applications and systems through the metadata in the files. The agreement on what is communicated across the Adobe CS products is embodied in the XMP specification. The specification describes what standards will be expressed with XMP, standards such as Dublin Core, EXIF, IPTC, GPS, and TIFF. In some cases, this standards information exists in a binary format within file headers. This information is converted and expressed with XMP within the CS applications. Once normalized, this data is now easily accessible within the packets and XML-based tools.

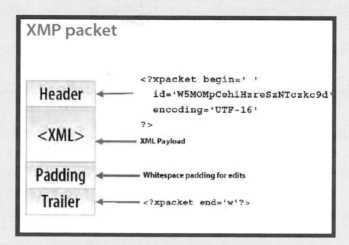

A visual description of what an XMP packet looks like.

The goal of XMP is to lower the barrier for metadata interchange by being built on standards and making the technology available via an open source license. A common open language across the publishing industry will help facilitate productivity and cost savings, and open the doors to new revenue opportunities.

I like to think of it in more human terms—imagine if your files could talk: they could tell you where they've been, where they are going, where they came from and what they're about. XMP sets the foundation for that dialogue!

Be aware that the Custom Poundhill Software Panel we examined earlier is, in truth, an XMP-compliant panel. What this means is that developers can make custom panels for any application that is XMP compliant, so theoretically, as more and more applications use this approach—even Microsoft Office has basic metadata support in its applications—it has the potential to be the standard way in which metadata will be handled.

Why should you, the CC, be concerned with issues such as XMP and metadata? The ability of XMP to assign multiple levels of descriptive data that can be understood by XMP-compliant applications, helps you enhance the value of your assets. In the old analog workflow, you gave your original content to someone who then continued to make your content usable in the production process. Now you are in a position to hand off your content, ready to go! Putting the right information in your file will help with production issues and databased management downstream.

SUMMARY

Most CCs probably wonder why they have to worry about what is to them "under the hood" issues. But the fact is that as the original has moved upstream and the correct output, routing, and management of data is more and more connected to the actual file, a CC has to understand some of the technology that is integral to their content being produced properly. XML, Metadata, and the new XMP all deal with ways to manage the exponentially growing number of files and content that need to be managed and sorted to avoid total chaos. Understanding data management approaches that rely on open source and nonproprietary solutions are key to adding value to your content and avoiding data overload. Understanding approaches such as XML for repurposing your content to numerous destinations is key to the marketability of your content. Content must be created in such a way that it does not need to be recreated from scratch every time another format is found for it.

in review

1. How does XML define how your content is to be handled?

2. Why are tags so important?

3. What is the most common way that XML is used and why?

4. What kind of content is best suited for XML?

5. What is metadata?

6. How is metadata used on the Web?

7. Why is metadata important to automation in the graphics industry?

8. Explain what PRISM is and how it affects the publishing industry.

9. What is EXIF metadata?

10. What is IPTC metadata?

11. What type of specifications is the DISC committee helping to create?

12. What can metadata do and not do when implemented at the system level?

13. What makes XMP different from other metadata approaches?

14. What is RDF and what does it do?

15. Why is a nonproprietary approach to metadata so important?

exercises

1. Create a new page with images and text in InDesign. Assign tags for XML fields. If you have access to real tag fields, great. Otherwise just create them. Note the hierarchy in the structure pane. Export the page to XML and open it in your browser.

2. Use the File Browser in Photoshop and open up a folder of images. Review the fields provided and enter keyword data, creating new keywords if needed.

3. Using File Info, fill in the description fields in four or five images with the same data. Then, using the search function, which looks like binoculars, in the File Browser, search for that metadata in your image folder. Tip—put images in one folder with a subfolder or two when needed. The more buried the images are, the longer the search function will take.

notes

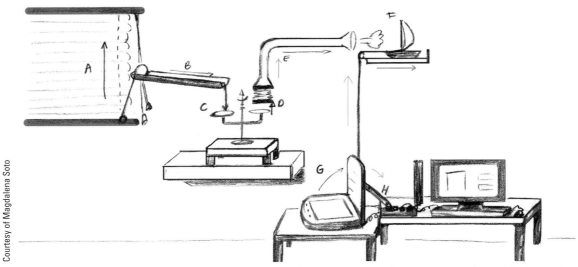

A whimsical automation depicting turning your computer on: A) Blinds go up and B) ball goes down chute C) tipping scales D) pressing bellows E) creating air blast which sends F) sailboat forward which G) raises scanner lid which H) presses start button on computer.

CHAPTER

Chapter Objectives

- **Understand what automation refers to in the creative workflow**
- **Define JDF**
- **Review application-based automation**
- **Explore AppleScript and its functionality**
- **Review scripting resources**

Introduction

In this chapter, we look at automation and scripting and how they can make the work of content creation faster, more efficient, and even fun. Not having to spend inordinate amounts of time doing repetitive formatting actions frees up a CC to be more creative and to work smarter. Detailed instructions on using the various software is not provided as excellent documentation exists within each mentioned application.

AUTOMATING CONTENT CREATION

It is only very recently that we have even been able to think in terms of automating parts of the design process. Historically, the act of designing a logo or a printed piece has been about creating a unique custom design or document. Once in production, it may be produced in quantity, but in the creation phase, activities associated with the designer's content creation have always been considered singular events.

Until very recently, perhaps only fifteen years ago, each CC would produce their work and hand it off to the next person in the production chain. Commercial photographers, as recently as six to eight years ago, would shoot in the studio or on location and hand in their transparencies to their clients. Producing from their photographs images usable in the printing process was not their concern. In the same fashion, a designer would design a layout or a logo, the page would be shot for film conversion, and the designer would not be part of the production process. Since workflow has gone digital, CCs are as integral to the production process for a printed piece as are the prepress and press personal. And, in keeping with that shift, the same techniques being employed in an efficient production process, whether to print or the Internet, can be used in some measure by CCs today.

What do we mean by automation? According to the Merriam-Webster's dictionary, automation refers to the "controlled operation of an apparatus, process, or system by mechanical or electronic devices that take the place of human organs of observation, effort, and decision." In the context of content and document creation, it refers to the automation and removal of human interaction from commonly performed iterative tasks. An iterative task is a sequence of events performed a specified number of times to achieve a desired result. For example, if you have fifty raster images that need to be converted from RGB to CMYK and stored in a specific folder with a unique identifier, do you really want to sit there and individually complete those tasks on each file? It would be a safe guess that most CCs would rather be creating something new than doing such a boring, repetitive task.

JDF

Before looking at specific ways to apply automation to your workflow, it is important to understand what is happening on a broader level in the graphics industry. Many industries have long since embraced automation and use it to streamline their production processes. They enjoy the resulting reduction of cycle time and the often-accompanying profit increase. The print industry, due to the nature of their product, has only recently begun the push towards true automation. There has been talk and theory, but now there is a file format standard that is being promoted by some of the biggest players in the field (including Adobe, Quark, Heidelberg, Kodak, and Fuji). This file format standard is called Job Definition Format (JDF) and is being developed by an organization called Cooperation for the Integration of Processes in Prepress, Press and Postpress (CIP4), which is an industry standards board with 302 industry participants (as of 2005), reflecting both users and vendors.

The definition of JDF by CIP4 states that:

> "JDF is a comprehensive XML-based file format/proposed industry standard for end-to-end job ticket specifications combined with a message description standard and message interchange protocol." According to CIP4, JDF:

- is designed to streamline information exchange between different applications and systems.

- is intended to enable the entire industry, including media, design, graphic arts, on demand and e-commerce companies to implement and work with individual work-flow solutions.

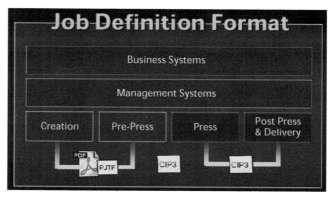

figure |5-1|

JDF covers information exchange from file creation to postpress and delivery.

- will allow integration of heterogeneous products from diverse vendors to seamless work-flow solutions.

So what does this actually mean? It means the development of a file format that has, as a part of it, a detailed description of the creative, prepress, press, postpress, and delivery processes required for the particular file. Imagine sending a child off to school with a note pinned to her jacket stating name, address, what bus to take home, any special foods or medicine needed, schedule of where to go during the day, who the parents are, and so forth. The note would have all pertinent information to allow the child to go to and return from school properly, with all special care instructions accounted for. The goal of JDF is to allow a file to travel through the whole production process with as much information as is needed to get the job accomplished as efficiently and automatically as possible. Eventually data built into the file from the CC at the beginning of the process will be required to ensure a smooth and efficient workflow through the entire process until final output, whether to Web or print.

Application-Based Automation

The desire to avoid repetitive tasks is not new. Template-driven design has been around for a while in everything from Microsoft Office Products to all page layout programs.

A template allows for the creation of a master document which has elements that will be used in all subsequent documents made for the same purpose. If you are creating a Web site that has the same logo, navigation bar, and flash animation on each page in the same place, there is no need to set up each page from scratch. You would create a master page from which you would create the rest. If you were printing a newsletter that always had certain elements such a banner, a mast-head, and a design element at the bottom of every page, you would create a master page in your application from which all individual pages would be created. What has changed in the last few

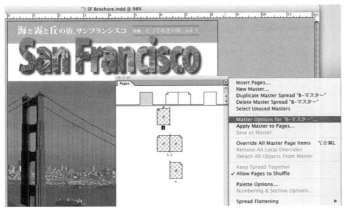

figure |5-2|

The master page menu in Adobe InDesign.

figure |5-3|

Actions window.

years is the inclusion, at the application level, of automation of application-based tasks. The ability to apply batch process to files that all have the same end state can greatly speed up anyone's workflow.

To help understand the value of automation we are going to explore its functionality in Adobe Photoshop.

One of the challenges when working with numerous images is applying the same action or effect to all of them. It can be quite tedious to individually open fifty images, convert them from RGB to CMYK, perhaps apply unsharp mask, and save each with a unique name. It's far more productive to automate tedious repetitive actions and gain time for doing truly creative jobs. Let's look at an action that might need to be done to images during catalog production. You have taken fifty shots with your digital camera and need to convert them all to CMYK, use Unsharp Mask, resize and save them. In Photoshop, the first step is to set up the actions you want performed. This is done through the Actions window.

Different software applications may use different terminology, but the basics are the same. To automate something, you must first record the action you want to perform. In Photoshop, the word *action* refers to "a series of commands that you play back on a single file or a batch of files." In the Actions Window, you can either create the Set that will contain numerous actions, or just create your action.

Most commands can be made actionable. Let's create the action that does the image conversion mentioned earlier.

The series of actions is recorded and saved as an action set called Conversion. This action can now be applied to one or many images.

To apply the action to a number of images, you would choose to batch-process them. Under File is a drop down called Automate. Choose Batch and you will be asked where the images are, what actions to apply to them, and where they need to end up.

figure |5-4|

Naming a new set.

figure |5-5|

A new action window.

You can be more sophisticated in your actions by recording complex paths, putting stops in your action that let you perform a task that cannot be recorded, and then resuming action. Modal controls allow you to pause an action while values are being specified for different situations; for example, choosing the percentage of contrast you want to apply, if you make sure the modal control dialogue box icon is closed on your Action window, then your executing action will not pause to wait for the OK. You can also load prerecorded actions from your Photoshop folder. In addition, at Adobe Studio, which is part of Adobe's Web site, you can browse through thousands of posted actions through Adobe Studio Exchange. (See Figure 5-9.)

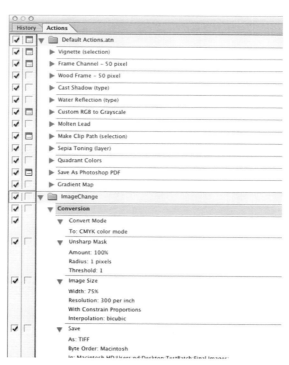

figure |5-6|

The steps taken in the action called Conversion.

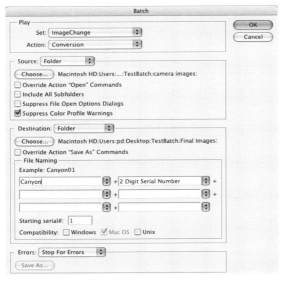

figure |5-7|

Batch window.

figure |5-8|

The modal control
dialogue box.

A common type of folder found in a production environment is a hot folder. A hot folder automatically moves a file to a specified location when a file is placed in it, or performs a specific action on that file. It could be moving a file into a printer queue, sending it to an FTP server, or initiating an action. In Photoshop, actions can be automated by droplets. A droplet is a small application that applies an action to the images that are dragged on top of it. The first step is to create the desired action, and then under File choose Automate and Create Droplet. It is a very handy way to perform common repetitive tasks quickly, especially if you are always referencing the same source and destination folders. Droplets can be used on both the PC and Mac platforms.

A variation on a hot folder is the watched folder. An application is directed to check a specific folder at different intervals. If there are new files in the folder, a specific action is then performed. Applications can have a built-in functionality to create such folders and actions, or the same can be done through scripting, which will be explored a little later in the chapter.

Other actions can be automated in Photoshop through the File menu. By choosing Automate, the following commands can be initiated to help automate your workflow:

- PDF slideshow from multiple documents

- Conditional Mode Change, which changes the color mode of an image

figure |5-9|

There are many postings by other CCs that you can browse for free—and you can post your own work.

- Contact Sheet II to create a series of thumbnail previews of selected images in a single sheet

- Crop and Straighten

- Fit Image without changing the image's aspect ratio

- Multi-Page PDF to PSD

- Picture Package to place multiple copies of a source image on a single page

- Web Photo Gallery, which generates a Web site from a set of images

- Photomerge to help create panoramas

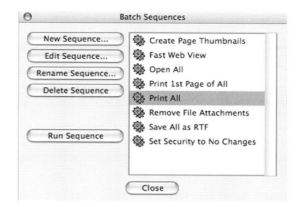

figure |5-10|

You can run batch sequences in Acrobat.

Automation is also featured in Adobe Acrobat. Through the Batch Sequences dialog box, you can pick from a list of existing sequences, edit any of them, or make your own.

Adobe Illustrator has numerous actions already loaded under the Actions Palette.

Many applications have their own version of automation. For example, CorelDRAW hosts a page called Automation Marketplace where different software providers offer automation solutions specific to CorelDRAW. Most content creation software today has some automation functionality. Many of them do it through scripting, which is the focus of the next section.

APPLESCRIPT

Scripting is the same as automation in the sense that it is a series of commands that tells an application or a system to perform a specified set of actions. A script can automate desktop tasks or interactions between applications—the only requirement being that the application is able to accept scriptable commands. In the previous section, we explored scripting in the form of built-in application automation. The choices either exist in a dialogue window, or you can create your own through the software. A knowledge of programming is not necessary, but to customize scripting requests or work at the system level, some understanding of scripting languages is required. Languages such as Visual Basic, Visual C++, or Java can be used; on an Apple computer, AppleScript can be used.

Not all CCs are interested in learning programming. The good news is that AppleScript not only comes on your Apple Computer with existing

| **FAST FACT** |

What is the difference between an action, as in Photoshop, and a script? An action is actually made up of a series of tasks that are recorded while being executed. This action can then be "played." All actions are played within the application. Actions cannot use conditional logic to make decisions based on current conditions like a script can. A single script can work between multiple applications or hosts. An action cannot.

figure |5-11|

Illustrator Action Palette in button mode.

scripts, but there are many places to get additional scripts, or you can write your own.

Apple Computer Company describes AppleScript as "an English-like language used to write script files that automate the actions of the computer and the applications that run on it." On the face of it, scripting appears anything but creative. However, if it relieves the CC of repetitive production tasks, it ultimately contributes to making more creative time available. Any time you can clearly identify specific steps to a routine task, you've probably found something that can be scripted.

Some uses of scripting can be running automated tasks when you are not using the computer, tasks such as backing up your hard drive in the middle of the night, or running an optimization program. The Speakable Items folder in OS X uses AppleScript to carry out the tasks you speak. The main goal of scripting is to take complex repetitive tasks and automate them, so you don't have to do them.

AppleScript relies on something called syntactical scripting. Syntax refers to the rules governing the structure of a language. It is the way in which linguistic elements, like words are put together to form phrases or clauses. Syntactical scripting deals with a logical description of things in a familiar way, rather than in a more complex programming manner. It strives to be as natural sounding as possible.

How It Works

Apple events are what tell the appropriate application what to do. Think of it as a command directed at an object (AppleScript is an object-oriented scripting language). When a script is run, or activated, it sends instructions in the form of statements to the AppleScript Extension, which then interprets the statements and sends the Apple events to the application needed. Apple events can have parameters, or modifiers, for the commands such as save a file as the event and modify it by having it save with sequential naming. Apple events can also return data results, if appropriate. For example you could run a script that takes a block of text from one application and sends it to a word processing application for spell checking. The results are then returned to the application actually running the script.

Statements are what make up scripts. They provide the instructions for what to do.

A statement that causes AppleScript to repeat an action or do something until a certain condition is met, is called a control statement. Words such as *tell, repeat, if,* and *try* would be used.

figure |5-12|

You can find AppleScript resources at the Apple Web site.

Statements are either simple statements or compound statements. A simple statement contains one statement, and a compound statement can include a number of statements. They are identified by 1) the number of statements included, and 2) the phrase "end tell" at the end of the string.

There are two approaches to creating an AppleScript script. You can write one or record one. Scripts are written in an application called Script Editor, which allows you to create, compile, test, and modify scripts.

To write a script, script text is entered into the top pane of the Script Editor. It then must be compiled. To compile a program means to take the original source and convert it to a form that can be understood and used by the computer. In the Script Editor, if errors in syntax are found, they are highlighted and the specific error messages are noted.

When compiled, script text will change appearance accordingly. Indents will be inserted to indicate hierarchical structure and formatting styles will be colored accordingly. To run the script, click the run button. To see what the specific script is and its results, click on the Event Log tab before running the script.

| **FAST FACT** |

If > statements for conditional execution (if this happens, then do that)

Repeat > statements for actions that need to be repeated

Handler > definitions for creating user-defined commands

Scripts can be saved as text files, script files, or self-running applications. In addition, applet bundles and script bundles are file formats that allow scripts to contain images, movies, templates, and other resources, making it an easy-to-distribute automation solution.

Contained in every scriptable application is a dictionary describing the scriptable commands and objects in the given application. It is accessed through the Script Editor via File > Open Dictionary. The example that follows, from Microsoft Word, shows that Microsoft is following what is referred to as the Standard Suite of "Common Terms for Most Applications."

In AppleScript, the term Suite refers to an Apple Construct that includes information for performing a particular type of scripting activity. For example, the Internet Suite vs. the Text Suite.

An easier method, if you are not interested in mastering the syntax of AppleScript, is to record the action that you want to script. Let's say you wanted to make a script to create a new folder called My Apple-Script on your desktop. You would launch AppleScript and click record

figure |5-13|

The Script Editor.

figure |5-14|

A syntax error will be indicated with a description of what is causing it.

Sample Script

Let's try out a sample AppleScript script. In OS X, if you follow the path Applications > AppleScript > Example Scripts > Internet Services you will find a script called Stock Quote. If you click on it, you will launch the Script Editor and get the text shown in the figure to the right.

Make sure you are connected to the Internet and click Run. The default ticker symbol will be AAPL for Apple, but put in any company's stock letters and see what happens!

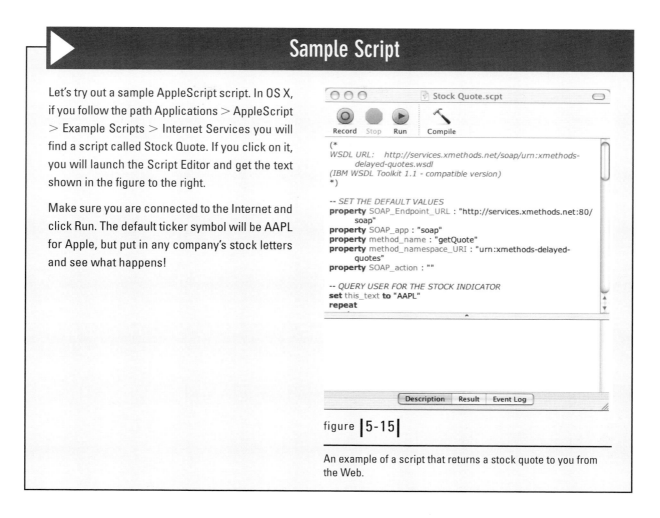

figure |5-15|

An example of a script that returns a stock quote to you from the Web.

in the Script Editor window. Then you would click on the desktop to make the Finder active and choose File > New Folder. Name your folder My AppleScript and move it to the middle of your screen. Click Stop in the Script Editor. Now, first toss the folder you made in the trash and then click Run in the Script Editor. You will see a folder created quickly on your desktop with the name you chose in the script. This is a very simple demonstration, but if you explore more applications that are

figure |5-16|

A Microsoft Dictionary of scriptable actions.

figure | 5-17 |

Scriptable actions for Microsoft PowerPoint.

scriptable, you will be able to make custom scripts that suit your workflow. Remember, though, that not all actions are recordable.

Scripting Resources

So, you don't want to learn to write AppleScript, and you have zero interest in programming. You can still include automation in your workflow by taking advantage of the incredible number of scripts that have already been written. There are numerous Web sites which provide scripts to automate many of the applications you use. At www.apple. com/applescript, there are scripts for QuickTime (see folder on Companion DVD), Microsoft PowerPoint, Safari, iTunes, OS X system level applications, and more.

By going to www.apple.com/applescript/toolbar, you can download some very useful scripts that you can drag right into your Finder Toolbar.

By going to MacScripter.net or ResExcellence. com, or by just doing an Internet search, you can pick up a wide variety of scripts.

Different applications offer their own scripting support. The following is a sample script from the Adobe InDesign Scripting Guide, which helps you get started using scripting in InDesign (see Companion DVD). Launch your Script Editor and enter the following text:

```
-Hello World
    tell application "InDesign CS"
        —Create new document and assign its
        —identity to the variable "myDocument"
        set myDocument to make document
        tell myDocument
            —Create a new text frame on the first page.
            tell page 1
                set myTextFrame to make text frame
                —change the size of the text frame
                set geometric bounds of my TextFrame to {"10p0",
                "10p0", "18p0", "18p0"}
```

> *—Enter text in the text frame.*
> **set** contents **of** myTextFrame **to** "Hello World!"
> **end tell**
> **end tell**
> **end tell**

Once you have entered it, click on compile to ensure its syntax is correct and save it as HelloWorld (format – script). Then click on run and InDesign will launch and create a page with a text box saying "Hello World!" Just think of the possibilities if you altered one or more of the actions in the script!

And, as mentioned earlier, at Adobe Studio Exchange, there are scripts available for downloading and many of them are free.

Other Scripting Possibilities

If you are creating content in Windows, you can use any version of Visual Basic (a free version called Visual Basic 5.0 Control Creation Edition is available at Microsoft), but you will need additional components. At this writing, you can download from Microsoft's Web site, Microsoft Windows Script 5.6 for Windows XP and 2000, which includes Visual Basic® Script Edition (VBScript.) Version 5.6, JScript® Version 5.6, Windows Script Components, Windows Script Host 5.6, and Windows Script Runtime Version 5.6.

JScript is another language that can be used in the Windows environment. JScript is an interpreted, object-based scripting language that is somewhat indirectly related to Java. InDesign also has a version of JavaScript that can be used on both platforms. It is application based and cannot be run from the operating system as JScript and OSA JavaScript's (Mac) can. Instead, it is run from the Adobe Scripts palette.

VERSIONING

The content you create is your asset. Maintaining control of what is the

figure | 5-18 |

There are scripts that can be placed as links right in the Finder Toolbar on OS X.

figure |5-19|

MacScripter on the Web.

figure |5-20|

Microsoft also has scripting resources: Visual Basic Scripting and Microsoft JScript.

figure | 1 |

A good designer can work in many different arenas. These examples by Vanderbyl Design in figures 1, 2, and 3 show approaches to signage, collateral, and interior space.

figure | 2 |

figure |3|

figure |4|

IT8.7-4 color chart.

figure | 5 |

Rich Media in the form of embedded video used in Graphic Exchange Magazine.

figure | 6 |

Cover of Graphic Exchange Summer 04—the debut of the Rich Media Edition.

figure | 7 |

XML Tagged frames seen in InDesign.

Courtesy of the Omni Group.

figure | 8 |

An example of stencils used in OmniGraffle.

figure | 9 |

An illustration done by Brian Drake used as a public service initiative by AIGA and Design for Democracy.

figure | 10 |

Brian Drake Design for the Chandler Center for the Arts.

figure | 11 |

Figures 11, 12, 13, 14, and 15 are examples of the different design solutions done by Brian Drake for the Savanna Line. Shown here is a PDF brochure for print and Web.

This is the tool

that makes the call

that hires your new employee

that starts to change

some lives forever

(starting with yours).

figure | 12 |

Direct 6" x 9" mailer.

Are you ready?

Are you ready for a change that will impact the way business is done, the way you think about people? The way you hire them? And why? Are you ready to make one call for your personal gain, your company's benefit and for the greater good?

Are you ready?

figure | 13 |

Direct 6" x 9" mailer.

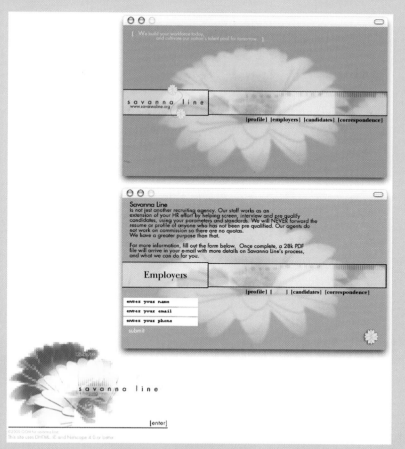

figure | 14 |

Web site.

figure | 15 |

Logo.

Figure 16 and 17 show Shannon Ecke's design solution for an information brochure (cover and inside) for the ASU Art Museum. *Courtesy Arizona State University.*

The ASU Art Museum has the mandate and freedom to explore new territory in art.

figure 17

Collections & Exhibitions

Antoine Predock's award-winning Nelson Fine Arts Center on the Arizona State University Tempe campus is home to the ASU Art Museum. With the adjacent Ceramics Research Center, the museum's 57,000 square feet house a 12,000-piece collection that includes works from the 14th century to the present. The permanent collection features paintings, sculpture, prints, drawings, ceramics and photography of an international array of artists.

The museum focuses on art n both contemporary and historical n that is provocative and relevant. Exhibitions range from large-scale projects of international importance to group and solo shows featuring emerging and recognized artists. ASU Art Museum shows the same creativity in exhibiting work that the artists demonstrate in creating it n recreating American masterpieces using smog-screening work by beginning filmmakers on the outdoor plaza; installing works in windows, alcoves and restrooms.

What you'll experience

Contemporary art. The collection includes traditional and experimental media, with outstanding examples by both established and young, innovative artists.

Latin American and Latino artists. Strong collections n including an extensive collection of contemporary Cuban art n reflect the museum's proximity to the U.S.-Mexican border and the significant impact of Latin American culture in the region, as well as the museum's commitment to art that addresses social issues.

Artists from the Southwest. The museum's dedication to supporting regional artists is reflected in exhibitions that feature artists who are on the cusp of broad recognition in the art world.

Prints. More than 4,000 prints and a specialized print study room are testaments to the depth of this area of the museum's collection, which spans the late medieval to the present day.

Historic American paintings. The ASU Art Museum collection originated with the donation of 149 works of American art spanning the period from the Colonial era to the early 20th century.

Crafts, particularly ceramics. As with prints, the museum boasts exceptional depth in its world class ceramics collection that provides resources for serious scholarly research.

Ceramics Research Center

The combination of gallery space and open storage at the Ceramics Research Center enables visitors to enjoy more than half of the museum's collection of 3,500 ceramic pieces at one time. An online database of ceramics information is being developed, which will provide extensive ceramics research capabilities for scholars, teachers, artists and collectors worldwide.

Educational Programs

The ASU Art Museum regularly presents lectures and gallery talks by artists and others in conjunction with its exhibitions. Among the major events each year are the Herberger College's annual Elaine Horwitch Lecture on Contemporary Art Criticism and the Forkosh Hirshman Lecture on Art and Society. Curator- and docent-led tours address diverse audiences, including community groups. ASU students and 6,000 school children annually. Workshops and the museum's annual Family Fun Day round out the museum's diverse educational schedule.

Volunteer Opportunites

Volunteering at the museum is a wonderful way for community members to merge their talents and thirst to learn with the desire to enjoy art. The museum seeks committed volunteers in the dynamic areas of touring docents, membership support, special museum events, retail store sales and in assisting with other specialized museum programs. Contact the museum at 480-965-2787 for additional information.

Getting to the Museum

Hours: Tuesday 10 a.m. - 9 p.m.; (May through August until 5 p.m.) Wednesday - Saturday 10 a.m. - 5 p.m.; Closed Sunday and Monday.

The ASU Art Museum is located in downtown Tempe, on the southeast corner of Mill Avenue and 10th Street. The Ceramics Research Center is located on the northeast corner of the intersection. For directions, call the museum at 480-965-2787.

Free Parking is available in ASU Art Museum-marked spaces in front of the Ceramics Research Center. Visitors using museum spaces must sign in at the front desk in the lobby of the ASU Art Museum or the Ceramics Research Center. ASU parking is also free on weekends and after 7 p.m. on weeknights.

On the web at http://asuartmuseum.asu.edu

figure | 18 |

A package design Shannon did for
Microsoft Windows ME while working at Landor.
Courtesy Landor.

figure | 19 |

Kathleen Evanoff used JavaScript and PHP to create a site for FreshStock, a boutique stock photo company.

figure | 20 |

Kathleen's own site, which showcases some of her best work.

figure | 21 |

Morgan and Company designed a clever package for Vino's Wine Charms, which structured the design itself so the charms would hang properly in the display.

figure | 22 |

Morgan and Company sought to capture the regional appeal of Grand Canyon Cookies through a brightly illustrated box.

figure 23

PrimeView provides its quality Web talents to deserving nonprofits such as Kartchner Caverns in Arizona.

figure | 24 |

PrimeView's Web site for the Z Club of Hawaii.

figure | 25 |

Moses Anshell's humorous advertisement for Alaska Raft
Adventures.

figure | 26 |

One of a series of advertisements created by Moses Anshell for Hotel
Casa Del Mar.

figure |27|

Many of LAgraphico's clients are in the entertainment industry. This
Spiderman 2 character display was done for Activision.

> ## AppleScript at the Smithsonian
>
> A case history posted at www.apple.com details how John Jones, the chief image technologist at the Smithsonian Office of Imaging and Photographic Services, has automated one of the more tedious operations that needs to be done. Scripts are run every night that grab images from a FileMaker Pro database and then generate JPEG copies for print and Web and for backup archive CDs. Another script runs after the image conversions that looks at the files and puts relevant image information (date, file size, image dimensions) back into the database. By morning all images added the night before are available and correctly labeled.

most recent version of an asset is important for a solo designer, but it is critical when working in a team environment. It is not uncommon for the wrong version of a job to move forward in production because the latest revision was not clearly marked. If someone on the creative team makes a change and doesn't update the links properly, the wrong job can wind up on press, on CD, or uploaded to the Internet. Versioning is the process by which information is stored and managed in such a way that modifications are tracked and the latest, most accurate version of a document is clearly indicated. It is about managing a document through its entire life cycle. When multiple participants are involved in making a creative piece, a system must be set up to keep track of the job. One approach to this could be to develop a naming system where a particular suffix or prefix is attached to the file name to show the current status. Time stamping might also be used, but when files move between work stations and servers, this can become irrelevant. Other problems can occur if you want to return to an earlier version of a job only to discover that along the way it has been overwritten and saved in an updated form. Or you may link to images that are not the latest ones, because there is no clear way to tell that. As difficult as it is to keep track of versions of a creative piece as an individual CC (how many have meticulously organized desktops?), it can become very unwieldy in a group.

The Adobe Creative Suite has developed an interesting approach using a feature they call Version Cue. It is in essence a workspace shared by all the applications, except Acrobat at this writing, that allows CCs who may have no formal experience with asset management tools, to efficiently and accurately keep track of versions of their document throughout the creative process. It allows for individual or workgroup tracking and let's descriptive comments be connected to each version so each subsequent creative can know what needs to be addressed (or not) in any given version. Looking at Version Cue can help you understand the issues that are addressed in any versioning solution.

The first step is to enable Version Cue at the system level and then to enable it within each application that will need to access it.

Michael Margolies

Credit: Dustin Commer, LPG Design

Michael Margolies.

Michael Margolies is a consultant, commercial photographer, and digital asset management expert. Formerly the Advertising Director of Technology and Prepress for Macy's West department stores, his team was responsible for retail advertising pages that were being versioned out to 80 to 100 regional newspapers a day. In addition, they did more than eighty original catalog spreads on any given day for Macy's direct mail catalogs. Add to that the job of creating these ads to run in seven different languages, and you have an enormously complex task. Michael found that the combination of AppleScript and a FileMaker Pro database allowed Macy's to have a highly efficient production system that connected everyone from merchandisers to creatives to the prepress team.

He describes himself as "a nice guy who works hard and when not saving the world from bad workflow problems I'm behind a desk or a camera." When asked about the value of scripting he replied as follows:

When considering what deep and profound thing I could tell you about automation and scripting the only real thought that comes to mind is don't make a big deal out of it! Often people who are new to workflow automation who learn about the complex and elaborate systems I have produced become afraid of the complexity. I hear comments like "I'll never be able to build what you are doing. I only

have myself to do it," or "I've never written a script before. Where do I start?" However, you don't build hundreds of interdependent scripts in one afternoon. You start by identifying a few repetitive tasks you'd like to get rid of and pick one to work on.

Even at Macy's this is how we began. We looked at the way we produced our work, followed and mapped out the workflow, and created diagrams that illustrated the flow of work through the department. We interviewed every staff member about what they do and how they do it. We watched the staff work and asked them what functions of their jobs were boring, repetitive, or time consuming. Over time, we developed a hit list of items to automate and then placed them in order of importance based on the value of the task and the person doing it, and the savings or productivity enhancement gain if the task was done automatically, or with little user intervention. Often just

going through this effort makes you take a hard look at what you do and how you do it. You begin to identify work that creates bottlenecks; sometimes tasks are being done for tradition's sake with no real value to the end product.

Later you examine how tasks could interact with each other; this is where scripting and the databases can get complex. Connecting one task to another and asking a database to manage functions is not something to jump into until you are comfortable with scripting and have a strong understanding of how your workflow really works.

Never assume you're done. There is always another task to be refined, another step to be replaced with a script or database function. Each layer builds on the one before. Attempting too much at once is both stressful to you and, perhaps more important, your staff. Keep things simple. If your scripts run like applications, keep the interface simple too. It may seem fun to design an elaborate or fancy interface (GUI) but that just gets in the way. An overly large or complex interface very soon becomes annoying to your production staff.

There are many choices in scripting languages, however 90% of production departments use Apple Macintosh so the first scripting language to learn is AppleScript. Anyone can write simple scripts, by doing just a few things.

1. Read the directions! The basic tutorials and directions that come with AppleScript will

A sample of Macy's catalog page.

Macy's catalog page.

give you the foundation and walk you through most of what you need to know. Many people will start with a "watch me" style of script where you tell AppleScript to record what you do as you perform the steps of the procedure you wish to automate. Stop the recording and try it. If it does not do exactly what you want, experiment a bit until you get it right.

(continued)

(continued)

2. Get scripts from others. There are many free scripts available online. Spend some time searching through Applescripting sites. Adobe's www.adobe.com/studio/main.html site and others have wonderful scripts, and actions and plug-ins that others have written and made available for free. Often they are written in an open format so you can modify them to your needs.

3. Buy a book. There are many well-written books available that will include scripts. These books walk you through all you need to know to develop your own automation. At Macy's West, for example, the main scripting guru who now creates amazing and elaborate systems was a graphic artist who wanted to learn scripting. He started at the bottom with a book and over time became a master at scripting and workflow automation. Not overnight but over time.

4. Take a class. There are many classes and seminars available that teach scripting languages. Many classes are free such as the ones available at the Apple stores or offered along with a technology expo or at trade shows. When I first began scripting and automation I took a one-day class and bought a used $5.00 book at a garage sale. That information carried me for the next 5 years!

5. Don't forget databases. Databases like FileMaker, Access, MySql are key tools to workflow automation. In fact, after the basic stand-alone scripts are done, the databases do the heavy lifting in most automated systems. Most databases come with examples you can modify to fit your needs, and never underestimate the value of the thousands of working databases available free on the Internet. You need only do the searching to find them. Google is one of my most valued tools. ■

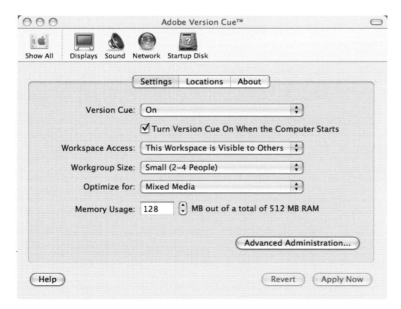

figure |5-21|

Version Cue system level set-up.

When setting up Version Cue, you need to make management choices about your workspace and this is done though Workspace Administration.

Users need to be added with the appropriate privileges (read only, read/write, administrator), projects created, preferences, etc. In particular, you can set up lock protection which restricts file editing to one person at a time.

This can prevent multiple people from accessing a file concurrently across the network. For the most part, once it is set up you do not need to visit the Workspace Administra-

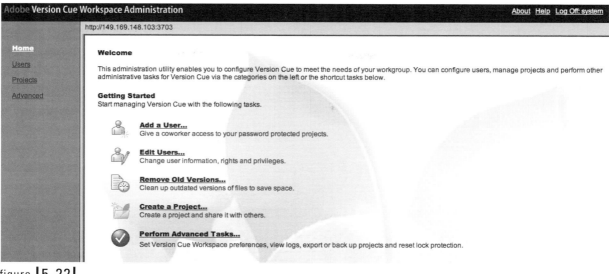

figure |5-22|

Version Cue Workspace Administration.

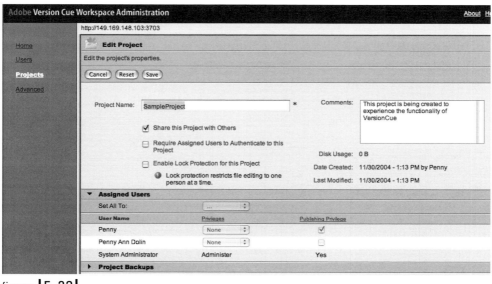

figure |5-23|

You can control properties of a project, such as whether users need to authenticate or not.

tion site unless you are cleaning up old versions or want to view logs and reports. You can also create new projects from within the CS application the first time you save your document by clicking on project tools. From that point on, every time you choose Save As, you will get a

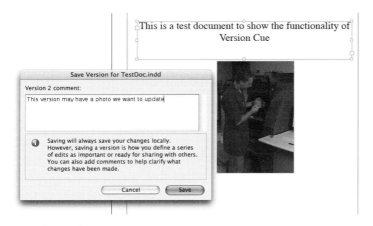

figure |5-24|

Version Cue also lets you keep track of what version you're on and if there is any updating to be done.

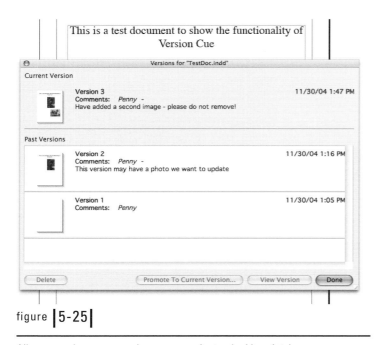

figure |5-25|

All your versions are saved so none can be trashed by mistake.

window with a space for version comments. When you are ready to close and do a final save, it will prompt you again if you want to save your document as a new version.

The value of not losing earlier documents and being able to view comments with each rev is apparent as one works in creative teams. No one person can bring the project to a halt by making an irrevocable mistake.

What Version Cue attempts to do is to provide a user-friendly and inexpensive DAM solution to the desktop of the CC. If more sophisticated controls are needed, there are numerous software companies promoting their DAM solutions. These include Artesia Technologies, MediaBin, North Plains Systems, and many more. There is even a DAM Users group at http:// www.damusers.com.

SUMMARY

It may seem in some ways that automation and the concept of advanced scripting of events is the antithesis of what a CC wants to be involved with. The reality, though, is that unless some of these concepts are taken to heart, a CC's workflow has the potential to get bogged down with the less than creative details of production in an inefficient and boring manner. The thought of automating certain actions and not having to do repetitive activities like changing color space and file type for hundreds of images can be liberating and can allow for more creative time. Discovering a way to create an interesting texture or change the characteristics of an image without repeating the 30 to 40 steps each outcome requires every time you want to apply the effect, makes the idea of actions sound very appealing. Scripting is something that can take rou-

tine OS level chores and make them doable by one click of the mouse. Scripting can automate processes between applications and allow a CC to build a structure for automating an entire workflow. Versioning allows you to maintain control of the most current version of an asset and never inadvertently use an earlier document in place of the finished one. It can also encourage more harmonious creative teamwork, as the ability to apply comments that travel with the file can keep everyone on the same page!

in review

1. What fundamental change has occurred for CCs since workflow has gone digital?

2. Define automation and give an example.

3. What is JDF and why is it important?

4. What kind of activities does application-based automation make easier?

5. What is a hot folder and is it similar to a droplet?

6. What is AppleScript?

7. What is syntactical scripting?

8. What is the difference between a control statement, a simple statement, and a compound statement?

9. What is the Script Editor?

10. What are the two ways to create a script?

11. What scripting software would you use on Windows?

12. What is versioning?

13. How does Version Cue prevent multiple users from accessing the same file concurrently?

exercises

1. Actions: Launch Adobe Photoshop and open a 5'' × 5'' document with a white background. Pick a font (18 pt) and (enter) your name. Do a series of effects to it until you are pleased with your result, writing down each step that you do. Then, using the Action window, create a new set titled "NameFont". Create a new action within the Set titled with your first name and record the steps, from the beginning, that you took to create your name. Save it and play it back.

2. Scripting: Launch AppleScript. Pick an OS-based activity such as creating a folder or arranging your desktop. Practice the steps first and when you are clear what you want to do, select record and record your script. Make note of what actions cannot be recorded. See if you have any syntax problems. Save it and play it back.

notes

CHAPTER

VI

Chapter Objectives

- Understand what a project entails
- Learn ways to handle project logistics
- Explore mapping and tracking project schedules
- Develop an understanding of Gantt charts
- Develop a project from beginning to end

Introduction

Creating wonderful content and learning the best applications in a truly digital workflow are top goals. But without management of the work process and a clear understanding of what your job requires, jobs can quickly become unwieldy and profit margins can shrink to nothing. To be a CC for a living, certain basic business approaches need to employed. But even business issues can be creative with the right tools.

MAPPING AND TRACKING

WHAT IS PROJECT MANAGEMENT?

What is a project? It refers to an undertaking that has a definable beginning and end. It is finite in nature and obvious when completed. The management part has to do with efficiently and intelligently managing all the parts of the project to ensure successful completion. The main parts of any project consist of the people, the resources, the time available, and the budget. Even if you are a solo CC, you will need tools to manage the workflow of your project if you are to finish on time and on budget. Although not perceived as the creative part of your job, good project management is what relieves you of the chaos and stress of tight deadlines. It is a fallacy that the best work happens under pressure. There may be exceptions, but creativity often flows better when you are not under the gun.

| FAST FACT |

Many think that the development of the practices and techniques of project management stem from the U.S. space program in the early 1960s. Programs such as the Apollo space program; Star Wars, the strategic defense initiative; and the subsequent space shuttle flights were enormously complex undertakings that required specially developed management skills and approaches.

The nature of projects is that they may need resources for a limited amount of time and that each project may require different resources. For example, you may have to design a Web site with extensive shopping cart capabilities, a skill you may not have at the expert level. For that project you would factor in a consultant or temporary team partner to facilitate the project. But you may not need those services at all for your next four projects. You might need to develop a brochure and an interactive DVD to accompany it, but don't have the specific skills needed for DVD authoring. You may provide all the content, but outsource the actual building of the DVD. One of the challenges of working with outside expertise to complete your project is the availability of resources. Having an idea ahead of time what services and resources you might need for any given project allows you to successfully plan and complete the project on time. If you don't need to pay extra for rush services, you also have a better chance of finishing within budget. Every project has a specific life cycle.

Understanding your methods of working and the reality of how projects often transpire, helps you plan better and not become anxious if things are not happening at the speed you like. The beginning of any creative project involves a little gestation time for the project concept to grow and take shape. Then the work begins, often at a faster pace and usually in a creative and fun manner. Then comes the work of pulling it all together for completion, and time can seem to slow down again! The four steps in a project life cycle can be described as:

- Concept and creation
- Logistics
- Implementation
- Completion and delivery

As a CC, the creative part of the process—coming up with the initial concept—is probably a familiar and comfortable activity. If a CC is already used to working with the right side of their brain, used to encouraging their intuition and imagination to come up with creative solutions to design projects, this first step will not be at all daunting. But note, to those in the more "left brain" disciplines, this can sometimes be a moment of discomfort or anxiety. The first real challenge for a CC often comes in the logistics step—what to do when, how not to duplicate effort, and what additional resources you may

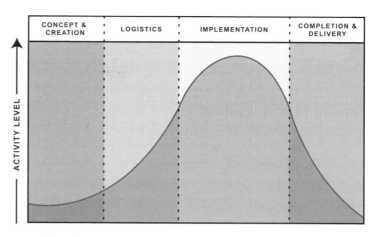

figure **|6-1|**

Project life cycle.

need to line up. We will look at various planning and mapping tools to help with this part of the process in the next section. After logistics have been determined, implementation needs to be handled. Basically—doing the work! Time and quality issues need to be considered at this point, as well as completion and delivery, which involves everything from how one provides the work to the customer to billing and follow-up for quality control issues.

Logistics

A good way to approach logistical planning for a creative project is to first define what the eventual finished product will be and then work backwards to see what steps you'll need to accomplish your goal. For example, if your client wants an eight-page brochure and a Web site that will be somewhat static (often referred to as a storefront site), you would probably ask if the same images would be used for both end results. If so, you know you need to acquire images at least as large as 300 DPI and that you will have a CMYK and an RGB workflow. You might also ask questions about whether text on the Web site will be straight text or be put into a graphic format, that is, uploaded as an image file.

You also want to ascertain if there are different completion dates anticipated. Perhaps the client wants the Web site right away but can wait for the print materials. Is any part of the job a rush? Will you need to hire any resources? Or, if you already work in a design firm, what team members will you need from the company? Will you still need to outsource anything?

| FAST FACT |

In the terminology of project management, WBS refers to your Work Breakdown Structure. It is useful to list all the tasks that need to be done in hierarchical format. This could also resemble a tree structure, much like an org chart. The primary purpose of the WBS is to make sure no tasks have been left unaccounted for. From the WBS, one can then map out what needs to be done chronologically.

Project Manager

There are many tools to help organize a project. We will look at a few to gain an understanding of what needs to be addressed in scheduling and mapping projects.

Mapping

Mapping is a method for using visual symbols to represent the process of a job or task. It helps you select the best path to complete a project. A variety of alternate paths can then be looked at and the most efficient map can be chosen. Think of a map that takes you from New York to California. There are a myriad of ways you could drive that route depending on your goal. Your purpose and eventual goal would determine the map you would use when you embark on your drive.

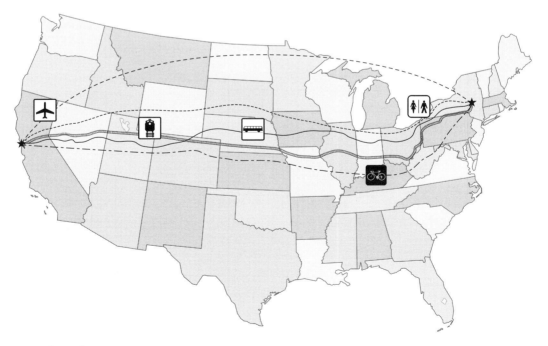

figure |6-2|

This map illustrates the variety of paths one can take to a destination.

The iconology of mapping can differ; the shapes of the icons can be round or square or hexagonal. What matters is consistency and understanding the meaning of each of the icons. Before we delve into the different icons or symbols typically used in mapping, it's important to understand the logic involved in understanding a project.

The overall project can be considered the whole process that needs to occur to be successful. That requires using process logic and is the bigger picture or view of the overall job. Lets say that you have been assigned a research paper for your class. You might say the overall process looks like choosing a topic, collecting the research data, writing the paper, and delivering it to the professor. Each of the steps in this overall process would be considered a separate task. Each task in turn has its own procedure that needs to be done. Take collecting the data. The procedure of that specific task might involve searching the Internet and printing out the relevant research information. The procedure itself would represent the specific steps taken to fulfill that specific task. A flowchart can be a very important tool to map out the processes and tasks needed. To create a useful flowchart that would represent the process and task logic used, clear mapping symbols are needed to represent the workflow that will be followed.

Flowchart symbols themselves have not been codified, nor are some symbols correct and others wrong. What is important is consistency and understandability. Figure 6-3 includes some of the most common symbols used in flowcharting software and books.

A common approach to basic flowcharting might result in a flowchart like that shown in Figure 6-4.

Let's create a process flowchart for our research paper using flowchart symbols. (See Figure 6-5.)

In the process-logic flowchart, the primary icon used is the one for illustrating a procedure. There is a start and an end with finite steps in between. If we take one of those steps and delineate the tasks, it might look like Figure 6-6.

The important steps to remember when creating an accurate and useful flowchart are:

- Look at the big picture—know your end goal(s)
- Write out what tasks you think need to be done
- Place the steps in the correct sequence
- Draw the flowchart

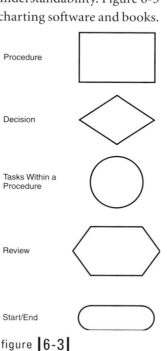

Procedure

Decision

Tasks Within a Procedure

Review

Start/End

figure |6-3|

Common flowchart symbols.

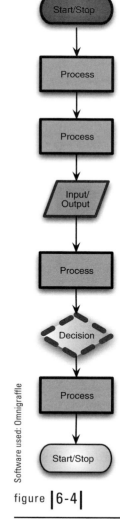

Software used: Omnigraffle

figure |6-4|

A basic flowchart (see color insert also).

Process Logic for Doing a Research Paper

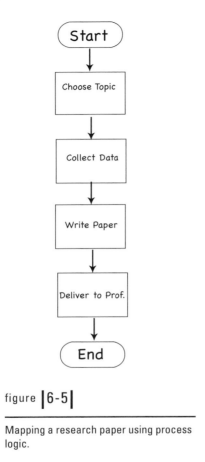

figure |6-5|

figure |6-5|

Mapping a research paper using process logic.

Task Logic for Gathering Data for the Research Paper

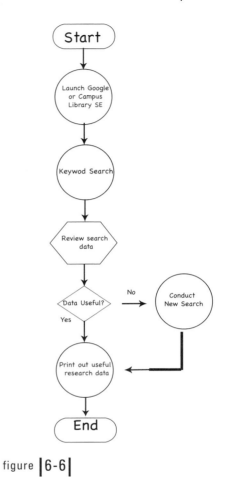

figure |6-6|

An example of a task-logic flowchart.

Of great importance to a CC who may be asked to create more than one final output for their content is to identify all the major activities and subprocesses that will be needed. Remember, it is important to visualize the end product first and then trace the steps back to the beginning to see where you should start and what activities do not need to be duplicated.

Software for Flowcharts

There are many, many different companies selling flowchart software. Some have very cool graphic icons and the ability to build very complex flowcharts. Some have templates to speed the process. Many of them also allow free 10 to 30-day demos of the full version. If you have Microsoft Office, you already have some very useful flowchart icons available. Adobe Illustrator CS has

libraries that you can load from the Symbols palette.

And, of course, you can create your own symbols that can reflect your unique creative style.

There are advantages to having software that facilitates the creation of flowcharts. Once mastered, they can be a lot faster to set-up and potentially more impressive to share with customers and to include in presentations. An example would be Omni Group's OmniGraffle software, which allows for drag and drop functionality in creating items such as flowcharts, org charts, network diagrams, and project processes. Items such as stencils are available, which are basically a library of shapes that can be used for specific diagramming purposes (see Color Insert 8). A wide range of graphical attributes can be applied, like shapes, color, and sizing, and it is designed with AppleScript support to allow for scripting. In general, software designed for diagramming and charting can make your workflow more efficient and streamlined when you don't have to create everything from scratch.

Credit: Adobe, Inc.

figure |6-7|

The symbol libraries in Adobe Illustrator CS.

figure |6-8|

You can create your own symbols in Illustrator.

Scheduling and Estimating

A well mapped out project allows you to correctly schedule and estimate costs for your project. In fact, your work map, scheduling, and determining the costs of your project are all part

| FAST FACT |

Henry Laurence Gantt was a mechanical engineer, management consultant, and industry advisor. He developed the Gantt chart as a visual tool that would facilitate seeing what was scheduled in a project and what actual progress was occurring. It is particularly useful for managing overlapping tasks. He was an early leader in the scientific management movement and recognized the importance of motivation through rewards as the key to the best in human productivity.

of the same process. Your schedule is your mapped plan with concrete dates. An accurate estimate can be put together because you have figured out the logistics, which might include bringing in additional talent, location fees, rush components, etc. Scheduling, if done realistically and clearly can accurately provide you with a time line within which you can be confident of completion.

Gantt Chart

One of the most widely used project planning tools is the Gantt chart. Developed in 1917, it is a bar chart that is constructed with a vertical axis representing the tasks that comprise the project against a horizontal axis that indicates the total time span of the project.

A Gantt chart tracks variants such as:

- tasks required by the project, sometimes referred to as the activities

- resources required by the project and who is responsible for obtaining/maintaining those resources

- milestones, which are important and noteworthy events on the way to completion of the project

- status of the project, or total percentage of time allocated as compared to what has actually been done

- dependencies, which refers to the concept that some activities are dependent on other activities occurring

In a typical Gantt chart, each activity takes up one row.

As each task is entered, it can be seen in a chronological fashion across the horizontal axis of the Gantt chart.

When a CC puts a well-constructed Gantt chart up on the

figure |6-9|

A basic Gantt Chart.

Credit: Courtesy of Kidasa Software (Milestone Simplicity)

wall, all deadlines can be seen and progress can be measured as to where you actually are based on what you projected. It is a great visual tool that is fairly easy to understand. It can show the

| 1 | Prototype Design | 10d 1.66h | | 12/27/04 | 1/10/05 | 20.00% | $1,500.000 | WebDesigner |
| 2 | Photography | 3d 0.00h | 1 | 1/10/05 | 1/13/05 | 10.00% | $2,400.000 | Photographer |

figure |6-10|

Each activity occupies one row.

entire project, or you could use it to show partial progress at any point. Gantt charts do change, but if you are working on a creative team, everyone must be aware of updates.

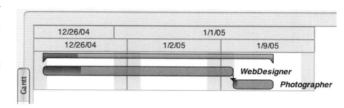

Tickler Files

figure |6-11|

Another easy way to track what needs to be done is, of course, to

Tasks are seen across the horizontal axis on a Gantt chart.

use a calendar. But there is only so much information that can be entered on the face of it. And there may be actions that need to be taken on specific days that require specific paperwork, or

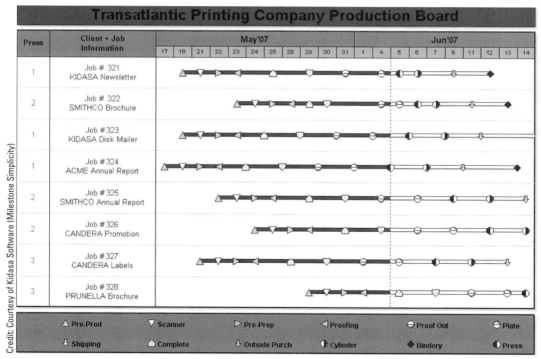

figure |6-12|

A sample Gantt chart done for a printing company.

figure |6-13|

A tickler file is a good low-tech way to keep track of what needs to be done.

items that need to be mailed or acted upon in some fashion. You could keep all physical pieces of material relating to a project in a master file in your desk, or you could manage it on a day-to-day basis. A tickler file is nothing more than thirty or thirty-one (depending on the month) hanging folders numbered consecutively. Whatever needs to be done on any of the days can be put in the file, and your calendar will remind you visually, if on paper, or audibly, if you use a software calendar. It's pretty low-tech but quite effective.

A properly mapped and scheduled project lets you see the time that will be needed, what resources need to contacted and when, and in turn, you can predict a cost for your project. Often CCs lose track of the business side of their projects. Estimating is quite important. Your estimate becomes your quote to the customer and needs to be followed in good faith. The only way to develop an accurate quote is to estimate the costs based on a realistic project map and schedule. For example, you might agree to do a Web site and then discover that the e-commerce capabilities they want fall out of your area of expertise, but that you can handle the rest. Knowing what it will cost to outsource that specific feature lets you know what to charge in your quote. It is also important to remember that you need to charge more than your cost or there won't be any profit when you're done. An overview of estimating and job costing is outside the scope of this book, but nonetheless one of the most important things to understand if you wish to make a living as a CC.

MANAGING A PROJECT

We've discussed the various tools and processes that help organize a work project. In this section, we are going to go through a mock project and see how it all ties together. We will look at a company called Silver Sight Studio that creates fine silver jewelry and needs a Web site to extend the market for their designs.

Silver Sight Studio has submitted the following request for quote (RFQ):

A Web site that will showcase their silver work and interest people in taking classes.

Features requested are a catalog of jewelry with photos, shopping cart capability, calendar with classes listed, information pages, and gallery pages. Approximately a fifteen-page site. All that will be supplied is copy and the silver jewelry.

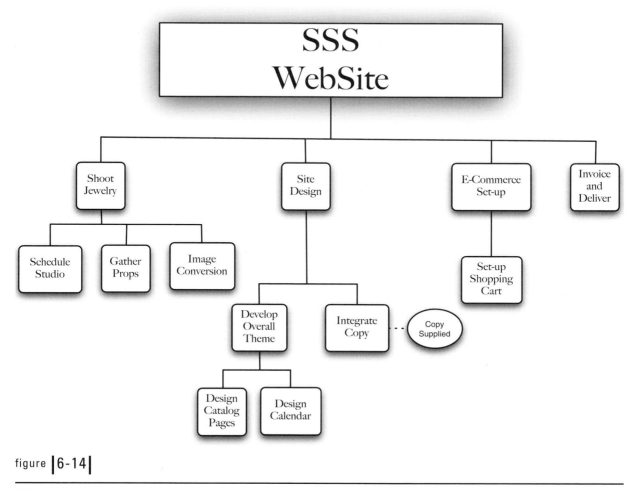

figure |6-14|

A Work Breakdown Sheet for the Silver Sight Studio Project.

The first thing to do is to create the WBS, which involves writing up all the tasks that might come up for this job. A WBS for this quote might look like the one shown in Figure 6-14.

Using the WBS, the next step is to develop a process flowchart or map to understand the chronology of what needs to be done. The order of the steps taken is important because some actions depend on the one(s) immediately preceding them. The first step would be to design a prototype for the site for the client to review and sign off on. The overall design of the site would be presented at this time and issues such as the size of the catalog and how many images need to be shot would be determined. Once the theme and items to be shown are decided, the actual building of the site can begin. At this point a photographer would be hired, a basic site would be built, and the e-commerce part of the Web would be set up. By creating a map using process logic, the CC can review the steps needed and develop a chronological understanding. Now remember, the client hasn't received their quote yet. The steps being taken are required to understand what price needs to be charged. A map of the overall process might look like Figure 6-15.

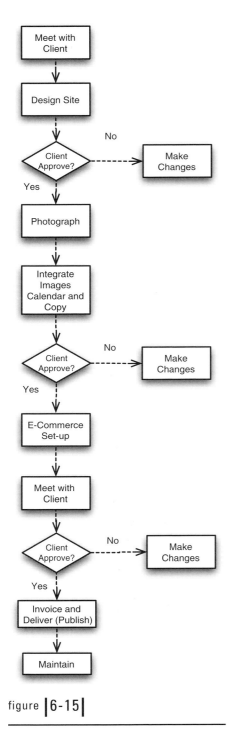

A process map for Silver Sight Studio.

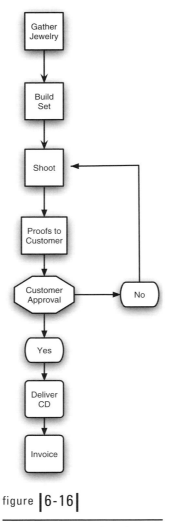

figure |6-16|

An illustration of task logic for one task in the Silver Sight Studio project.

To illustrate what we explored earlier regarding task logic, let's take one of the steps in this process, the task of photographing the silver jewelry, and elaborate. This involves hiring a photographer, gathering the props and setting up the studio, shooting, and converting the images to JPEGs for Web viewing. Illustrating this task might look like Figure 6-16.

Mapping out the specific tasks in your process can often help you function more efficiently and faster and, hopefully, avoid too many unpleasant surprises during the way. Now that you have mapped it all, the next step is to develop a schedule. Depending on when your client wants the project finished, there may or may not be rush charges or special additional fees. Perhaps in the time frame you've been given, the photographer you wanted is not available, and those who are available and capable of doing the job are more expensive. If you're outsourcing the e-commerce development of the site, that cost needs to be known and whether the timing will work. The best way to answer these questions is to develop your schedule and initial Gantt chart, which can provide you with a useful visual of the overall time frame. You can also set up a schedule on paper, with an Excel spreadsheet or use project management software. The cost of project management software varies, but there are several software companies that offer a light version of their product for free. Some, such as AceProject, offer online-hosted software that can be accessed from any location.

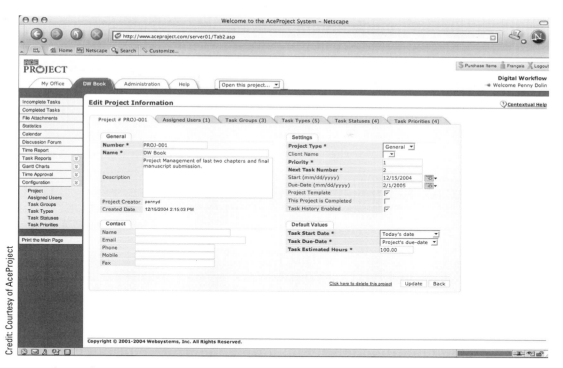

figure |6-17|

An example of using project management online.

The free version limits the amount of projects and tasks you can have and how many users can be on concurrently, but for a solo CC it is quite useful. Some companies offer downloadable packages that are free, but also come with restrictions on the number of projects and tasks. They can also restrict the importability or exportability of files. But in general, they are extremely useful and a great way to learn about the many advantages of project management software. JTech Software, which specifically promotes project management software for the Mac, has a free light version that has excellent functionality and will be used to illustrate the scheduling for Silver Sight Studio's Web site project.

Project management software uses the terminology already discussed for Gantt charts. Often the team members working on the project or those hired to facilitate some part of the project are referred to as resources. Tasks are often represented as items. This type of software is specifically designed to help with the planning and controlling of resources, costs, and schedules for a given project. For our example, the terms are defined as follows:

- Item—a task within a project
- Depends—indicates an item dependent on an earlier item
- Duration—the amount of time the item will take

| FAST FACT |

- Resource—an individual who is in charge of accomplishing a given item
- Milestone—a significant event in the project that is easily identifiable and completes a phase within the project

The request for quote has indicated that the job needs to be completed by February 21 with the request being submitted on December 20. The process flowchart has made it clear what needs to be done, so the project details can be filled out within the project management software. If the Web design begins on December 28, the client can expect to meet and review the proposed site on January 12. The CC has determined the cost for this part of the project to be approximately $1500 for the ten-day duration.

Note that the client meeting has the number 1 indicated in the fourth column from the left (Figure 6-18). This shows that the meeting is dependent on what happens with the Web design. Obviously, if the design isn't finished by January 12, the meeting will be postponed. Once this milestone has been accomplished—the customer approving the design—the photographer can then be hired, so this step is dependent on step 2.

As indicated, getting the photography underway is dependent on the client meeting, in Figure 6-19. Note that the duration for the shoot is only three days, but the dates indicated comprise five days. That is because the preferences have been set to only count Monday through Friday as working days.

If you look at the entire projected schedule, you can see what needs to happen when, and what the anticipated costs will be by following this schedule.

You can also make a Gantt chart of the project for fast review. Note the milestones indicated by the diamond-shaped icons in Figure 6-21.

| 1 | Web Design | 10d 1.66h | | | 12/28/04 | 1/11/05 | $1,500.000 | WebDesigner ▼ | 10d 1.66h |
| 2 | Client Meeting | 0d 0.00h | 1 | | 1/12/05 | 1/12/05 | 0,00 | ▼ | 0d 0.00h |

figure |6-18|

This shows that the client meeting is dependent on the event preceding it.

1	Web Design	10d 1.66h			12/28/04	1/11/05	$1,500.000	WebDesigner ▼	10d 1.66h
2	Client Meeting	0d 0.00h	1		1/12/05	1/12/05	0,00	▼	0d 0.00h
3	Photography	3d 0.00h	2		1/13/05	1/17/05	$3,600.000	Photographer ▼	3d 0.00h

figure |6-19|

Photography is brought into the schedule.

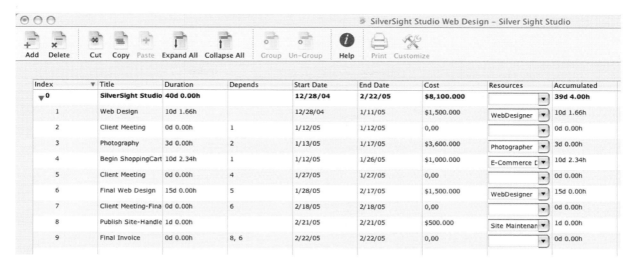

The table in the figure contains:

Index	Title	Duration	Depends	Start Date	End Date	Cost	Resources	Accumulated
▼ 0	**SilverSight Studio**	40d 0.00h		**12/28/04**	**2/22/05**	**$8,100.000**		**39d 4.00h**
1	Web Design	10d 1.66h		12/28/04	1/11/05	$1,500.000	WebDesigner	10d 1.66h
2	Client Meeting	0d 0.00h	1	1/12/05	1/12/05	0,00		0d 0.00h
3	Photography	3d 0.00h	2	1/13/05	1/17/05	$3,600.000	Photographer	3d 0.00h
4	Begin ShoppingCart	10d 2.34h	1	1/12/05	1/26/05	$1,000.000	E-Commerce D	10d 2.34h
5	Client Meeting	0d 0.00h	4	1/27/05	1/27/05	0,00		0d 0.00h
6	Final Web Design	15d 0.00h	5	1/28/05	2/17/05	$1,500.000	WebDesigner	15d 0.00h
7	Client Meeting-Fina	0d 0.00h	6	2/18/05	2/18/05	0,00		0d 0.00h
8	Publish Site-Handle	1d 0.00h		2/21/05	2/21/05	$500.000	Site Maintenan	1d 0.00h
9	Final Invoice	0d 0.00h	8, 6	2/22/05	2/22/05	0,00		0d 0.00h

figure | 6-20 |

Silver Sight Studio project schedule.

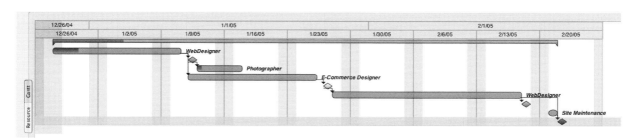

figure | 6-21 |

Silver Sight Studio schedule in Gantt format.

At this point, the CC can look at the resources needed and the schedule required and come up with an accurate quote. If the client accepts, the project begins and you can modify your schedule as required.

CARE AND FEEDING OF YOUR CLIENT

All the best workflow technology and project management won't ensure ultimate success for a CC unless communication with the client follows the three Cs, which means being clear, concise, and consistent.

Clarity refers in particular to the communication between a client and a CC. The CC must ask enough specific questions to have a complete understanding of what is wanted, when it is

wanted, and what the client's budget is. The questions a CC asks to create an accurate estimate, prior to the final quote, make the difference between earning a living through one's creative talents or having it as a hobby. This information is obtained by asking the client the right questions; i.e., How much time is available? How many meetings may be required? Where will we meet? How will the job be printed/uploaded? How will it be delivered? Do you have a budget you can't exceed? etc. The answers to these questions will help you prepare an accurate estimate. What follows is a partial list of things that should be considered when preparing a quote. It is excerpted from a list put together and posted on the Graphic Artists Guild (GAG) Web site (www.gag.org).

The Graphic Artists Guild

The Guild is a "national union of illustrators, designers, Web creators, production artists, surface designers, and other creatives who have come together to pursue common goals, share their experience, raise industry standards, and improve the ability of visual creators to achieve satisfying and rewarding careers." It has excellent resources available including advocacy (legal resources), insurance plans, professional development, industry information, and various professional discounts. Because many graphic artists work independently, it is a great way to develop a sense of community and receive benefits only available through trade organizations. You can visit their Web site at www.gag.org.

Determining Your Estimate

- Time you will spend/rate of pay (you don't have to share this with the client when you are pricing by project)
- Meeting time
- Research time
- Concept development time
- Thumbnails, roughs (give a specific range of how many concept roughs you will provide)
- Comp preparation
- Layout
- Color selections (don't forget to get corporate color specs from the client)
- Production supervision
- Production coordination
- Revisions (give a specific range of how many revisions you will provide at each step of the project)

- Delivery

- Rush fee

- Bookwork and administration (final bill calculations, invoices, phone time)

- Expenses

- Photography

- Supplies and props

- Postage/freight/courier

(*Courtesy of the Graphic Artists Guild—Pre-Contract Checklist*)

Being concise is of the utmost importance. Merriam-Webster's dictionary defines concise as "free from all elaboration and superfluous detail." It means getting to the point and saying what you mean. This is also the time to be thinking about the contract with your client. Does it make clear all your terms and expectations—for both parties? Again, the GAG has a good checklist of questions that should be asked.

- Who is billed? Designer or client?

- Advanced payment? how much? (This is particularly sensible if you have a new client whose reputation has not yet been established.)

- Progressive payments? how many? (usually 3)

- Payment upon completion or payment by invoice (30 days)

- Interest added (or late charge) on past 30 day account

- Rights and ownership. (Save your client some money by only charging them for the rights and usage they really need.)

- Is the usage local, regional, national, international? (More geography is typically more $$)

- Limited or unlimited usage?

- If limited, define reuse rights

- Limited or unlimited media? (ie: Print only, print and Web, one-time specific use, etc.)

- Always clearly state the limits on time, distribution, and media

- Know your reuse fees in advance

- Determine who owns original work (usually purchased by a separate fee)

- Will the client or artist negotiate rights/fees with contractor or subcontractor? (if applicable)

- Are you flexible in negotiating your rights and amendments for reuse rights?

- Kill fee: In case of cancellation of project, a kill fee is customarily assessed in relation to the amount of work finished.

- Client Approval: **Don't start work until you have a fax or hard copy of the SIGNED estimate.** Remember to get your client's signature of approval—in writing—not only throughout the process, but a final approval BEFORE going to press (or publishing the site to the Web)! It's not a bad idea to state that final signature approval is required in your contract.

Consistency has to do with the manner in which you conduct business over the long term. For example, inconsistent charges for your services can lead to confusion and mistrust. If you charge $500 for design services once and then $1000 the next time with no explanation, you probably won't get the job. Getting the work to the client on time and within budget each time you work with them engenders confidence and creates more work and referrals. Consistency in how you manage, bill, and follow up on all your projects helps promote you as a professional.

SUMMARY

Administrative and management issues are probably not terribly high on the list of "look forward" to activities when developing content, but they are quite necessary. Think of every one of your jobs as a project to be completed and you can design a structure within which you can work efficiently and never lose sight of the big picture. There are many software solutions for managing your projects, so creating icons and charts from scratch may not be the best use of your time. Having professional management tools to create time lines, charts, and schedules that can be shown to the client through e-mail or PowerPoint presentations also enhances your reputation as a quality CC. Part of the secret to successful project management and job delivery is having good customer communication. Be clear, concise, and consistent and you will find you have more clients than you thought possible! Not such a bad place to be.

in review

1. Explain the importance of project management.

2. Define and describe the four stages of a project life cycle.

3. What is a WBS?

4. Why is mapping a project important?

5. What is a flowchart?

6. What is the difference between process logic and task logic?

7. Why does a Gantt chart facilitate scheduling and project management?

8. What are the steps you would take to provide an accurate quote to a client?

9. What is a milestone?

10. What are the three Cs and why are they important?

exercises

1. Developing a Process and Task Map: Choose any process you'd like outside of graphics; such as cooking a meal, changing a flat tire, or preparing for an exam. Map out the process that needs to be followed and then choose one task from that process and map the task logic involved. Use either your own symbols or those provided through software. See product references within the chapter.

2. Developing a Schedule: Pick any type of graphic project (print, Web, multimedia) and develop a schedule using a thirty-day time line. At least five tasks should be represented. PMX software from JTech can help facilitate this. See the link on the Companion DVD.

CHAPTER

VII

Chapter Objectives

- Explore the way different professionals approach the business
- Understand the importance of technology in content creation
- Understand the connection between analog and digital workflow
- Explore future possibilities for content creation and design

Introduction

We have explored many different ways to use technology to assist in the creative process. From managing your bits and bytes to overall project management, being a creative professional today requires more than just talent. In this chapter, we are going to meet some working professionals, ranging from individual CCs to design, advertising, premedia, and Internet companies.

CONTENT CREATORS

Designers of all types, Web including multimedia and print, that work independently face the daunting task of not just being creative, but of managing the technology and their business. There is a smaller window for mistakes and far less cushion for failure if they wish to succeed. Truly creative CCs that embrace the technology as tools for enhancing what they do can produce some spectacular results.

Brian Drake

Brian Drake, based in Scottsdale, Arizona, exemplifies a CC who has become a true cross-media creative and is making it all work. He has been in the field for more than ten years. Originally trained as a musician and a graduate of Berklee College of Music, he had become fascinated with the design of the J-cards and Jackets being made to accompany the records and found himself drawn toward design. He has worked in Boston, Chicago, and New York and describes his area of expertise as multidiscipline design and message delivery.

Brian was an early adopter of Lingo and Director and usually has open on his Mac Cinema4dXL, Flash, DVD Studio Pro, FCP, After Effects, Photoshop, Illustrator, and QuarkXPress. He is starting to use Adobe InDesign. He began designing in the late 1980s in the somewhat pre-digital days, but he says that "as I progressed in the digital domain, it is worth noting, that I always strived to find the historical or 'analog' counterpoint to the discipline. I began a long autodidact study of typography, and its various production incarnations over the decades. I feel it is important to understand the deep craftsmanship that went into type making, and to further that point, the skill and thought it took to spec type before one could press a key on a computer."

Many of his projects cross from print to Web to broadcast and he has found that "Today, to maximize my profits, still meet my clients expectations, and get to a deeper creative center, I use technology and find it a great ally." But he does stress that technology is the tool, not the end destination. Just being a Photoshop expert is not the achievement. Using Photoshop as part of his toolkit to create meaningful client pieces is the true purpose of the software. One of his favorite projects was for a company called Savanna Line. It is a nonprofit IT staffing firm that was looking to redefine the ideas behind lifelong employment.

figure |7-1|

Brian Drake.

He needed to create a long-lived "transportable identity system." He began with a simple two-color and one-color mark designed for both Web and print. (See Color Insert Figure 15.) As Brian recounts it, "From there, I began a process of discovery, looking at

the best way to speak to the client's audience, and find ways to help generate new business. For the Savanna Line business model to work, they needed two main elements. First, they needed a diverse talent pool. To maximize their budget, I decided on a multipronged Internet approach to finding talent. First and foremost was the use of e-mail channel advertising.

Using technology, tied with creative, I created an e-mail campaign to attract potential talent to the Savanna Line Web site. Once there, the potential talent could submit a resume and fill out a 'prequalification' form. These submittals were then stored in a 'talent' database. An automated e-mail response was sent to both HR at Savanna Line and the talent, acknowledging their submittal, and triggering the review process for Savanna Line.

Attracting large companies, who have a need for qualified candidates and could offer enough employment opportunities to sustain a staffing firm, was the second key challenge. We needed to find a way to cut through the clutter and noise in a densely competitive field, and present the Savanna Line mission to these potential employers. To answer this challenge, I devised a traditional direct mail and e-mail channel advertising approach.

Using the e-mail channel, I created several targeted ads for employers, which offered a PDF brochure and rate card, when a potential employer responded. (See Color Insert Figure 11.) I used specific URLs to track response rates and discovered ways to cross-manipulate the e-mail advertising with direct mail, in the post, follow-ups.

This immediacy shortened prequalification times for the client and allowed greater close percentages for the Savanna Line team. This same PDF brochure was used sparingly, in print form, for leave-behinds and 'in person' meetings.

The second phase of the Savanna Line 'employer' effort was traditional direct mail. I chose to print 4/1 oversized on Gilbert 100# voice. (See Color Insert Figures 12 and 13.) This was the company's strongest introduction to the Fortune 500 client base. This series featured highly focused copy and specific URLs for customer response tracking, and had a staggering 11% response rate. (See Color Insert Figure 14.)

I gave Savanna Line a three-level approach: concept, execution, and delivery. Executing between print and the Internet allowed Savanna Line to make the most of their budget. Designing once and using software tools and PDF workflows allowed me to maintain my deadlines and maximize profits. This tight relationship, based on success, also allowed me to remain an invaluable resource for their design needs."

Brian's Web site at www.briandrake.tv (link is on Companion DVD) showcases much of his work and is as sophisticated as what he can do for his clients.

When asked for words of wisdom for CCs starting out, his thoughts are in line with the trend towards perceiving the design process as primarily about creative problem solving. "A graphic designer, today, must be more than the sum of his or her software tool kit. You must think. You must problem solve and make emotional connections with your audience. When you make

| FAST FACT |

Brian Drake Bytes:

On design reference books—"I look for historical art and design books. Profiles on movements, theories, and specific cultural revolutions interest me most. I have many type-specific books, which I rely on for previewing type in rough layouts, without ever sitting at my computer."

On design magazines—*CA, Print, Graphis*

Belongs to American Institute of Graphic Arts (AIGA)

figure |7-2|

Brian Drake's Web site, www.briandrake.tv (link is on Companion DVD).

technology your core focus, your software skills, ability to use different operating systems, what have you, you make your and our profession about memorization and not about intellectual problem solving. Knowing Photoshop is a memorization exercise. Anyone can do it.

In a world of 'me too' designers, and everybody's 'brother,' 'neighbor,' or 'friend' is a 'Web guy' with hack copies of Photoshop, you must make your long-term value stretch way beyond the software game. Solving communication problems cannot be done in software. It takes instinct, knowledge, reason, and guts. Photoshop ain't got that.

So let those actions do the grunt work, use PDF workflows, design once, repurpose many. Use the Internet for more than e-mail and surfing. Embrace Colorsync for your entire workflow. Deliver multi-format data and graphics with XML.

But use these tools in support of the 'idea'. In support of the concept.

Use on-line questionaires, client poling, and Flash-based surveys, tied to databases, to deliver proof that your concept is the best solution for the client. Never let the execution tools stand in the way of the concept. If the concept can only work in the software, it may just be the wrong concept. Many great ideas work on a cocktail napkin."

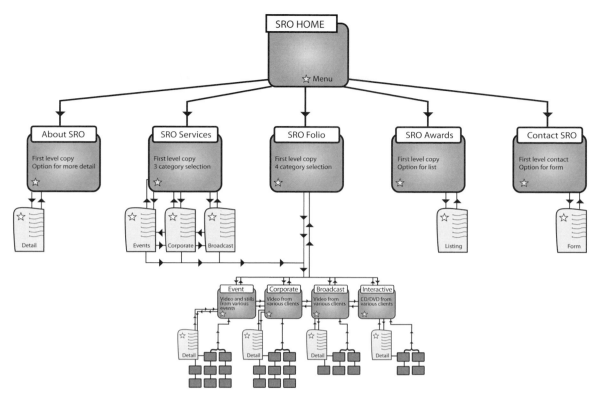

figure |7-3|

Brian finds that a good site map becomes a great selling tool and is invaluable for client communication. "Created in Illustrator, using library items, this map features instant updates, through use of library items, and exports to Flash in a snap, for instant Web publishing. Because I use a vector program, I can also print 11x17 for client presentations and meetings from the same file. All of my Web projects start at this phase and use a library template for rapid development and client approval."

Shannon Ecke

Shannon Ecke has been involved in both professional design and design education for more than eight years. Following graduation from Arizona State University in 1997 with a BFA in Graphic Design, she held design positions in Minneapolis at Charles S. Anderson Design Company and in Seattle at Landor working with clients such as Microsoft. (See Color Insert Figure 18.) It began as an internship and quickly became full time. "It was an incredible opportunity because I was exposed to proven design processes and techniques and I tried to learn as much as I could. I think a really good design job is one that fills your needs at the time and one where you don't stop learning." She currently works at The Herberger

figure |7-4|

Shannon Ecke.

SHANNON ECKE

figure |7-5|

Shannon Ecke's logo for her independent creative work.

figure |7-6|

Shannon's brochure designed for the 3rd Annual Ceramic Studio Tour at ASU combined shape and texture successfully.

College of Fine Arts at Arizona State University, Tempe, as a senior designer. Shannon creates design solutions primarily for printed collateral such as corporate identities, packaging, and brochures, but she also designs for the Web.

Shannon is extremely active in and supportive of design education and serves as the Education Director for the Arizona Chapter of the AIGA. When asked about the importance of technology in her work, she stressed that the technology is a tool that supports the idea. "The technical side of design is always an ally; it's how you use it that is important. Be aware of your limitations and capabilities from the technical standpoint, but don't let it trap you. It may be easier to create a design solution directly on the computer instead of pursuing a great idea because it may be a challenge to execute, but it's the great idea that people remember. Think creatively first and then try to figure out how to execute the idea through the tools we have to work with."

One of her favorite projects was one that challenged her to create a good design solution in spite of a limited budget. "Although a small project, one of my favorite projects was the Ceramics Studio Tour invitation for the ASU Art Museum in 2004. With a very limited budget I created a two-color foldout brochure that combined good design with the required content, using manipulated typography and textures. The brochure allowed the event to have a unique

look and feel that has evolved over the past three years. The ASU Art Museum has been extremely appreciative of my design capabilities on this project, and I feel that my talent has truly made an impact, which makes me proud to be a graphic designer."

Shannon appreciates a client who understands the value of design and "hires you because of your accomplishments and capabilities in the design field and trusts that you will work with them to attain their goals. A bad client hires you for the same reasons and then second-guesses your decisions throughout the entire process. Communication is the key to a healthy designer/client relationship; be very clear on expectations, roles, responsibilities and time lines."

She primarily works on a Mac and uses the Adobe Creative Suite, but is always open to other software that can help with her content creation. Shannon's words of wisdom are succinct and to the point:

- Be a sponge
- Remember the power of convention
- Learn the business of design
- Under-promise and over-deliver
- With every project, try to do something you haven't done
- Don't be afraid to fail
- Remember the power of contrast
- Tell a story
- Adapt

| **FAST FACT** |

Shannon Ecke Bytes:

On design reference books—
Make It Bigger by Paula Scher,
soakwashrinsespin by Tolleson
Design, *The Brand Gap* by Marty
Neumeier, *Don't Make Me Think*
by Steve Krug

On design magazines—*HOW,
Eye, Emigre*

Belongs to AIGA

Kathleen Evanoff

Since 2000, Kathleen has worked as Senior Web Designer at the J. Paul Getty Museum in Los Angeles, California, designing and developing online exhibitions, including the Webby Award winning "Devices of Wonder."

After majoring in fine art at college, Kathleen soon discovered that there were not an abundance of positions for artists outside of teaching art or art history. To combine her creativity with a more practical industry, she took a printing course at a technical college and found that there were opportunities for graphic designers at newspapers and print shops. "After completing classes I worked in a small print shop as the all-in-one front-desk, layout, illustrator, and prepress person. I helped customers decide upon a design and layout for their print projects, creating any

figure |7-7|

Kathleen Evanoff.

illustration, logos, typesetting, and all prepress work including camera and stripping negatives. I did everything but run the presses."

Kathleen's design career began at Microsoft where she spent eight years as a Microsoft Graphic Artist. Her position at Microsoft led to a love of working on the computer and she easily fell into Web design. "Designing for the Web was fascinating to me. I felt no struggle about leaving the 'old' ways. I disliked Exacto knives, Schaedler Precision rulers, pica rulers, and the arduous demands of print. It was no trouble to take up the software versions of these tools. It is so much easier to hit 'Delete' or 'Backspace' than to start from scratch on a flawed layout. I never looked back."

Her artistic approach is evident in her personal Web site, RarePixel.com, where she showcases many of her projects. (See Color Insert Figure 20.) When asked about her favorite Web site, she points without hesitation to the award-wining site she designed for the J. Paul Getty Museum—Devices of Wonder.

"The exhibition launched in November 13, 2001, and was at the museum through February 3, 2002, but the beauty of an online exhibition is it continues long after the physical exhibition is taken down. (View at www.getty.edu/art/exhibitions/devices.) The physical exhibition contained several hundred interactive devices from the 1600s to present day, few of which could be handled by visitors. The online exhibition was conceived as a vehicle to allow 'guests' the ability to interact with various objects from the exhibition: To do this we first chose 22 objects from the hundreds in the exhibition: several objects from each exhibition theme, and photographed these from every angle. With these images we used Macromedia Flash to create an

figure |7-8|

The splash page from the Devices of Wonder Web site designed and developed for the J. Paul Getty Museum.

figure |7-9|

The navigational elements of the site introduced by "Android Clarinetist."

interactive playground where users can play with the object and read about it by clicking on an 'About Me' button. We chose one device, the 'Android Clarinetist,' as host who appeared frequently to introduce concepts and guide users through the site.

We worked many months on the exhibition to perfect the presentation and make Flash animations that were as intuitive and transparent to use as possible. To the gratification of all involved we were awarded a Webby in the "Weird" category. We had to admit the objects were weird by today's standards."

Web design is about content creation that cannot be separated from technology. If you are creative and enjoy technology, designing Web sites can be extremely gratifying. Kathleen has never shied away from learning new software and feels "The technical side is a definite ally. I enjoy creatively solving technical problems and I feel most delight at inventing better ways to use the software I use every day. My geek nature pays off when designing for the Web. It is vital to dream up all the technical conveyances a site design might employ to present content. Without skill and knowledge of HTML, JavaScript, CSS, XML, ASP, Perl, PHP, and the many other Web programming standards, and a fascination for every new technology being used, it is very difficult to design efficiently for the Web. Categorizing content into intuitive navigation systems that give users what they want in the fewest clicks is uppermost in good Web design, and is near impossible to achieve without knowledge of programming possibilities or a willingness to explore the technical potentials."

Primarily working on the Windows platform, she is also skilled on the Mac. Her software of choice is Adobe Photoshop, Illustrator, Macromedia Studio (including Homesite), Dreamweaver,

and Flash. As to words of wisdom for young CCs, her recommendations not surprisingly apply to the Web world:

> "Keep it simple—If you have really good content, focus on it. The page design and site architecture should support the content, not interfere and block users from finding it. This applies to any design, but it is amplified on the Web.
>
> Remember your audience—Remember to test what you create with *real* people. Your designs should be unambiguous, instant, serviceable, and functional if you are to maintain your audience's attention. Any audience is quick to leave if what they seek is hidden under layers of fluff or vanity. Get directly to the heart of the matter and find ways to give the user what they want in fewer than 2 to 3 clicks."

THOSE THAT HIRE

Design firm, advertising agency, communications company, Web solution provider, and information architects are all names given today to those that hire creative talent, or have them as staff to give shape and form to what they sell to their clients. It is a marketplace that can also take a lot of creativity to navigate. What follows are some perspectives from those that hire creatives (the talent) and understand the challenges faced in such a technical workspace.

Morgan and Company

Kathy Morgan is the co-founder, president, and creative director of Morgan and Company, a full-service graphic design studio that focuses primarily on print collateral.

They do corporate ID and branding, annual reports, Web site design, packaging, and environmental graphics. Kathy's background includes a BFA in Advertising Design from Arizona State University and working as the in-house art director for the well-known Tom Hopkins International sales training organization. From Tom Hopkins she learned to "never see failure as failure, but as an opportunity to develop my sense of humor." When asked to define what she does for a living, she likes to say "we practice psychic design instead of graphic design. To do this job well, it's essential to get on the same wavelength as clients and suppliers. I enjoy the feeling of community that's established during the creation of every single project, the bringing together of just the right people, everybody's mojo working just so to create this something that never existed before. I'm also honored by the great trust

 M O R G A N A N D C O M P A N Y

figure |7-10|

The Morgan and Company logo.

our clients extend to us, allowing us to learn about all different aspects of the world through their companies."

She learned early on the great satisfaction of working with clients that they truly wanted to work with, rather than just anyone who walked through their door. In particular, an account that asked Morgan and Company to do everything—identity, packaging, presentations, and even environmental graphics—proved to be hard work but ultimately fascinating, and the final outcome was a win for both the company and client.

Morgan & Company has in-house staff but does hire freelance at times. "We rely almost exclusively on in-house staff, but occasionally hire outside help for copywriting and design when we're overloaded or if I'm looking for a specific style. Of course, we also subcontract photography and illustration on a project

| FAST FACT |

Kathy Morgan Bytes:

On design books—David Carter's *American Corporate Identity* series.

On design magazines—HOW and *Creative Business*. I also like the e-mail newsletter creativepro.com.

Belongs to a local Creative Roundtable with about a dozen other studio owners

figure |7-11|

Morgan and Company's task was to create a unified theme for US West Wireless—from printed collateral to environmental graphics. As part of the assignment, they were asked to consider all the details that contributed to the customer experience. Clothing, lettering, badges, shopping bags, shelving, and more were selected to coordinate with the architectural elements.

figure |7-12|

figure |7-13|

basis as needed, along with outside programming for Web site construction, which has become too specialized." When asked what some of the challenges are when working with outside creatives, issues such as availability, consistency, and unfamiliarity with long-term clients are mentioned. Kathy states, "I only hire outside when the direction and parameters are very clear. I prefer to have a staff person here in my office, so when questions arise, they can be dealt with immediately and collaboratively."

Morgan and Company has been a successful firm for more than twenty years and has weathered the major technological changes that have impacted the industry so far. They have gone from an IBM Selectric typewriter to a command line PC in 1984 to Mac IIs to the latest Mac OS X on GHz plus machines. But there has always been the understanding that the creative process is unique and not tied to technology. Kathy urges young CCs to "Use paper and pencil first; that's where the best ideas come from. I always ask designers who interview with me to bring their sketches and preliminary work. I want to see if you can think. The computer is only a tool. Turn it on only after you've turned on the right side of your brain. Nowadays, anyone with a computer can make something look 'professional'—so our challenge becomes, what can you as a designer bring to it that they can't do themselves? What is your value?"

PrimeView LLC

Started in 1995, PrimeView has grown into a well-staffed, multi-disciplined Internet company with clients throughout the United States. According to founder Peter Liefer, PrimeView is considered a full-service eBusiness solution provider.

"We specialize in working with clients to create and implement their digital presence. We provide the marketing, advertising, publishing, media applications, and software services necessary for a company's digital presence and offer secure hosting services."

figure |7-14|

PrimeView logo.

A PrimeView client generally is one who wants "to create a streamlined shopping experience or use Web interactivity that allows them stay in touch with their customer or user base and attract new viewers. After we review a client's operations and their customer information flow, we design

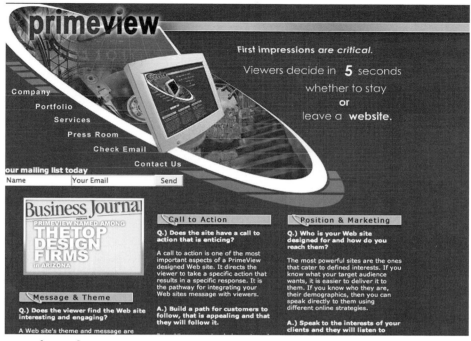

figure |7-15|

PrimeView's Web site.

the information architecture that will best serve the client's business goals and digital presence opportunities. Based on our usability and scalability tests, PrimeView designs a 'typical client's' site and plans a coordinated marketing and advertising program for the site's deployment." PrimeView prides itself on taking the customer's expectation and far exceeding it. A good example of this is the site for SeaTech Aquariums. The goal was to develop a recognizable brand for the firm that could be reproduced in other advertising mediums. A unique look was developed that gave the viewer the feeling of a cool underwater environment.

PrimeView is also interested in nonprofits as a way to promote the greater good, and has designed sites such as Friends of Kartchner Caverns. Peter describes the friends as "a nonprofit organization that promotes the use of and donates funds to Kartchner Caverns State Park. We designed the Web site as an educational interactive experience designed to educate and interest viewers about this unique cave system." (See Color Insert Figure 23.)

When asked about hiring freelance creatives or using in-house, Peter indicated that they review all projects and honestly assess whether they

| FAST FACT |

Peter Liefer Bytes:

On design books—*OZ Graphix* series; *CMYK;* Adobe Photoshop How To books; *Web Design: The Complete Reference* by Thomas A. Powell; *The Designers Guide to Color Combinations* by Leslie Gabaraga

On design magazines—enjoys looking at annual reports. "I read two types of 'design magazines.' Those that speak directly to designers and creatives, and those that speak to the people who hire designers and creatives"

Belongs to AIGA

figure |7-16|

The SeaTech Aquarium Web site.

have the in-house talent or not, but more often than not, they work with the in-house creatives. "The greatest area of concern that we have in working with creatives is not their design capabilities, which we can judge from their references, previous work, and referrals but their ability to understand project management." In addition, familiarity with digital formats and understanding the technical side of Web development are extremely important. "Since we are designing for the Internet, it is vital that our creative teams are comfortable working with digital formats. This is the biggest problem area for creatives who have recently graduated and want to work for Web design firms. They simply don't know the media. They don't know how to produce Web-ready material. The page designers and coders are concerned with the size of the graphics, the load time, and the display. Creatives need to listen and understand the requirements of the media in which they want to work."

Moses Anshell

Moses Anshell is a remarkable full-service advertising agency. They consider themselves to be an "idea factory" where clients come for creative solutions to marketing problems. For more than twenty-three years they have been amassing awards and clients. Louie Moses, the Creative Director and President, has been the recipient of Clio Awards, Addys, Art Director Club Awards, and an Emmy. He is the creative force behind the agency and his responsibilities include copywriting, art direction, broadcast production, directing, and creative strategy development.

Jos Anshell, the chief executive officer and director of client services, is responsible for the overall management of Moses Anshell. He is considered the "strategic force behind the Client Services and Marketing departments, ensuring that clients receive top-notch thinking." His background is in business and marketing, and he graduated from Northwestern University with an MBA. His industry experience prior to Moses Anshell included working at Lever Brothers, Columbia Records, Bristol Corporation, and Fairmont Foods.

The two represent the ideal team of creative talent, and marketing and business savvy. What is really notable are the efforts the firm has made on behalf on nonprofits and other deserving organizations. Their involvement with the Arizona Humane Society in producing various types of collateral—print to TV—have allowed it to grow into the state's largest animal welfare and protection agency.

When asked what some of the challenges were in working with outside talent, Louie said "understanding our culture." An advertising agency develops a voice and a style and outside creatives need to communicate in a way that fits that approach. There is a good deal of playfulness

figure |7-17|

A sample of the work done for the Arizona Humane Society.

figure |7-18|

An ad for Taglio, a Scottsdale, Arizona, hair salon.

in the creative ideas that become collateral. It is evidenced in their broadcast work and many of their off-beat print advertisements. (See Color Insert Figure 25.)

When asked for words of wisdom to impart to the next generation of designers, Louie says he understands the importance of technology, but that creativity starts with your concept, not the tools you use. "The biggest problem with the digital age is concept vs. execution. Because choices are so prevalent it becomes difficult to stay focused on concept. Dressing up a bad idea is so easy with fancy digital tricks. I try and encourage all my creative people to work with paper and pencil first before going to the computer. The concept should work on a scribble on a napkin. The best work I've ever created came from little scribbles, not detailed designs."

THOSE THAT GET THE FILES

As has been stressed in this book, the best design or content in the world doesn't do much good if it can't get out of the computer or be published to the Web. Not too long ago designers and photographers "handed" off their work to the next person in the production process and they were then out of the loop. Today with decisions being made much farther upstream, the decisions made can mightily impact the production process—especially in print. Different prepress, or premedia, shops take different stances on it, but whether you get charged or not, handing in poorly made files slows down the production process and ultimately affects you and your customer. It pays to learn how to craft files correctly.

FrontEnd Graphics

FrontEnd Graphics has been going strong for more than twenty-five years. Founded by Betty Maul, the president and driving force behind FrontEnd, the company is a full-service facility specializing in on- and off-premises print production and consulting for all media.

The services range from layout and design, digital photography, print, mailing, and distribution to all media—both electronic and traditional. At least 98% of the jobs coming into FrontEnd are digital and "jobs come to us in various stages; sometimes creative is generated by our client. When this happens we assure the integrity of their files. If the job is generated internally, file integrity per output device is automatic. For the most part, about 20% of the files that come in need extensive repair to print." But even though their percentage of files needing major surgery may be lower than some other facilities, there is still a point at which customers may be charged for the extent of corrections needed. Betty indicates that this is a business decision.

"We usually offer the suggestion of fixing for the client at an hourly rate, or we give them the option of resubmitting a corrected file based upon our suggestions."

Betty's career has spanned the analog and the move into digital. She stresses that the best way to understand and apply the new technologies is to have a firm understanding of the traditional craft that defined this industry until relatively recently. Always willing to offer words of wisdom to those coming into the graphics field, she exhorts them to "Please remember that every keystroke command you utilize in your production replaces a traditional skill. Build a page as you would give driving directions to a stranger . . . be as direct as you can without throwing in a huge amount of information that isn't necessary to find

figure |7-19|

FrontEnd Graphics.

the destination. Go three miles make the first right and second left. . . . Don't tell me about the stores I will pass and the colors of the buildings along the way, etc. All the extra information, example of files with extra directions or poor builds . . . text boxes within text boxes, layers upon layers in Photoshop, just take longer to rip, helps me lose money on the job, and doesn't allow me to quickly and perfectly get the outcome I expect on proof. If you can't get it to print on your proof, there must be a reason."

LAgraphico

Started over 25 years ago, LAgraphico is now an extremely successful graphic solutions provider with more than 200 employees. Originally a prepress facility, they grew into a full-service facility with several presses and are now partnering with a creative design company.

Al Shapiro, the founder and guiding light of LAgraphico has created a culture where turnover is almost nonexistent and, even though large in terms of people and equipment, the feel is still that of a family-run business. Al earned his BS in printing management from California State University, Los Angeles, and has been a part of the industry for more than forty years. He sees his company as a "technology partner for creative imaging, premedia, and printing." The bulk of their business is from entertainment companies that produce worldwide marketing campaigns for movies and home videos. (See Color Insert Figure 27.)

Almost all work is submitted digitally now and if PDF/X-1a files aren't submitted, they are made. Al estimates that 80% or more of incoming files are flagged in preflight as needing some sort of correction or repair. When production was asked what are the most common problems with

LAgraphico

CREATIVE IMAGING, PREMEDIA, PRINTING
2070 Floyd St. · Burbank, CA 91504-3487 · 818.295.6100

figure |7-20|

LAgraphico logo.

figure |7-21|

DVD wrap done for U.H.V. for the movie "Intolerable Cruelty."

| FAST FACT |

Al Shapiro Bytes:

Belongs to The Association of Graphic Solutions Providers (IPA); Printing Industry Association (PIA); Technical Association for the Graphic Arts (TAGA); Adobe Service Provider Network (ASN)

figure |7-22|

LAgraphico produced the promotional brochure and envelope for the movie "Master and Commander."

incoming files, the list was similar to what was discussed in Chapter 2. The LAgraphico list includes:

- No layered files to make required edits
- Bad imaging—masks, ghosts, resolution
- Layered files not matching flat files
- Missing/wrong fonts for layouts and PSD files
- Missing/wrong profiles in image files
- Spot color naming/identification
- Layout doesn't fit die—bleed and miters
- Unorganized files/folders

When significant changes or alterations are needed, the client is charged. When asked how the company weathered the changes from analog to digital when the Macs hit in 1989, Al admitted that the growth was slow at first. "Then suddenly, within a span of months, computers filled out the area where the old stripping tables were." According to his current IT Manager, Ty Kang, "During this time, there were many instances when Al had to force employees to use the newly installed hardware and software. For Al, it was always about seeking out a faster and better way to do the work."

Al and LAgraphico have never shied away from technological challenges as they have presented themselves. In fact, it has been crucial to their success. Al's words of wisdom echo this theme. "It pays to embrace new technology—use it and put it to work for you. Partner with others who share a commitment to developing technologies in the graphic arts. Content creation has never been so dependent on technology. You can never stop

learning about the new tools for the trade. Get involved when you have to and share your insights with others."

SUMMARY

We have covered a wide range of topics that stretch from conception to output. No one expects that a true CC whose interest and training is focused on designing graphical communication will become expert in all the vagaries of technical production. But because the stages of graphic communication are now so intertwined, we cannot ignore where the boundaries intersect. Just as a painter improves by understanding the types of brushes available, the color tendencies of certain oils, and varied responses of different canvases, so does a CC gain in value and the ability to create by understanding the tools being used today. Developing an understanding of and instituting an efficient digital workflow, even at the level of a one-person shop, is critical to success in the design world today. And the world of design may evolve radically again, so it's best to be used to change. The following piece by Gene Gable will serve as a conclusion to this book and perhaps open the door to what may or may not be on the horizon!

IN CONCLUSION

Gene Gable has spent more than twenty-five years in publishing and graphic arts and currently serves as executive producer and founder of the Context Conference. After chronicling the desktop publishing revolution as a journalist and as president of *Publish* magazine, he assumed the title of president for Seybold Seminars and Publications from 1999 to 2002. He is also a contributing editor at creativepro.com. Gene can be contacted by e-mail to *ggable@sonic.net.*

Night of The Living Page

Will a mega-dose of XML mixed with automated page composition make screaming zombies out of the design community?

It's 3 AM, and an eerie still has come over your office. A chill is clearly present—perhaps it's the air conditioning, or maybe not. The pulsating power buttons on the bank of Macintoshes breathe as one, in and out, in and out. A screen saver flickers and then goes black. The night watchman is half sleeping in the lobby, but even he can sense that something is terribly wrong. Those pages you thought you put to bed hours ago have taken on a life of their own, breaking free from the confines of their hard discs. They are mutating into something horrifying—feeding themselves with new content, new graphics, and new purpose. Your design is being changed from something beautiful and innocent to a disfigured monster. And it scares you like nothing has ever scared you before. We are in an era of smart composition and automated page design that for some will mean a frightening loss of control. But for others in the design and production

figure |7-23|

Could the Night of the Living Page be far off?

community, intelligent pages represent the ultimate experiment and opportunity. How can a creative person continue to produce effective pages when the bulk of them are laid out by machine?

The Customer Takes Control

The reason page production, whether in print, for the Web, or for any other media, is moving from a design-intensive linear process to an automated, round-trip process is simple: consumers of published information are taking control of what they want to see and in what format they want to see it. Aided by government regulation and common sense, they will stop receiving or caring about anything that isn't tailored to them and incredibly current.

All those who use information for business or pleasure benefit from high formatting—good type, quality graphics, true colors and coherent structure. We have come to assume those elements in printed page design, and increasingly in Web pages. And though it is not currently possible to deliver those qualities in the "pages" that make up cell-phone screens, instant messaging windows and other forms of electronic communication, it is only a matter of time.

This is why I am optimistic about the role of graphic designers, even though the near future is scary and full of obstacles. Eventually, the differentiation between useful, relevant information and "junk" information will hinge on design. But design can no longer be as labor-intensive as it is today, and it must be automated.

Enter Just-in-Time Publishing

The challenge for anyone involved in the formatting and design of information is to make all forms of that process seamlessly automated, and insert the concept of round-trip communication from data to page and from page back to data. Only then we will achieve the nirvana of personalized, just-in-time publishing.

In the last few months, I've been doing a great deal of thinking about the future of the publishing process in preparation for a new conference I'm launching (*for details, see **www. contextconference.com***). It is my contention that designers who continue to think only in terms of whole-page layout and production, will fail. Those creative professionals who embrace the idea that individual elements of content must carry structure and design with them, will thrive and become even more essential to the communications process. In every operation, the size of individual content elements will vary. For some, content will reside on a story level, or chapter level. For others, content elements might be as small as individual words or figures. Regardless, each useful element will need to contain enough information so that it can be interpreted, positioned and formatted automatically based on rules and templates created by the designer.

The Page as Container

Data and information by itself is rarely useful. We have come to depend on the structure of the page to bring meaning and purpose to otherwise random graphic elements. These days, the page can be any sort of container—from hard paper to small or large screen. So, despite the many varieties of pages out there, we can somewhat predict the various uses that content will take. That is where the designer fits into the automated publishing process.

In automated publishing, the emphasis is less on the elements of graphic style we have come to know so well: type size, style, color, etc. Instead, the emphasis will shift to the relationships between content elements: What is the hierarchy of information? Which content elements trump the other elements, and how do they interact to form the whole? Additionally, content is taking on greater and greater layers—a static image may well represent a video behind it, a paragraph may reveal a full chapter underneath, and a headline may actually be the window into an entirely different set of pages.

The best way for me to describe the publishing process of the future is that each page is essentially a snapshot in time—a planned and controlled window into a sea of information, all passing by rapidly—changing, morphing, and updating as it goes by. Just as a photograph captures a split second of reality, a page communicates because of the content elements it pulls together and presents. In print, this snapshot is forever frozen—it serves its purpose and remains useful only as long as the reader needs it. On the Web, pages are constantly changing, and never really exist except when they are viewed. Most forms of pages are now disposable—useful for only a moment until something better comes along.

Adding to the pressure to create pages quickly and without any design intervention, is the increasing ability of publishing systems and even printing presses to deliver one-off, customized output. There is no way a publish-on-demand system can work if anyone has to manually be involved in the page design and production.

How Can We Automate Design?

Most designers can relate to the idea of templates, master pages, and other means of simplifying page layout. But these tools only solve the problem of repetitive production issues—they do not think for themselves, do not understand the elements they are automating, and still need considerable intervention to create successful final pages.

In the automated publishing systems being developed now (and some already on the market), XML tags reside with the individual content elements—headlines know they are headlines, subheads know they are subheads, captions know they are captions, etc. Designers create the hierarchy of content based on their ability to anticipate as many uses of the content as possible. This anticipation and planning is the key to success in all automated publishing workflows, and I believe designers are in the best position to understand how individual content elements should behave.

Instead of templates, designers in a publish-on-demand world create rules for how content elements come together to form a page. These rules can change depending on the specific purpose. For example, a rule might say that if a page has a picture, it first should appear in the upper-right-hand corner. If that space is not available because of another specified priority, then the picture should move to the bottom left. A rule can state that if a caption runs longer than three lines, it should be reduced in size by one point until it fits. If a chart falls on the page, it can be specified that it should move to the next page unless it has five lines of text below it. Every page element can carry multiple rules, which change depending on the actual use. On a landscape page, an element may behave one way, but when it appears in a vertical format it knows to behave completely differently.

By writing good rules, the designer can assure that no matter how a page comes together, and no matter what specific content resides on a page, that the end result will be consistent and graphically acceptable. Rules can specify more than just position, they can specify color, size, type style, etc. A rule might say that on a screen page, the color is RGB, but when the same element is used on a printed page, it is specified as a Pantone spot color. The element can automatically be re-sized, increased or decreased in resolution, cropped, or changed to black and white.

When a rules-based system works, pages can be created automatically based on information about the recipient, on geographic information, on language, or on any other variable factor. This way, if every page contains different information, it can still follow company style, insure brand integrity, and be reproduced appropriately for the delivery system in play. A full-text

version can appear when displayed on a large screen, and an abbreviated version when published to a small screen. If a customer is online, pages can contain links to more information—if they are viewing the material on a stand-alone device or printed page, instead of links a toll-free phone number might appear for more information.

You can see how rules-based systems can make publishing more efficient, less wasteful, and more focused. We often publish more information than is necessary to be sure it is useful to as many readers as possible. Automated publishing can present encapsulated content that expands as necessary, based on the needs of the reader.

The Era of the Phantom Page

The problem with all of this for the design community is that there is no "final" version of anything. Pages will be in flux all the time, and despite the best of efforts, sometimes the rules may not cover everything and the results will be disappointing, if not downright embarrassing. Automated publishing is a little like raising a child—you do your best to instill values and knowledge, but at some point your kids are on their own and you can only keep your fingers crossed and hope for the best. Whether you call it smart content, intelligent information, or XML-enriched data, publishing is taking on a life of its own. But what is so exciting about automation is that it will finally allow the creative professional to insert themselves at the beginning of the information cycle, not at the end. Traditionally, design has been the final resting place of content—a necessary but detached part of communications—a one-way, dead-end process that is both time consuming and misunderstood. Finally, design formatting will be as essential to a company or organization as data management, inventory control, customer relationship, or any number of other core business practices.

Publishing systems must finally be an integrated part of content and data management—part of a genuine "round-trip" process. Changes that happen at the page level must be reflected back at the data-management stage and vice versa. The ultimate goal is to handle and format content only once, but not sacrifice good design.

The New Knowledge Set for Designers

Good design is good design, so I don't think creative professionals need to change the basic knowledge set they already have. But the massive amount of time and effort that has been put into production skills is going to become less and less relevant. Instead, designers will need to step back and focus on core brand values, establish design priorities, and help define how data is created, stored, and used.

Accordingly, designers will have to become more enterprise-savvy, to learn about databases, to learn more IT lingo, and develop an excellent knowledge of XML. But don't panic—actual XML coding will be increasingly automated. Right now we're in the equivalent of the early

PostScript days when a working knowledge of coding was necessary to get predictable and successful results.

So rather than be frightened by pages that come alive and take on a life of their own, put yourself in the mad-scientist role and be the one who builds the monster. Control will reside with those who understand the parts that make up the whole. Put them together correctly, and the results will serve you well.

notes

APPENDIX

A

Appendix A

Aquent has been a leader in delivering creative services for over nineteen years. Aquent's Marketing and Creative Services group is a business unit of Aquent Incorporated. Aquent connects design professionals with companies who wish to hire them on a freelance, project, or permanent basis.

www.aquent.com

AQUENT'S APPROACH TO SKILL ASSESSMENTS

Ron Frank, Director of Assessment Development, Aquent

Background to Our Skill Assessments

The goal of any test or skill assessment (SA) is to find out how much someone knows or how well they know how to do something. To see if someone knows about the rules of driving on the road you give them a multiple choice test. To see how well they can actually drive, you put them behind the wheel of a car and watch them go through a series of maneuvers. That's what Aquent's assessments are like: We actually see how somebody uses the software.

There are many tests that claim the ability to determine how well people can use an application. They have questions like the following (aimed at an InDesign user):

A frame contains a grayscale image the color of which you would like to change to Pantone 357. To do so you must first select it using the:

 a) Frame Tool
 b) Direct Selection Frame Tool
 c) Selection Tool
 d) Direct Selection Tool
 e) Arrow Tool.

While this is certainly a challenging question it's not actually determining if the test taker could, while using InDesign, successfully change the color of a grayscale image. Many expert users of software couldn't tell you the name of the tools they use every day. Knowing names of

tools is not evidence of how well a person knows how to use software. Looking at someone's actual documents is. Seeing if they can do X in a certain amount of time, and do it well, is how you can determine somebody's skill.

This philosophy is what led Aquent to the demanding task of creating assessments that really determine how well a person can use different applications.

How We Develop Our Skill Assessments

The first challenge for us is to make an assessment that will actually tell us if the candidate would be able to do what our clients most frequently request. Step one of the solution is to interview agents (the people matching the talent and the clients), review orders and compile the data we collect. In turn we use this data to create mock projects which the candidates will have to recreate from instructions we give them. In the end, the candidates take a skill assessment that reveals whether or not they possess the skills our clients are looking for.

The next challenge for us is to make the assessment brief enough to be taken in a limited amount of time, about 60–90 minutes. We do this by further honing down the list of skills to the ones that are requested the most. This filters out a large number of tools in any given software program. For example, we don't have too many clients asking for talent who know the 3D tools in the latest version of Adobe Illustrator, so we don't put them in. It doesn't mean we can't find a talent who knows these tools when we occasionally get asked for them. It just means we don't look for those skills every time someone is assessed in Illustrator. In this way we keep the time necessary to take the assessments to a minimum yet keep them thorough for the types of clients with whom we do business.

The final significant challenge is to make our assessments easy to score and purely quantitative. They need to be easy to score because our agents are not experts in all the software — who is? Without the checklists being quantitative we would have no way to keep the scores consistent from agent to agent and office to office. To make the assessment easy to grade we have created a checklist consisting of elemental pieces. For example, our general Adobe Photoshop Skill Assessment checklist has 52 items on it while the instructions only have about 18 steps. For the quantitative aspect of the checklist, we make the items very black and white and assign point values to each of them. A typical checklist question might say something like: Did the candidate convert the file to RGB mode? This is very easy for an agent to check with even the most rudimentary Photoshop skills.

One might assert that if the above question is the typical caliber to be found on an Aquent checklist item then the Aquent assessments must be pretty easy. Don't be fooled though. Our assessments are considered very challenging (we hear this all the time from the candidates who take them). The instructions that result in the candidate converting the file from CMYK to RGB don't simply ask the candidate to do so. Rather they would say something like, "Be sure to prepare the image for output to a typical slide recorder." Since slide recorders utilize the RGB

color space and service providers always recommend preparing your files accordingly, the candidate in turn needs to consider this, know this, and know how to switch to RGB mode. By checking something easy like this the agent is not only determining that the candidate knows **how** to change modes but **when** to change modes and, specifically, that they know about printing to a slide recorder. Having a multi-component instruction like this on our assessments helps us reduce the amount of time needed to take them.

Tips to Help You Prepare for and Take Our Assessments

As mentioned, the assessments are very challenging. To help you prepare for them, here are a few suggestions.

1. Make sure you know which software, which version, and which platform you'll be working on when you come in to take an assessment. If you're thinking QuarkXPress 5 in OS 9 and you sit down at a machine running Quark 6 in OS X, you're going to be in for quite a surprise.

2. When taking our assessments or when you're working on the computer in general, three things to keep in mind are, in order of importance:

 - The simpler the better.

 - The easier to modify, the better.

 - The easier for someone else to modify, the better.

For example, in a layout program like InDesign (or QuarkXPress) if you want a block of text to have a pale green background it's far better to apply the color to the text box itself than it is to make a separate colored box and place it behind the text. Using a single element allows for easy moving or resizing of the text box. Having two elements becomes quite cumbersome and requires scaling both items, sometimes individually. The amount of time wasted if you consider this occurring throughout an entire magazine is quite considerable. Simple also leads to consistency. If you type a bunch of spaces and/or tabs to get text to line up then it's not going to be easy to make this consistent from page to page or document to document. It's much better to just set the proper indentation as a single tab or for the whole paragraph. Using styles and master pages is an extension of making things easy to modify.

3. Be prepared. Few people actually finish our assessments in the time given—but that's okay! We make them that difficult so they are challenging for even the most expert user. However, we represent a lot of talent with varied levels of skill. If you think your skills are rusty, brush up on them. Read a book. Read a manual. Invent a project and do it. Go through a training video. Just make sure you've used the software within the past couple days so everything is fresh in your head when you come in.

If you have questions about Aquent's skill assessments please don't hesitate to contact me at rfrank@aquent.com. If you're ready for a full- or part-time position or a temporary job contact your local Aquent office. Your local office can be found on our Web site at www.aquent.com.

APPENDIX

B

Appendix B

GRAPHICS COMMUNICATIONS INDUSTRY GLOSSARY©

The DDAP Association, Idealliance (formerly GCA) GRACoL and SWOP have joined forces to bring you this definitive industry glossary. The definitions and terminology that appear herein are provided as an educational service of these groups to create a better understanding of terms used in our workplace and promote a high level of cooperation and digital partnership.

For more information or reprint permission, please contact:

The **DDAP Association** is a graphic arts industry group charged with promoting "Universal Exchange of Advertising through Open Process Integration and Accredited Standards." With the focus on digital delivery of advertising, this group advocates the use of accredited file formats in digital workflows and supports our members' transition to digital ads through the development of educational tools and seminars and consultation to build solid business practices.

Barbara Hanapole
Executive Director
DDAP Association (Digital Distribution of Advertising for Publications)
URL: www.ddap.org
Email: ddap1@mediaone.net

IDEAlliance (formerly GCA) is the leading global membership organization for advancing the processes of information interoperability and dissemination of knowledge. IDEAlliance will accomplish this mission by: Engaging in and supporting creation and adoption of globally recognized standards for information definition and exchange; Developing and encouraging efficiencies in the processes of information and image management and delivery; and Promoting understanding of the processes by conducting information activities and preparing and publishing educational materials with an emphasis towards standards development as exemplified by GRACoL.

URL: www.idealliance.org
Email: info@idealliance.org

SWOP, Inc. has become a major factor in the success of the Publication Printing Industry in the United States over the past 25 years. This has been a result of a combination of attainable goals, dedicated people driving the process and an industry willing to improve itself. The resulting recommended specifications are for the use of all those involved in the production of publications—including the advertiser, publisher, printer, advertising agency and prepress service supplier.

Barbara Hanapole
Executive Director
SWOP, Inc.
URL: www.swop.org
Email: swopinc.@mediaone.net

TERMS

A

Absorption—The relative amount of ink absorbed by paper during printing.

Accredited Standards Committee (ASC)—comprises government and industry members from North America who draft standards for submission to the American National Standards Institutes (ANSI).

Additive Color System—A color system in which wavelengths of light mix to form other colors. A mix of the three primary colors, Red, Green, Blue, produces white.

Advertising Production Club (APC)—Based in New York, the club was founded in 1931, with an objective to explore technologies and profile new practices and procedures in print production of ads.

Aliasing—The pixilated or stair-step appearance of slanted or curved lines on low-resolution, computer generated images. Also called jaggies. Jagged edges on computer-generated elements are less visible when output on a high-resolution output device.

Alkaline Paper—A stable, acid-free paper used for products that must resist deterioration and preserve their images for as long as possible. Archival photographs, high-quality books and fine art prints are made on alkaline paper.

Alley—Space between columns of type on a page.

Alpha Channel—An eight-bit channel reserved by some image-processing applications for mashing, transparency or additional color information.

American Association of Advertising Agencies (AAAA)—Founded in 1917, is the national trade association that represents the advertising business in the United States and offers its members services, expertise and information regarding the advertising business.

American Business Media (ABM)—Formerly American Business Press. Established in 1907, it is the industry association for business-to-business information providers.

American National Standards Institute (ANSI)—*Pronounced an-see.* ANSI is a nonprofit organization that provides administrative support to standards development activities within the

United States. It is the sole U.S. member body to the International Organization for Standardization (ISO) and is the organization through which all official U.S. input to the ISO takes place. It has four basic functions: (1) facilitate U.S. standardization policy developments; (2) accredit national standards developers; (3) promote U.S. standards interests globally; and (4) provide information and training on standardization.

Analog Proofing—A process or method to simulate printing using either on-press proofing presses and production presses, or off-press proofing devices. This process requires the image to be sent from the creation computer and subsequently reproduced on an interim media such as film or plate, prior to reaching the proofing media.

Apparent Dot Area (ADA)—The dot or tone percentage amount of a printed tint as measured on a densitometer utilizing the Murray-Davies equation.

Artwork—Images, including type and photos, prepared for printing.

Authoring Application—"See Native Application definition"

Author's Alterations (AAs)—Corrections made in proofs that are not caused by a prepress service provider or printer error.

Automatic Picture Replacement (APR)—A process that facilitates the creation of totally electronic files with high-resolution art and photos in place. A low-res version of the image is used as the electronic FPO during the design process, and the images are "swapped out" for the high res versions during the RIPing process.

B

Basis Weight—Weight in pounds of a ream (500 sheets) of paper cut to the basic size for its grade.

Bind—To fasten sheets or signatures and adhere covers with glue, wire, thread or by other means.

Binder—An adhesive component of paper designed to hold the paper together.

Binder's Board—Very stiff paper used to make bound book covers.

Bit—Abbreviation for binary digit. The smallest unit of information in a binary system, a bit is the fundamental unit of information used in computers. A bit element is a 1 signaling on or a 0 signaling off in a data string. Most computers work with eight-bit strings called bytes.

Bitmap—A computerized image made up of dots or pixels. While satisfactory for pixel-based screen displays, bitmap images give a jagged appearance on paper or film. For high-quality print output, bitmap images must be translated to raster images.

Black Plate Change—Changes made to text or line work on the black plate in process printing.

Blanket—A fabric-reinforced sheet of rubber used on offset presses to transfer the impression from the plate onto the paper.

Blanket Cylinder—Cylinder of a press on which the blanket is mounted.

Bleed—Live matter, such as illustrations, photographs, graphics and text, which extend beyond the edge or edges of a trimmed page so that when the page is trimmed the live matter extends to the edge, leaving no white space.

Blind Folio—Page numbers that are not printed on the page.

Blueline—A blue-toned positive photo print produced from film negatives which is prepared as a proof to check content, such as text and placement of graphic elements.

Body Copy—The main text of a story or article.

Brightness—Also called value. (1) One of the three attributes of color, the other two being hue and saturation. Brightness describes differences in the amount of light reflected from or transmitted through an image regardless of its hue and saturation. It refers to the amount of light (paper white) apparent in an area. (2) When speaking about paper, brightness is the light reflectance or brilliance of the paper at a specific wavelength, often perceived as whiteness. Generally, the higher the brightness rating, the better quality the paper.

Bulk—Thickness of paper, expressed in thousandths of an inch or pages per inch (ppi).

Burn—In lithography, to expose a blueline proof or printing plate with light.

Burst Perfect Bind—To bind by forcing glue into notches in spines of signatures and then adhering a paper cover.

Butt—To join without overlapping or space between.

C

C1S—Paper coated on one side.

C2S—Paper coated on two sides.

Calendar—To make paper smooth and glossy by passing it between rollers during manufacturing.

Caliper—Thickness of paper, expressed in thousandths of an inch.

Caption—Supplementary line or lines of copy above or below a picture or illustration.

Carload—Usually 40,000 pounds of paper.

Cast Coated—Coated paper with a surface similar to that of a glossy photograph.

Card Stock—Also called cover stock. A stiff paper often used for postcards, catalog covers and other items that require rigidity. Card stock is usually described by point sizes that give the thickness of the sheet in thousandths of inches. For example, 10-ptcard is 0.010-inch thick. Card stock can also be described by poundweights based on the weight of 500 sheets measuring 20 inches x 26 inches each.

Case Binding—Casebound, or cased-in, books are typically hard bound books. The book covers, called "cases," consist of rigid or flexible boards that are covered on the outside and on the edges with cloth, leather or other material.

Character Generation—The process of using master font information to create type images as a series of dots or lines on a computer or typesetter. The type images can be sent either to a screen for display or to an image setter for final output.

Characters Per Inch (cpi)—The number of characters that fit within a linear inch in a particular font.

Chrome—Alternate term for a transparency.

CMYK (Cyan, Magenta, Yellow, Black)—The subtractive primary colors used in printing. When all of the colors are subtracted out of the process one is left with white. Conversely, when all of the primaries are added together one gets a form of black.

CIE—Abbreviation for Commission International de l' Eclairage, or International Commission on Illumination. CIE established several visual color models that have become the basis for all colorimetric measurements.

CIP4—The International Cooperation for the Integration of Process in Prepress, Press and Post press, better known as CIP4, is a consortium of vendors in the prepress, press and post-press industries formed with the goal to find ways to make their products work together better. This group has developed the Print Production Format, or PPF, a uniform, vendor-independent file format intended to move the industry closer to computer-integrated print production.

Cleat Bind—Alternate term for side stitched.

Coarse Screen—Screen with ruling of less than 120 lines per inch.

Coated Paper—Paper with a coating of clay, white pigments and a binder, that improves ink holdout.

Coatings—A term applied to the mineral and chemical substances used to cover the surface of paper to provide improved affinity for printing inks, a reduction of the lateral spread of printed images, higher opacity, good ink hold out, and higher brightness than an uncoated sheet. Coatings are generally composed of adhesives and pigments, with miscellaneous additives included for special sheet properties.

Colorant—A pigment or dye that is the color portion of ink, toner, proofing films or paper.

Color Bar—Strip of color printed near the edge of a press sheet or off-press proof to help evaluate ink density.

Color Cast—An unwanted dominant color present in the original image or in its reproduction. Color cast usually results from lighting variance during photography or improper processing or proofing conditions.

Color Break—In multicolor printing, the point or line at which one ink color stops and another begins.

Color Correct—Retouching or enhancing color in a color separation.

Color Electronic Prepress System (CEPS)—A high-quality, proprietary computer-based system that may include equipment for page make-up, scanning color separations, displaying color, and making color corrections. This is to be contrasted with PC-based color scanning and manipulation systems often referred to as desktop publishing systems (DTP).

Color Gamut—The range of colors that can be formed by all combinations of a given set of light sources or colorants of a color reproduction system. The normal human eye can perceive a wide gamut of colors, colors within the full range of the visible spectrum, including detail in very bright light and deep shadows. Transparencies and monitors, which display color using transmitted light, can hold some of that color range, or gamut. Due to such limitations as reflected light, ink impurities, and paper absorption, a conventionally printed image is limited to a much smaller range of colors.

Color Management System (CMS)—A color management system is a collection of software tools designed to reconcile the different color capabilities of scanners, monitors, printers, image setters, and printing presses to ensure consistent color throughout the print production process. Ideally, this means that the colors displayed on your monitor in your proof accurately represent the colors of the final output. It also means that different applications, monitors, and operating systems will display colors consistently.

Color Process—Alternate term for four-color, cyan, magenta, yellow and black, printing.

Color Proof—Used as a versatile feedback and process control mechanism in preparing color content for printing. The proof is used to confirm the color produced by the prepress production group prior to shipment of films, or digital data, to the reproduction group. The final color proof made by the prepress production group, and approved by its customer, is the reproduction group's contract as to the expected performance of the printed page and this final color proof is also sometimes referred to as the contract proof.

Color Separation—The photographic or electronic means of separating color artwork into cyan, magenta, yellow and black components.

Color Transform—A mathematical equation used to transform digital color from one color space to another; as in moving data from the RGB color space to the CMYK color space.

Committee for Graphic Arts Technologies Standards (CGATS)—The accredited standards development committee under ANSI responsible for graphic arts industry standards. It is charged with the overall coordination of graphic arts standards activities and the development of graphic arts standards where no applicable standards developer is available.

Complementary Colors—Colors that lie opposite each other on the color circle. Here, any given color reflects exactly those wavelengths that the color directly opposite of it on the color wheel absorbs. A color will give a greater degree of color contrast to its complementary color than to any other color.

Composite Proof—Proof of color separations in position with graphics and type.

Comprehensive Dummy—A complete simulation of a printed piece.

Computer-to-Plate (CTP)—A variety of technical mechanisms used to expose printing plates from prepared digital data, avoiding the intermediary step of producing film.

Computer-to-Press Cylinder (CTPC)—A variety of technical mechanisms used to engrave gravure press cylinders from prepared digital data.

Concept Creation—Focuses on the initial stages of the creative process and encompasses thumbnail and roughs as part of the design stage.

Contact Sheet—Alternate term for proof sheet.

CT or Continuous Tone—An image in which the subject has continuous shades of color or grey without being broken up by dots. Continuous tone images cannot be reproduced in that form for printing but must be screened to translate the image into dots.

Continuous Tone Proof—This is a proof that does not contain halftone dots. It is produced as either a view file (i.e., the amount of data used to display an image on a monitor) or fine file (i.e., the amount of data required to achieve satisfactory results in print) resolutions.

Contract Proof—A proof that when approved by the print buyer, constitutes a contractual obligation with the printer to purchase the printed materials that match the proof.

Contrast—Range of gradations in tones between lightest white and darkest black in continuous tone copy or the abrupt change between light and dark in line copy. Quantified as the difference between the highlight and deepest shadow density readings as measured by a densitometer.

Copy—All written material. For a graphic designer or printer, everything that will be printed, including illustrations, photographs, graphics and text.

Copy Block—Shown as an area on the dummy (i.e., rough layout) as the amount of space to be occupied by type.

Copyright—Ownership of creative work by the writer, photographer or artist.

Corner Marks—Lines on a mechanical, negative, plate or press sheet showing the corners of a page or finished piece.

Cotton Content Paper—Paper made from cotton fibers rather than wood.

Creep—In saddle-stitched documents, a stair-step condition caused by multiple overlaid signatures. The inside pages creep away from the spine and push out on the opposite edge. Creep is a concern when using thick paper or too many pages.

Crop—To eliminate portions of an illustration or photograph so the remainder is clearer or able to fit the layout.

Crop Marks—Markings that show where a page, photograph, illustration or transparency is to be trimmed.

Crossover—Image that goes across the gutter to the opposite page.

Cutoff—The circumference of the impression cylinder of a web press; also the length of the sheet the press will cut from the roll of paper.

Cut Stock—Term for paper 11x17" or smaller.

CWT—Abbreviation for 100 pounds.

Cyan—A process color-process blue.

D

Data Blocks—The maximum size of continuous data that can be recorded as a single block. The larger the data block, consistent with the total data size, the more efficient (i.e., less over head) the transfer and storage of the data.

Data Compression—The translation of a computer file into a format that uses less disk space. Compressed files must be decompressed to be used. (See also lossless compression and lossy compression.)

Data Transfer Rate—Generally defined in units of kilobytes per second (KBS) or Megabytes per second (MBS). Care should be used as sometimes the "B" means bytes and sometimes bits—which is a difference of a factor of eight. The data transfer rate is the sustained rate at which data can be written or read either by any given device itself or the rate at which data is transferred between various systems and devices.

DCS—The Desktop Color Separation (DCS) image file format, which contains both a low resolution preview (one file) and the information necessary for a separation of the image (four files, CMYK), is a picture format definition for electronic color separations. Two types of programs use the DCS format: DCS producers and DCS consumers. DCS producers are applications that produce color separations from color images. DCS consumers are desktop publishing and page layout applications capable of driving an output device. Many applications that create color separations have a record-keeping function that maintains a connection between the document being created and the high-resolution files used for printing. A DCS producer application provides information to a DCS consumer (such as a page layout program) in a "main" file about the location of high-resolution separation files. When the document is color separated, a DCS consumer application will locate and use the high-resolution files.

DCS2—The low-resolution preview and the information necessary for a separation of the image are combined into one file (see DCS). It also has the ability to specify additional plate colors. DCS 2.0 can point to spot color plates in addition to the standard cyan, magenta, yellow and black.

Debossing—Indented letters or designs on paper or other material. Uninked dies or blocks produce the effect. Any colors to be used are applied first by regular printing methods.

Deckle Edge—Feathered edge on specially made sheets of text and cover paper.

Densitometer—An instrument that measures the lightness or darkness of an image. A reflection densitometer measures the light reflected by an area that has been darkened by ink or by photographic processing. A transmission densitometer measures light transmitted through an area of film. In printing, a reflection densitometer is used to measure and control the density of color inks on the paper.

Density—Relative darkness of copy, ink on paper or emulsion on film, as measured by a densitometer.

Density Range—Expression of contrast between darkest and lightest areas of copy.

Desktop Publishing (DTP)—The process of creating fully composed pages using a personal computer and off-the-shelf software, usually with an output device such as a laser printer.

Die—Sharp metal rule used for die cutting or block of metal used for embossing or foil stamping.

Die Cutting—Cutting irregular shapes in paper using metal rules.

Digital Ad Lab (DAL)—A digital advertising users group representing ad agencies, publishers, suppliers, printers, and manufacturers formed to promote and facilitate the adoption of 100% digital ad workflows. The core mission of the group is to provide an open forum for the exchange of ideas, issues and resolutions to enable the full adoption of digital ads.

Digital Data Exchange Standards (DDES)—A body of accredited standards developed for the graphic arts industry by the ANSI accredited Image Technology committee (i.e., ANSI IT8), the ANSI CGATS committee, and the ISO accredited graphics technology committee (i.e., ISO TC130). DDES provides standardized exchange formats, standard device interfaces, and standard digital color process control tools for the digital information developed and used in design, production and reproduction for both graphic arts and intermedia.

Digital Distribution of Advertising for Publications (DDAP)—DDAP is a leading graphic arts industry group charged with promoting "Universal Exchange of Advertising through Open Process Integration and Accredited Standards." With the focus on digital delivery of advertising, this group advocates the use of accredited file formats in digital workflows and supports our members' transition to digital ads through the development of educational tools and seminars and consultation to build solid business practices.

Digital Press—An output device capable of outputting graphic arts quality material (i.e., integrated text, graphics and well controlled, repeatable, process color images) directly from digital data. Fundamental to this class of devices is that some flexibility also exists in the area of binding and finishing the printed material.

Digital Proofing—A proofing process to simulate printing using inkjet, thermal transfer, electrostatic or other digitally based systems including soft proofing directly from color monitors. This process requires that the image be sent from the creation computer to be reproduced directly on the proofing media.

Direct Digital Color Proof (DDCP)—Prepress color proofs that are imaged directly from digital data without involving the intermediate steps of film and contact exposure. *(See also Color Proof.)*

Dot Gain or Spread—Dots printing larger on paper than they are on negative or plate. This is also referred to as Tone Value Increase, or TVI.

Drop Out—To eliminate halftone dots or fine lines due to overexposure during platemaking. The lost copy is said to have "dropped out."

DPI, or Dots Per Inch—A measure of resolution usually applied to scanners and output devices.

Duotone—A halftone image created by overprinting two different halftone screens of the same image with different colors and tonal ranges. Duotones are commonly printed using black ink and a colored ink and sometimes with two black inks (also called a double-hit, or double-bumped black) to increase the detail and saturation of the black part of an image. They can also be created from two different spot colors.

Duplex Paper—Paper with a different color or finish on each side.

Dynamic Range—The range of tones from lightest to darkest a scanner can see and resolve.

E

Electronic Data Interchange (EDI)—The transfer of business data between different companies using networks, such as the Internet. ANSI has approved a set of EDI standards known as X12.

Electronic Mechanicals—Digital page layout files created on the desktop.

Embossing—Raised letters or designs on paper or other material. The effect is produced by uninked dies or blocks. Any colors to be used are applied first by regular printing methods.

Emulsion—Coating of chemicals on papers, film and printing plates that, prior to development, is sensitive to light.

Enamel Paper—Alternate term for coated paper with gloss finish.

Equivalent Weight—The term used to denote the respective weights of the same paper of two different sheet sizes.

Error Correction Circuits (ECC)—These are algorithms that have built-in techniques to check the validity of the transmission of the data. The simplest is the parity error check, where, say 7 bits are transmitted and the eighth bit (of a byte) reflects whether the sum of the 7 data bits is odd or even. If after receipt, these two do not agree, then the data is transmitted. ECC is applied to improve the bit error rate (BER). These techniques, in one form or another, are in use on almost all memory devices and data transmission systems.

F

File Format—A set of instructions that describe how to store, access, or transmit digital information. Being able to match the format of data created in one program to what can be received by another is the basis for file compatibility.

Fine File—A high-resolution file that is ultimately used to image final halftone films plates or the ultimate output itself. The fine file is generally calculated after all corrections are made to the view file. As a general rule, the view file contains roughly one-third to one-fourth of the total amount of data found in a fine file. Fine files for the print medium can range from about 32 Mbytes up into the GigaByte range for one file.

Fine Screen—Screen with ruling of more than 150 lines per inch.

Finish—Surface characteristic of paper.

Finishing—Term used for all bindery operations.

Flexography—Method of printing on a web press, using rubber plates with raised images.

Fluorescence—The ability of a substance, such as paper or ink, to absorb ultraviolet light waves and reflect them as visible light.

Flush Cover—Cover that is trimmed to the same size as inside pages.

Fold Marks—Markings at the top edge of a page showing where folds should be.

Folio—A page number.

Font—The complete assortment of upper case and lower case characters, punctuation and numerals of one typeface.

Form—One side of a press sheet. When folded, the form is called a signature.

Fountain—Reservoir for ink or water on a press.

Four-Color Process—Technique of printing that uses the four process colors of ink to simulate color photographs or illustrations.

Furnish—The mixture of fibers, water, dyes, and chemicals that become paper during the papermaking process as approximately 95% of the water is removed. Also called slurry and stock.

G

Gamma—(1) In photography, the degree of contrast in an image. Film types are listed, as creating certain gamma ranges appropriate to different uses. (2) In electronic color correction, the difference in the status of the color curve. The color curve represents highlight to shadow values between current values and corrected values.

GCR or Gray Component Replacement—Also called achromatic color replacement (ACR), integrated color removal (ICR), and polychromatic color removal (PCR). Removing the achromatic (also called contaminator graying) component of cyan, magenta, and yellow when they all combine and replacing it with black to provide the necessary density to meet TAC requirements. Gray component replacement is distinct from under color removal, which reduces process colors in only dark, neutral areas and adds black. GCR separation is done with specialized software on electronic scanners.

Ghost—A faint, unwanted image on a printed sheet that is a result of the printing system itself. A ghost usually appears as a lighter image printed as a repeat of an image and is caused by the layout of the press form and inability of the press's inking system to compensate for a large change in ink coverage.

Ghost Halftone—Halftone that has been screened to produce a very faint image.

Gigabyte: (10G9)(GB)—1,000 (thousand) megabytes or 1,000,000,000 Bytes (See Megabyte).

Gloss—A shiny coating on paper. Gloss is the relative amount of incident light reflected from a surface. Gloss coatings allow very little ink absorption, thus providing excellent color definition and contrast.

Grade—One of seven major categories of paper: bond, uncoated book, coated book, text, cover, board and specialty.

Grain—(1) In photography, the speckled appearance in prints or transparencies produced by clusters of silver particles in photographic emulsions. Frequently considered undesirable and apparent when an original is enlarged too much, grain can also be emphasized for special, softening effects. (2) In paper making, the direction in which most wood pulp fibers lie within the sheet due to the direction of flow as the paper is made. Folding paper against the grain breaks more wood pulp fibers than folding with the grain, resulting in an uneven, less precise fold.

Graphic Arts—The crafts, industries and professions related to designing and printing messages and producing print communication.

Graphic Arts Technical Foundation (GATF)—Chartered with developing leading-edge practices for printing and publishing, GATF consolidated with the Printing Industries of America, and its 30 local affiliates to provide the industry with a single source for technical and management solutions.

Graphics Primitives—Graphics primitives are generally mathematical instructions used to create boxes, circles, bar charts, pie charts, etc. on a computer. Graphic Primitives are comprised of vector data.

Gravure—Method of printing using etched metal cylinders, usually on a web press.

Grayness—A function of the unwanted absorption of wavelengths of light by process color inks. The portion of a process ink that makes it deviate from a pure saturated hue. To calculate percent grayness of a process ink using a densitometer, multiply 100 times L the lowest of its densities to red, green and blue wavelengths of light then divide that number by H (the highest of its densities to red, green and blue wavelengths of light).

Groundwood Paper—Newsprint and other inexpensive papers made from pulp created by grinding wood mechanically.

Gutter—Space between columns of type where pages meet at the binding.

H

Halftone—a binary approximation of a continuous-tone image that enables the press to reproduce it using ink spots arranged in patterns.

Halftone Dots—Dots that, by their varying sizes, create the illusion of shading or a continuous-tone image.

Hard Dot—A halftone dot that has a hard, crisp edge without the fringe seen with the soft dot. The halftone dot also has a fairly uniform density over its entire surface.

Heat-set Web—Web press equipped with an oven to make ink dry faster; thus, able to print coated paper.

Helium-neon laser—The most common form of gas laser that emits between a fraction of a milliwatt and tens of milliwatts at a wavelength of 632.8 nanometers (nm.). Helium-neon (HeNe) lasers can expose red-sensitive films.

Helium-Cadmium (HeCd) laser—is a metal vapor laser in which the active medium is an ionized metal vapor (cadmium) mixed with an inert gas (helium). Helium-cadmium lasers can expose blue-sensitive films.

Hickey—A speck or imperfection in printing, most visible in areas of heavy ink coverage, caused by dirt on the plate or blanket. This prevents ink from being applied in the area, resulting in a characteristic donut-shaped effect.

High Contrast—Few or no tonal gradations between dark and light areas.

Highlights—The lightest areas in a photograph or halftone.

HTML (HyperText Markup Language)—Computer language used to describe the contents of documents on the Internet.

Hue—One of the three attributes of color, the other two being saturation and brightness. Hue is determined by the color's dominant wavelength within the visible spectrum.

Hue Error—Characterizes colorants used as process colors. Expressed as a percentage, hue error indicates the deviation from a theoretically pure process hue. It does not indicate any error or problem with the process inks. To calculate hue error using a densitometer, multiply 100 times the difference between M and L (the middle and lowest of its densities to red, green and blue wave lengths of light) then divide that number by the difference between H and L (the highest and lowest of its densities to red, green and blue wave lengths of light).

I

IDEAlliance (formerly GCA)—A global membership organization whose mission is to support adoption of globally recognized standards for information definition and exchange, develop and encourage efficiencies in the processes of information and image management and promote understanding of the processes by publishing educational materials.

Image Area—Portion of a mechanical or plate that will print.

Image Assembly—Combining individual elements of a page, such as editorial content and partial page advertising, into one complete page unit.

Imagesetter—A general term used for devices that generate graphic arts films or paper from electronic data sources.

Image Technology Standards Board (ITSB)—The standing organization within ANSI with planning and coordination responsibility for image technology standards.

Imposition—Arrangements of pages on flats so they will appear in proper sequence after press sheets are folded and bound.

Impression—The result of one cycle of a plate cylinder on a printing press.

Indicia—Postal permit information printed on objects to be mailed and accepted by USPS in lieu of stamps.

Information Systems Standards Board (ISSB)—The standing organization within ANSI with planning and coordination responsibility for information systems standards.

Ink Fountain—Reservoir on a printing press that holds ink.

Ink Jet—Method of printing by spraying droplets of ink through computer-controlled nozzles.

Inserts—Additional pages included in the binding of a printed piece, often on different paper stock and/or with different print values.

Interleaves—Extra blank pages inserted loosely into printed pieces.

International Color Consortium (ICC)—A group of eight industry vendors working in consortium for the purpose of creating, promoting and encouraging the standardization and evolution of an open, vendor-neutral, cross-platform color management system, architecture and components. Through the development of the ICC profile specification, color data created on one device may be translated into another device's native color space. The adoption of this format by operating system vendors allows end users to transparently move profiles and images with embedded profiles between different operating systems and be confident that their image will retain its color fidelity.

International Federation of Publishers Press (FIPP)—An organization in Europe responsible for creating specifications for magazine color proofing and printing.

International Prepress Association (IPA)—The International Prepress Association is a trade association consisting of graphic communications companies and their suppliers.

International Organization for Standards (ISO)—A worldwide federation of national standards bodies from over 100 countries whose mission is to promote the development of standardization and to facilitate the international exchange of goods and services. The ISO Technical Committee responsible for the graphic arts is TC 130.

International Telecommunications Union (ITU)—One of three major accredited international standards bodies.

ISO 12639—Prepress digital data exchange—Tag image file format for image technology (TIFF/IT) This International Standard specifies a media-independent means for prepress electronic data exchange. This International Standard defines image file formats for encoding color continuous-tone picture images, color line-art images, high-resolution continuous-tone images, monochrome continuous-tone images, binary picture images, and binary line-art images.

ISSN—International Standard Serial Number assigned by the Library of Congress in Washington, DC to magazines, newsletters and other serials requesting it.

IT8.8—Prepress digital data exchange—Tag image file format for image technology (TIFF/IT). This standard specifies a transport-independent means for transferring the standard data formats developed by ASC IT8. It was created to satisfy the need for a transport-independent method of encoding raster data in the IT8.1, IT8.2 and IT8.5 standards. It includes a transport-independent way to encode high-resolution continuous tone images, in addition to the color picture, color line art, monochrome picture, binary picture, and binary line art image formats in IT8.1, IT8.2 and IT8.5.

J

Jaggies—See aliasing.

K

Kelvin (K)—A thermometric scale used to measure light temperature. 0K is absolute zero (a hypothetical temperature representing the complete absence of heat); water freezes at 273.15K, which is 0C or 32F. The most common use of Kelvin temperatures in the graphic arts is to describe lighting sources for viewing and analyzing color. The color of light sources is measured

in Kelvin. A standard balanced light source (neutral in hue and with the brightness of midday sunlight) measures 5000K.

Knockout—When type or line art is to be printed over a photograph or other variable color background, the best way to produce a consistent color is to first reverse the type or artwork out of the background and then drop in the desired color. This process is referred to as knocking out. *(See also reverse type.)*

L

Laser—Abbreviation for light amplification by stimulated emission of radiation. It is the amplification of only one frequency of light within the spectrum to create a directional, intense beam. The beam has a very narrow bandwidth capable of producing images through electronic impulses.

Laser Printing—Method of photocopying, using a laser beam to charge the drum.

Layout—Drawing of a design for a proposed printed piece showing position, color and size of copy.

Leading Edge—The edge of the paper that enters the press first. (Gripper edge.)

Letterpress—Method of printing from raised surfaces. The "Letterpress" is the name of the press used.

Light Table—Translucent glass surface lit from below, used by production artists and strippers.

Line Interleaved—Color data that is organized in the computer in a line-by-line fashion (i.e., a line of yellow, a line of magenta, a line of cyan, a line of black, etc.).

LW or Line Work—Artwork that, unlike a continuous-tone image, has no gradations of tone and therefore does not require screening for reproduction in print.

Lines Per Inch—The number of lines or rows of dots there are per inch in a screen and, therefore, in a screen tint, halftone or separation.

Lithography—Method of printing, using a chemically-coated plate whose image attracts ink and whose nonimage areas repel ink.

Loop Stitch—Type of binding method—saddle stitched with staples that are also loops that slip over rings of binders.

Loose Color—These are color images that are color separated and sent to the customer as individual elements. This term is also used to describe the images that have been separated but not yet stripped.

Lossless Compression—Data compression methods that rearrange or re-code data in a more compact fashion and lose no information when decompressed. Because all data are preserved, there is a distinct limit to the amount of compression that can be achieved (for example, 3:1 or 5:1). *(See also data compression and lossy compression.)*

Lossy Compression—Data compression methods (for example, JPEG) that selectively discard repetitive information to decrease file sizes. Depending on the amount of compression requested, the lost information may or may not be noticeable. At rates of 25:1, the results are easily seen. *(See also data compression and lossless compression.)*

Loupe—Alternate term for Graphic Arts magnifier.

LPI, or Lines Per Inch—See Image Capture section for description of dpi, lpi and ppi.

Live Area—Alternate term for Image Area.

M

Magazine Publishers of America (MPA)—The MPA is the industry association for consumer magazines. Established in 1919, the MPA represents more than 200 US-based publishing companies with more than 1,200 titles; more than 75 international companies; and more than 90 associate members providing services to the industry.

Magenta—One of the four process colors; also known as Red.

Make-Ready—Also called set up. All work done on a printing press before running a job. Make-ready includes adjusting the plates, feeder, grippers, side guides; putting inks in the fountains; registering the plates; and, matching the printed result to the supplied proof (bringing it up to color). For short runs of a few thousand, the make-ready costs are a significant percentage of the total printing costs.

Matching Color—Printed color that is required to match something such as the original image, a product color, etc.

Matte Finish—Slightly dull finish on coated paper.

Maximum Latency Time—This is the maximum time for a computer memory unit to reach any new location on a disk from any previous location.

Mechanical—Assembly of type, graphics and other line copy, complete with instructions to the printer.

Medium Screen—Screen ruling of 133 or 150 lines per inch.

Megabyte: (10G6)(MB)—A megabyte is 1,000,000 bytes. A typical 8 x 10 inch process color image at 150 line screen contains 28,800,000 bytes. Each byte represents one color of a pixel (e.g. picture element) and there are 7,200,000 discrete pixel locations in the data describing this image, with each pixel being described by four colors (one byte for each of CMYK). This number of pixels is generally four times the line screen, i.e.: Pixels = 4 (Line Screen) 2 (Area) = 4(150)G2 (8 × 10) = 7,200,000 Data = (No. of Colors) × Pixels = 4 × 7,200,000 = 28,800,000 bytes.

Metallic Ink—Ink containing powdered metal that sparkles in the light.

Metamerism—The phenomenon that results when the color of two objects match under one lighting condition and not under another.

Micrometer—Instrument used to measure thickness of paper.

Middle Tones—Tones in a photograph one-half as dark as its shadow areas and represented by dots between 30% and 70% of full size.

Moirè—An undesirable optical pattern that happens when two or moirè grid patterns overlap, such as the halftone dots produced by an angled screen. A moirè may also occur when a pattern in the artwork, such as a herringbone weave or window blinds, interferes with a halftone dot pattern. Manipulating stochastic artwork when scanning or using stochastic screening may eliminate the moirè.

N

Nanometer—One-billionth of a meter. The wavelengths of electromagnetic energy, which includes visible light, is measured in nanometers.

Native Application or Authoring Application—A program, which runs on a particular brand and model of processor or in a particular operating system, Also, the file format in which an

application normally saves its documents. The native format is generally readable only by that application (other programs can sometimes translate using filters).

Negative—Image on film or paper in which blacks in the original subject are white or clear and whites in the original are black or opaque.

Negative Space—Alternate term for White Space.

Newton's Rings—Irregularly shaped patterns, similar to oil on the surface of water that appears in a color separation. They are caused by the varying amounts of air between the scanning cylinder and transparency surfaces as they come into contact. The light refracts into a rainbow pattern as it passes from the cylinder through the air pockets to the transparency. This is avoided by applying a coat of oil (to make airless contact) or a thin mist of powder (to prevent any contact) between the two surfaces.

Non-Image Area—Portion of a mechanical or plate that will not print.

NPES—The Association for Suppliers of Printing, Publishing and Converting Technologies.

O

Off-Press Proof—Commonly, a proof generated before the production presses run and before, or instead of a press proof.

Offset Printing—Method of lithographic printing that uses the repellant properties of oil and water to reproduce an image on a flat surface that contains both the image and non-printing areas. Lithographic plates are dampened with water that is repelled by the image area. Ink is then applied to the image area by ink rollers. An intermediate blanket cylinder picks up and transfers the ink image from the plate to the paper.

Open Web—Web press without a drying oven, thus, unable to print on coated paper.

OPI or Open Prepress Interface—The automatic replacement of low-resolution FPO images in page layouts by high-resolution scans, typically done at a prepress provider, or printer.

Output—Processed optical or electronic data transferred to another device such as a secondary storage unit, a laser printer, an electronic manipulation station, or an analog or digital proofing device.

P

Page Descriptor, and/or Document Descriptor—Description of all of the elements to be placed on the page, their respective position on the page (XY coordinates), and the page's position within the document.

Pagination—Assembly of type with other line copy into page format.

PDF or Portable Document Format— A file format used to represent a document in a manner independent of the application software, hardware, and operating system used to create it.

PDF/X-1—A standard file format for the blind exchange of digital data. It was originally accredited by ANSI as PDF/X-1:1999 and then ISO as PDF/X-1:2001. The standard specifies methods for using PDF to disseminate object-based composite digital data that is complete and ready for final print production. CMYK and optional spot-color support are defined and all fonts must be embedded.

PDF/X-1a—A subset of PDF/X-1 that prohibits the embedding of OPI-referenced files.

Perfect Binding—A binding method where the binding edge of a book or magazine is ground down about 1/8 inch and coated with a fast-drying glue. Then, a flexible cover is attached, creating a squared-off backbone.

Perfecting Press—A press capable of printing both sides of the paper during a single pass.

Pica—A typographic measurement. There are 12 points to a pica and approximately 6 picas to an inch.

PICT—A common data format for graphics popular with illustration applications running on the Macintosh platform. PICT data can be created, displayed on the monitor, and printed.

Pixel—Abbreviation for picture element. The smallest unit that can be sensed, manipulated, or output by a digital system or displayed on a computer screen. More pixels per inch mean better resolution. Pixel Interleave-Color data within a computer that is organized in a pixel-by-pixel order (i.e., a pixel of yellow, a pixel of magenta, a pixel of cyan, a pixel of black, etc.).

Pleasing Color—Printed color that is more subjective in nature (e.g., flesh tones, sky, etc.) than matching color.

Plate—Reproduction of type and images on metal, plastic, rubber, or other material to form a printing surface.

Platesetter—A device used to expose metal plates (sometimes paper or plastic plates) directly from digital files. Some platesetters also produce proofs from the same file.

PMS Pantone Matching System—A check standard trademark for color reproductions and color reproduction materials owned by Pantone, Inc.

Point—(1) In measuring type, 1 point is 1/12 of a pica or 1/72 of an inch. Twelve points make up a pica and 72 points to an inch. (2) In measuring the thickness of heavy paper stock such as bristol board, a point is 1/1000 of an inch. Thus, 10-pt stock is 10/1000, or 0.010 inch.

Porosity—The open or closed characteristics of a paper's surface that allows air to pass through and ink to penetrate. Generally, coated papers have very closed surfaces, low porosity, and hold ink on the surface well. Some papers used for blow-in cards are porosity rated for bindery use.

Positive—Characteristic of an image on film or paper in which blacks in original subject are black or opaque and whites in the original are white or clear.

PostScript(®)—A vector-based page description language that is resolution, platform and device independent. It consists of a specific set of software commands and protocols that form images on output printers when translated through a raster image processor.

PPI or Pixels per Inch—A way of describing the resolution of a digital image. See Image Capture section for description for dpi, lpi and ppi.

Prepress—A term used within the graphic arts industry that covers the steps between the creation of an idea and the placing of a printing plate on a printing press. The primary function of prepress is to accept the creative input (layout, text, images, symbols) and format these into imagery that can be used to manufacture printing plates that yield the desired print results. As such the work is highly device dependent (e.g., ultimately it goes on a printing press) and highly resolution dependent.

Press Gain—The growth of the printed halftone dot from its size on the film and printing plate to its actual size on printed paper—generally a 10 to 25 percent size gain at 50 percent dot size.

Press Run—The number of pieces printed.

Printing Plate—Surface carrying image to be printed.

Process Colors—The colors needed for four-color process printing: yellow, magenta, cyan and black.

Process Control—a method of monitoring, controlling and improving a process through statistical analysis. The four basic steps of process control include measuring the process, eliminating variances to make the process consistent, monitoring the process and improving the process to its best target value. Progressive Proof or Prog-Press proof showing each color of a job separately or several colors in combination.

Proof—Test sheet made to reveal errors or flaws, predict results and record how a printing job is intended to appear.

R

Random Proof—Also called first submits, scatter or loose proofs. A press proof or off-press proof of unassembled images randomly placed on a page. Generally the first proof to be evaluated, a random proof can be used for preliminary color OKs and color correction.

Raster Image Processor (RIP)—The process of converting a vector-based page description language, such as PostScript, to a raster format at the resolution and in the format required for a specific output device or image setter/platesetter. The RIP may also incorporate machine-specific instructions, and the RIP may occur either in the imaging device or in a separate computer system. Some RIPs support color separations and trapping, and can output to proofing prior to imaging.

Ream—500 sheets of paper.

Register—Also called registration. Two or more images positioned in predetermined alignment. Out of registration refers to an element reproducing slightly above or to the side of the matching one underneath it.

Register Marks—Marks outside the main image area on a layout that indicate how one color of a separation or plate should be placed in relation to the others in order that all colors are in register with each other.

Resolution (res)—The degree of image sharpness that can be reproduced by a piece of equipment. Resolution is measured in dots per inch (dpi), or pixels per square millimeter. On high-end scanners, resolution is counted both vertically and horizontally; for example, res 12 is counted as 12 x 12 = 144 pixels per square millimeter. Desktop publishing equipment usually measures resolution in dots per inch; for example, a 300 dpi printer. The higher the resolution, the better the image detail appears and the larger the file becomes, requiring more computer memory and longer processing times.

Reversed Type—Type knocked out or reversed in a colored field, such as white type in a black background.

RGB (Red, Green, Blue)—The primary color set for additive color space. When one adds all of the primaries together one gets white.

Right Reading—Copy reading correctly (normally) from left to right.

Rosette—A regular circular pattern created by the halftone dots of process colors when reproduced in register and at the correct screen angles: K (black) at 45°, Cyan at 105°, Magenta at 75°, Yellow at 90°.

Rotogravure—Gravure printing using a web press.

S

Saddle Stitch—A binding method where signature is opened up and stapled at the center. Multiple signatures can be stacked on top of each other and stapled. Pamphlets, folders, leaflets and magazines (of a maximum thickness) that consist of folded signatures bound by staples through the centerfold are called saddle stitched.

Saturation—One of the three attributes of color, the other two being hue and brightness. Saturation is the intensity of a hue at a given lightness. The closer a color is to neutral gray or white, the less saturated the color. The farther away it is, the more saturated it is. Thus, bright red is a saturated color and pink a less saturated color.

Scatter Proof—The use of large area proofing materials to proof many different images, loose or stripped, at one time.

Screen Density—Amount of ink, expressed as percent of coverage that a specific screen allows to print.

Screen Ruling—The number of rows or lines of dots per inch in screen for tint or halftone.

Self Cover—A publication format where the cover stock is the same weight as the text stock, as opposed to attaching a separate cover of heavier paper. Self covers are commonly used for booklets and similar small publications.

Sharpen—In detail enhancement, to electronically exaggerate the difference between tones or colors at their edges. During scanning, the function of unsharp masking can be adjusted to increase edge contrast and artificially enhance the detail overall. Certain color manipulation programs have special tools to selectively sharpen isolated areas of an image.

Sheetfed Press—Press that is fed one sheet at a time.

Shingling—Adjustment of inside margins, or gutters, made during page layout, file preparation or assembly to compensate for creep. Creep occurs when inner pages of a saddle stitched document creep away from the spine and push out on the opposite edge.

Side Stitch—A binding method where two or three staples are passed through the signatures, usually on the left side of the book.

Signature—Sheet of printed pages which, when folded, become part of a publication. Signatures always contain pages in increments of four, such as 4, 8, 12, 16, 24, or 32 pages.

Silhouette—Eliminating the background from behind an object in a photograph or piece of art.

Slur—An undesirable printing condition whereby the printed image is smeared. Slur can result from insufficient blanket pressure due to improper packing (offset), slippage of a press part during the printing stroke (screen-printing), mechanical problems on the press, or lack of ink tack. In offset printing, slur causes halftone dots to enlarge dramatically and affects color fidelity. Type can become blurred and difficult to read. Print control targets containing micro-line slur bars can be placed at the edge of a form to spot and diagnose the problem. Slur is distinguished from a similar press problem called doubling, where the image is printed again next to the correct version instead of just smearing the ink.

Soft Proofing—An image displayed on a color video monitor that visually simulates the expected printed results from the same digital data.

SPACE or Specifications for Publisher/Agency Communications Exchange—An ANSI standard for the exchange of digital data relating to the business transactions that take place between advertiser and publisher, such as insertion orders and ad rates.

Specifications for Newsprint Advertising Production (SNAP)—A set of guidelines supported by the Coldset/Non-Heat set Web Section of the Web Printing Association (WPA) and the Newspaper Association of America (NAA) for consistent and predictable printing of advertising by non-heat set, offset presses, usually on newsprint and similar uncoated stocks. SNAP specifies color standards, film densities, screen rulings, reverses, surprinted type, proofing, color bars and proofing stock.

Specifications for Web Offset Publications (SWOP™)—SWOP guidelines cover film densities, screen rulings, reverses, surprinted type, proofing, color bars, and proofing stock. The purpose of SWOP is to encourage uniform communication among those involved in the production workflow and to promote consistent quality color in web offset publications.

Stitch Bind—To bind with wire staples.

Stochastic Screening—An alternative to conventional screening that creates tonal gradations by placing same-size micro dots (typically 12 to 30 microns) in a computer-controlled, random order within a given area. The computer uses frequency modulation to vary the number and placement of same-sized dots. The random dot pattern eliminates many moirè problems and allows more than four-colors to represent the tones in an image.

Subcommittee—Under ISO and IEC, subcommittees are those organizations that are responsible for the development of international standards within a defined area. Under ANSI, subcommittees have responsibility to deal with special international issues which involve subjects of a wider scope than those assigned to individual technical committees, task groups, or study groups.

Subtractive Color—Colors in which each element of a mixture subtracts another segment from the light absorbed. (e.g., In printing, the principal colors are Cyan, Magenta and Yellow. Whereas with color monitors or CRTs the primary colors are Red, Green and Blue [additive].) The mixing of inks, pigments, etc., are subtractive color processes.

Substrate—A base upon which something is applied. This can include paper that is printed with ink, acetate that is coated with a photosensitive emulsion, and proofing material (paper-based or plastic) that is laminated with colorant. Because the graphic arts industry repeats an image at different stages of reproduction onto various materials (originals, proofs, final printed pieces), the use of the term substrate permits a discussion of the characteristics of those materials as an element in the perception of that image.

Surprint—To print over another image. In photography, two images are exposed on one piece of film creating a double exposure. In a layout for printing, an image (usually type) would be planned to print over another area of an image. For instance, a black headline could surprint a light area of an image instead of removing all color below the type (dropping out). That would eliminate the need to mechanically trap (create overlapping edges) the type to the image. (Also known as Overprint.)

T

Tabloid—The page size of a newspaper, approximately 11 3/4" wide and from 15" to 17" long, or about half the standard newspaper page size.

Tack—The stickiness of an ink. Tack is the relative measurement of the cohesion of an ink film, which is responsible for its resistance to splitting between two rapidly separating surfaces.

Technical Advisory Group (TAG)—A TAG is an ANSI-recognized group that has the primary responsibility for participation in the ISO Technical Committee or Subcommittee Work. It is the TAG's job to recruit delegations, supervise their work, and determine ANSI positions on proposed standards.

Tensile Strength—One of the tests for paper strength, which measures the number of pounds of pull per unit needed to break it.

Terabyte—1,000 (thousand) gigabytes or 1,000,000 (million) megabytes. (*See Megabyte.*)

Text Stock—Paper stock used for the pages of reports, books, and other printing where the stiffness of card stock is not required. Text stock is described by pound weight determined by the weight of 500 25" × 38" sheets. For example, 500 sheets of 80-lb. text stock cut 25" × 8" weigh 80 pounds (standard US text pound).

Thermal Dye Sublimation—Also called thermal dye diffusion transfer, or D2T2. A digital proofing technology that vaporizes solid process dyes with either a heated print head or a laser beam and transforms them onto a special stock where they become solid again.

Thermal Wax Transfer—Digital proofing technology that fuses process colored wax from a ribbon by heating it with pinpoint print heads and melting it onto a special stock.

Thermography—Method of printing using colorless resin powder and heat applied to wet ink yielding raised images.

TIFF/IT (Tagged Image File Format / Interchange Technology)—TIFF/IT is a standard file format for the exchange of data accredited by ANSI (American National Standards Institute) and ISO (International Organization for Standards). It was designed to solve the problem of exchanging files that were built on dissimilar high-end prepress systems that converted Post-Script into internal raster data prior to imaging them. A TIFF/IT consists of three files, four in some systems. A CT (continuous tone) 300 ppi; a LW (line work) file 1200 to 2540 ppi; and a FLYT (Final Layout) file that contains information that permits other applications to position the CT raster data file of one resolution against/within the LW raster data file.

TIFF/IT-P1 (Tag Image File Format/Image Technology, Profile 1)—The current version of the TIFF/IT standard, ISO 12639. The P1 variant (Profile 1) restricts the images to CMYK or monotone data, thus eliminating the possibility of sending an ad in an RGB color space.

Tip in or, Tip on—To glue an edge of a sheet to another sheet or signature.

Tolerance—The acceptable range of error from a measured standard.

Tone Compression—Reduction of an original tonal range to a tonal range achievable through the reproduction process.

Tone Value Increase (Total Dot Gain)—The difference between tone value on the print and the corresponding tone value on the separation film or in the electronic file.

Total Value Sum (TAC/Total Area Coverage)—The sum of the tone values on all four-color separation films or in the electronic file of the image. Tone Value Sum (TVS/TAC) is defined as the value obtained by summation of the percent dot areas for all four separations (yellow, magenta, cyan and black) in any single defined area of the image. (ISO12647-1 & CGATS. 6-1995)

Touch Plate—An additional printing plate that adds a matched color to a process color image. (Also known as Bump Plate.)

Tracks—These are parallel recording channels on a memory device (such as magnetic tape), and concentric recording channels on disk drives and high performance optical drives. Tracks are found spiral recording patterns on memories such as the CD-ROM.

Transpose—To exchange the position of a letter, word, or line with another letter, word, or line.

Trapping—(1) Image trapping is a technique in which abutting colors are slightly overlapped to minimize the effects of misregistration of the printing plates. (2) Ink trapping refers to the way various colors of ink on a press adhere to one another when wet compared to the way one layer of ink adheres to the paper.

Trim Marks—Lines on a mechanical, or plate, or press sheet showing where to cut edges off of paper or cut paper apart after printing.

Trim Size—Size of printed product after last trim is made.

Type font—A type font is a given size and orientation of a typeface. Type fonts are stored in several ways: Bit maps for each size, outline encoded or vectors (run length coded bit maps), etc. In some cases the type fonts are stored as masters (generally outlined) at 1 to 4 sizes over the size range to be printed. In these cases, it is the job of the RIP to create the required size and orientation of the type fonts from these masters. Generally bit map (or run length coded) type is stored for each size the printer will use. Sizing and rotation (other than 90-degree increments) is difficult to do while maintaining quality on bit map type. The specific advantage of outline type is to be able to size and rotate while maintaining quality. The disadvantage is that outline type consumes more calculational time of the RIP. The advantage of bit map type is that it can be fine-tuned to the specific imager and requires very little of the RIP power to be placed on the page. The disadvantage of bit map type is that it requires large amounts of memory and, if stored on a host, requires significant bandwidth, or time, to transmit to the RIP (i.e., download).

U

Uncoated Paper—Paper that has not had a final coating applied for smoothness. Uncoated paper is absorbent and soft in appearance.

UCA or Undercolor Addition—Important in achieving optimum quality with GCR color separations. UCA refers to the addition of chromatic colors (yellow, magenta, cyan) in the neutral shadow areas of the image to ensure sufficient TAC for the reproduction of the dark shadow areas.

UCR or Under Color Removal—Reducing the cyan, magenta, and yellow inks independently within the darkest neutral shadow areas in an image reproduction to control TAC. The three

colors are reduced so the shadows have better detail, trapping is improved, and reproduction is more consistent.

Unsharp Masking—A function of the scanner or image editing software that increases the overall contrast at the edges of density or color changes by exaggerating the differences to increase the detail of an image.

V

Varnish—A clear, liquid, resinous coating, either matte or glossy, that is applied to a printed product for protection and appearance.

Vectors—Vectors are mathematical descriptions of both images and the placement of images. Vector information requires the RIP to convert these instructions. Vectors, if calculated to high enough resolution, maintain the capability of rotation and sizing over wide ranges.

Vellum Finish—Relatively rough finish on uncoated paper.

View File—A low-resolution continuous tone reduced file of the actual data used to form the final output page. The view file is used primarily to drive the color display. Alternatively, the view file can be output to continuous tone material to provide a low-resolution proof at a quality slightly better than that found on the color display.

Vignette—Color manipulation affects in which all or a portion of an image fades gradually away until it blends into the non-imaged area. Sometimes used to refer to a graduated background tone. Colors can be vignetted into each other.

Viscosity—Thickness or thinness of a fluid as measured by its resistance to flow. Ink viscosity is adjusted to maintain a proper flow through the ink train of a press and onto the paper.

Visible spectrum—The portion of the electromagnetic spectrum to which the human eye is sensitive; wavelengths of approximately 400 through 700 nanometers. Due to the characteristics of cone sensing (color reading mechanism of the retina), it is generally agreed that humans detect only red, green, and blue. All perceived colors are combinations of those sensitivities (hue) in relation to the strength of the transmitted or reflected light (brightness) and the intensity of the light hitting the retina (saturation). Ultraviolet wavelengths are shorter and infrared wavelengths are longer than the sensitivity range of the eye, and are invisible as a result.

W

Web—Roll of printing paper.

Web Press—Press that prints from a continuous roll of paper.

Wrong Reading—An image that appears backwards compared to the original.

X

XML (Extensible Mark-up Language)— A language for the Web and a subset of SGML, intended to enable generic SGML to be served, received, and processed on the Web.

INDEX

I

index

A

acquisition of content, 12
action, 102–106
Active Server Pages (ASP), 77
Adobe Creative Suite, 9
Adobe GoLive Application, 46, 47
Adobe Photoshop, 27, 37, 47, 86, 87,
 102, 103, 104, 146
American National Standards Institute
 (ANSI), 57
amplitude modulated (AM screening), 29
analog processes, 4
AppleScript, 105–110
application-based automation, 101–105
automated publishing, 100, 163,
 164–165

B

bandwidth, digital, 20, 21
batch sequences, 105
batch window, 104
Berners-Lee, Tim, 44
binary digit, 5
binary system, 5
bit, 5
bitmap data, 27
body copy, 77
Brandson, Michael, 10–11, 88
Brill Communications, 67, 68
Brill, Dan, 68–69
Burman, Linda, 82–83

C

calibration, 36
Calillau, Robert, 44
Cascading Style Sheets (CSS), 80
CCI NewsDesk, 78
charged coupled device (CCD), 27, 28
Chromix, 37
clarity of communication, 137–138
closed loop workflow, 35
collaboration, 9

color, 35, 36
color gamut, 35
Color Management Module (CMM), 37
Color Management System (CMS), 37
color profiling software, 37
Committee for Graphic Arts
 Technologies Standards (CGATs),
 55, 57
complimentary metal oxide semicon-
 ductor (CMOS), 27
concise, 139
Connolly, Bob, 64–65
consistency, 140
content, 4
 creating and organizing, 8–9
 tagging, 9
content creator (CC), 4, 144
content-management system, 9
convergence, 64
conversion, 77–80, 102, 103
Cooperation for the Integration of
 Processes in Prepress (CIP4), 100, 101
cross-media, 6

D

data management solution, 9
database, 14
database applications, 89
densitometer, 37
depends, 135
digital asset management (DAM), 11–14
digital content, 8
digital data, 4–5, 5, 6
Digital Distribution of Advertising for
 Publications (DDAP), 58, 59
Digital Image Submission Criteria
 (DISC), 87
Digital Media Asset Management
 (DMAM), 12
Digital Rights Management (DRM), 21
digital workflow, 6–11
dots per inch (DPI), 26, 27, 28–29

Drake, Brian, 144–147
droplet, 104
DSL, 20
Dual Inline Memory Modules (DIMM), 16
duration, 135

E
Ecke, Shannon, 147–149
editing the metadata list, 90
estimating, 138–139
ethernet, 20
Evanoff, Kathleen, 149–152
EXIF data, 85, 86
exporting your print job to the web, 46–47
Extensible Markup Language (XML), 45
eXtensible Metadata Platform (XMP), 91, 92, 93
Extensible Stylesheet Language (XSL), 45
Extensis Portfolio, 16, 89
extracting metadata, 90

F
fields, 89, 90
file browser, 86
file properties, 86
file servers, 18
file transfer protocol (FTP), 43
Finder Toolbar, 111
fixed resolution file, 27
FlightCheck, 38
flowcharts, 127, 128
fonts, 33, 34, 35, 61–63
formatting, 12
frequency modulated (FM) screening, 29
Frontend Graphics, 158–159

G
Gable, Gene, 161
Gantt chart, 130–131
General Requirements for Applications in Commercial Offset Lithography (GRACol), 39
Geschke, Charles, 31, 32
Gigabit Ethernet, 19
global positioning system (GPS) data, 86
Goodwin, Linda Manes, 60–61
Graphic Exchange Magazine (gX), 67, 69
graphical user interfaces (GUIs), 4, 17

H
halftone, 29
halftone screen, 29
Heidelburg Speed Master 74, 29

hot folder, 104
hypertext markup language (HTML), 44, 45
Hypertext preprocessor (PHP), 77
Hypertext transfer protocol (http), 43, 44

I
IDEAlliance, 87, 88
Image Technology Standards Board (ITSB), 57
InDesign page, 79
interactive buttons, 64, 66
International Color Consortium (ICC), 37
International Press Telecommunications Council (IPTC), 10, 86
Internet, 4
Interpress, 32
ISDN, 20
item, 135

J
Japan Electronic Industry Development Association (JEIDA), 85
JavaServer Pages (JSP), 77
Job Definition Format (JDF), 100–101
Jones, John, 113
just-in-time publishing, 163

K
Kang, Ty, 160
keywords, 15
knowledge set for designers, 165–166

L
LAgraphico, 159–161
layout tools, 9
Liefer, Peter, 154, 155–156
lines per inch (LPI), 26, 30
liquid crystal display, 28
local area networks (LANs), 20
logistics, 125–126

M
Macromedia, 9
MacScripter, 112
magnetic storage, 17
mainframe, 4
mapping, 126–128, 134
Margolies, Michael, 114–116
Markzware, 38
Maul, Betty, 158–159
MediaServer, 11
megahertz (MHz), 15
memory, computer, 16–17

metadata
 application, 84
 database applications, 89
 Digital Image Submission Criteria
 (DISC), 87
 editing the metadata list, 90
 EXIF data, 85, 86
 eXtensible Metadata Platform (XMP), 91,
 92, 93
 Extensis Portfolio, 89
 extracting metadata, 90
 fields, 89, 90
 file browser, 86
 file properties, 86
 global positioning system (GPS)
 data, 86
 International Press Telecommunications
 Council (IPTC), 86
 overview, 82–84
 palette, 86–90
 Resource Description Framework
 (RDF), 91
 system level, at the, 90–91
Metcalfe, Bob, 19
Microsoft JScript, 111, 112
Microsoft Office, 9
milestone, 136
modal control dialogue box, 104
Monaco EZColor2, 37
Morgan and Company, 152–154
Morgan, Kathy, 152, 153, 154
Moses Anshell, 156–158
Moses, Louis, 156

N
naming convention, 12
networks, 18, 20–21

O
OC-1, 20
OmniGraffle, 129
open-loop workflow, 35
optical storage, 17
Oracle, 78
OS X, 34
OS X GUI, 17

P
packaging, 41, 42
palette, 86–90
PC era, 4
PDF (portable document file)
 advantages of, 56–57
 application, 54–55
 development of, 54
 fonts, missing, 61–63
 interactive buttons, 64, 66
 PDF/X specification, 58–61
 preflight basics, 62
 rich media PDF, 63–67
 specifications, 57
PDF file, 46, 47
PDF/X specification, 58–61
Penikis, Gunar, 92, 93
phantom page, 165
photosites, 28
pixel, 28
pixel data, 27
pixels per inch (PPI), 26, 27–28
platforms, 17
polarity, 17
PostScript, 17, 31–32, 34
Poundhill Software, 88
preflight, 38, 39
preflight basics, 62
Primeview LLC, 154–156
print server, 18
process map, 134
process separations, 29
process support, 9
process-logic flowchart, 127
profiles, 36–37
project life cycle, 124, 125
project management
 clarity of communication, 137–138
 concise, 139
 consistency, 140
 depends, 135
 duration, 135
 estimating, 138–139
 flowcharts, 127, 128
 Gantt chart, 130–131
 item, 135
 logistics, 125–126
 mapping, 126–128, 134
 milestone, 136
 nature of, 124–125
 process map, 134
 process-logic flowchart, 127
 project life cycle, 124, 125
 request for quote (RFQ), 132–133
 resource, 136
 scheduling and estimating, 129–130,
 136–137
 software, 134–135
 software for flowcharts, 128–129
 task-logic flowchart, 128
 tickler files, 131–132

project management *(continued)*
 Work Breakdown Structure (WBS),
 125, 133
publish-on-demand, 164
Publishing Requirements for Industry
 Standard Metadata (PRISM), 82, 85
publishing to the web, 43–48

Q
Quark, 9

R
Random Access Memory (RAM), 16
raster image processing (RIPing), 18, 27, 31,
 32, 33
Redundant Array of Inexpensive Disks
 (RAID), 11
repurposing, 11–12, 46, 82
request for quote (RFQ), 132–133
resolution-dependent, 27
resource, 136
Resource Description Framework (RDF), 91
rich media PDF, 63–67
Romkey, John, 5
root, 80
rules-based systems, 164–165

S
samples per inch (SPI), 26, 27
satellite, 20
scheduling and estimating, 129–130,
 136–137
Script Editor, 107
scriptable actions, 110
scriptable applications, 108, 109
scripting, 105–111, 115
Semantic Web, 84
servers, 18
Shapiro, Al, 159, 160
silicon wafers, 16
Simple mail transfer protocol (SMTP), 43
software, 134–135
Software Construction Company (SCC), 11
software for flowcharts, 128–129
Specifications for Non-Heatset Advertising
 Printing (SNAP), 39
Specifications for Web Offset Publications
 (SWOP), 39
spectrophotometer, 37
speed of computers, 15–16
star topology, 20
statements, 106–107
stochastic screening, 29
storage, 17

structure pane, 80
submitting your files, 43
substrate, 29
Suite, 108
syntactical scripting, 106
syntax error, 108

T
T-1, 20
T-3, 20
tagged image file format (TIFF), 27
tagging content, 9
task-logic flowchart, 128
tickler files, 131–132

U
ubiquitous computing (UC), 4
unshielded twisted pair (UTP), 20

V
Vanderbyl, Michael, 6, 7
vector image, 27
Version Cue, 48, 113, 116, 117, 118
versioning, 48, 111, 113, 116–118
Visual Basic Scripting, 112

W
WAM!NET, 11
Warnock, John, 31, 32
watched folder, 104
web server, 19
web, publishing to the, 43–48
wireless hub, 20
Work Breakdown Structure (WBS), 125, 133
Work in Progress (WIP), 40–41
workflow server, 18, 19
World Wide Web Consortium (W3C), 82
WYSIWYG, 37, 45

X
XML
 application, 76, 77
 body copy, 77
 Cascading Style Sheets (CSS), 80
 conversion, 77–80
 InDesign page, 79
 root, 80
 structure pane, 80
XML metadata, 9

Z
Zwang, David, 8